See it

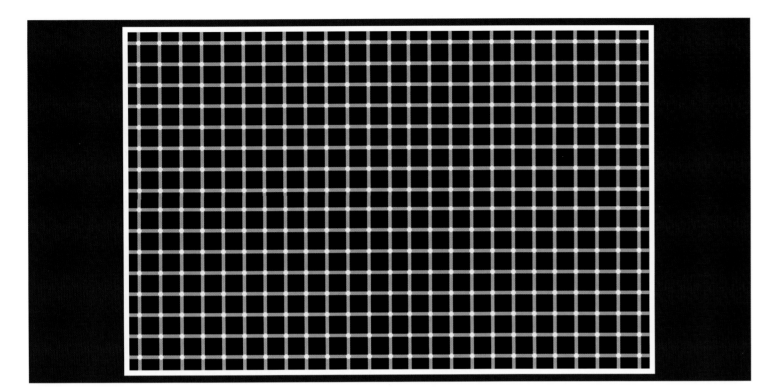

FIGURE 7 The scintillating grid illusion demonstrates some of the extra processing our brain does when perceiving an image.

As manipulative and crazy as this type of thinking sounds, it's actually really common, especially in movies. In *Jaws*, numerous shots, especially those showing swimmers in the water panicking, were shot right at water level. The idea was to make us subconsciously feel that the big, scary shark is right below us, allowing us to empathize with the swimmers.

Cameras do have some unique advantages over our eyes. For instance, we can use the camera to capture light that our eyes can't usually pick up. We know that the earth is always rotating. If sunrises and sunsets were to stop, we would have a problem. What many people don't realize is that this also means the stars move slowly at night, movement our eyes can't pick up. Yet with a long enough exposure, such as the one shown in Figure 8, a camera can capture the earth's rotation, painting "star trails" across the sky. However, just pointing the camera at the sky and holding the shutter open for a long time won't make a great image; especially for shots like star trails, where your eye can't see what you're shooting, it's important to previsualize your photograph (to see your photo in your mind before you take it) and make appropriate camera and lens choices for that photo. In later chapters we'll talk more about how we can form a mental photograph and then, using our cameras and tools such as Photoshop, create these photographs. We'll also talk more about things, including infrared light, that a camera can see that our eyes can't.

Josh Anon | Ellen Anon

See It

Photographic Composition
Using Visual Intensity

Focal Press
Taylor & Francis Group

NEW YORK AND LONDON

First published 2013
by Focal Press
70 Blanchard Road, Suite 402, Burlington, MA 01803

Simultaneously published in the UK
by Focal Press
2 Park Square, Milton Park, Abingdon, Oxon OX14 4RN

Focal Press is an imprint of the Taylor & Francis Group, an informa business

Notices
Knowledge and best practice in this field are constantly changing. As new research and experience broaden our understanding, changes in research methods, professional practices, or medical treatment may become necessary.

Practitioners and researchers must always rely on their own experience and knowledge in evaluating and using any information, methods, compounds, or experiments described herein. In using such information or methods they should be mindful of their own safety and the safety of others, including parties for whom they have a professional responsibility.

Product or corporate names may be trademarks or registered trademarks, and are used only for identification and explanation without intent to infringe.

Library of Congress Cataloging in Publication Data
A catalog record for this book has been requested

ISBN: 978-0-240-82150-4 (pbk)
ISBN: 978-0-240-82363-8 (ebk)

Typeset in Helvetica Neue LT Std
by TNQ Books and Journals, Chennai, India

As an aside, if you're shooting in a situation where things are changing quickly, whether it's because of light or action, we feel it's worth taking your "gut instinct" shot before you start to really think about the scene—that way you at least have something to capture the moment. Plus you can use that gut instinct to determine what you find appealing.

EYE/BRAIN DISCONNECT

It is quite common and easy to think that our camera is a physical tool that functions exactly like our eyes. In many ways, this is part of the reason that photography is so popular–people want to capture what they see and think a camera will capture a scene just like their eyes do. This view makes sense to a certain extent. After all, both cameras and eyes have ways to adjust focus, aperture, and exposure.

Except that if things were that simple, then why does it happen that so often the shot we think we're taking isn't the one we end up seeing on our screens? Put simply, our eyes work very differently from our cameras. We all know about the mechanics of our cameras and how we can adjust things like aperture (the size of the opening on the lens allowing light to fall on the sensor), shutter speed (how long the shutter's open, letting light fall on the sensor), and ISO (how sensitive the sensor is to light falling on it), but how many photographers know the mechanics of how their brains process what they're seeing? Chapter 2 will go into detail on how scientists currently believe our brains interpret what our eyes see, but we're going to give you a teaser about our brains' mechanics in this section.

In a morbid experiment in 1878, believing that our eyes are like cameras, Willy Kühne immobilized a rabbit, forcing it to look at a particular scene—a window—killed it, and then "developed" its retina to form an image. Surprisingly, the image formed a somewhat recognizable scene of a window! Shortly thereafter, he managed to get the eyes from a condemned man right after that man's head was severed. Unfortunately the image he got from the convict's eyes wasn't identifiable.

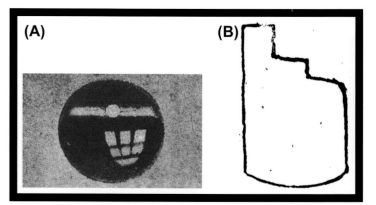

FIGURE 6 Kühne's images from developing a rabbit's eye (A) and a human eye (B).

While it may or may not be that our retinas function like a piece of film, our eyes don't function just like a camera: there's extra processing going on inside our brain to turn what our eyes perceive into a meaningful image. To look for a second at the weird things our brain does when processing an image, close your eyes and imagine what a grid of gray lines on a black background will look like. Next, imagine that there are small, white circles everywhere the gridlines intersect. Figure 7 has that drawn out. Take a look at it.

When you imagined this image, you probably didn't anticipate those black circles that appear and disappear as you look at the image. We'll look at this illusion more in Chapter 2, but hopefully this proves to you that your brain sometimes does funky stuff when processing an image. If you still don't buy this, go look at some different optical illusions online. It's surprisingly easy to fool our brains!

If we want to take a photo that captures what we see, we need to be aware of what processing is happening. Then we can make changes to the shot we're taking, both as we're taking it and later on with our computers, to cause other people to see the image the same way we saw the scene when we took the photo.

Contents

Dedication vii

About the Authors viii

Acknowledgments x

Preface xii

Chapter 1 Learning to See 1

Chapter 2 Light and Perception 23

Chapter 3 Lines, Shapes, and Textures 51

Chapter 4 Color 83

Chapter 5 Framing 103

Chapter 6 Light 141

Chapter 7 Visual Storytelling 161

Chapter 8 Putting It All Together: Classic Good Images
and Visual Intensity 189

Chapter 9 Creating Images in the Field 221

Chapter 10 Improving Visual Intensity with
Digital Manipulation 265

Chapter 11 Going Beyond with Creative Digital Techniques 295

Selected Bibliography 327

Index 329

To my family, for always having a spare compact flash card handy. — Josh Anon

To my family for all their support and to Drs. Gary Brotherson and J.P. Dailey, who continue to go the extra mile to make sure that I can still "See It!" — Ellen Anon

Dedication

JOSH ANON has been a nature photographer for most of his life, with his interest in photography starting when he received his first Kodak 110 camera at the ripe old age of four. Camera in hand, he received a B.S. in computer science from Northwestern University in Evanston, Illinois.

After graduating, Josh started working at Pixar Animation Studios in Emeryville, California. There he has worked on *The Incredibles*, *Ratatouille*, *Toy Story 3*, and more. Currently he is a camera and staging artist.

He has traveled the globe searching for the next great picture, be it a hundred feet deep on the Great Barrier Reef, on a cold and windy beach in the South Atlantic, or in the Arctic Circle. His award-winning images, represented by the prestigious Jaynes Gallery and available on www.joshanon.com, have appeared in a variety of galleries, calendars, and other publications, including the *NBC Nightly News*, *Nature's Best*, *Photo Media*, and more. Josh teaches photography, both privately and for the Digital Photo Academy, and he and his mother, Ellen, have also co-authored *Aperture 3 Portable Genius* (Anon and Anon, Wiley, 2011) and *Photoshop CS5 for Nature Photographers* (Anon and Anon, Sybex, 2010).

When not shooting and making movies, Josh can be found developing iOS applications and kiteboarding.

ELLEN ANON got her start in photography at a similar young age, but it remained a hobby for many years, as she initially followed a different fork in the road, earning a Ph.D. in clinical psychology. A broken foot in 1997 forced her to take a break from working as a psychologist and she used the time to study photography. Doors began opening and a new path emerged that led to her becoming a freelance photographer, speaker, and writer. Her goal with her images is to go beyond the ordinary in ways that she hopes stimulates others to pause and appreciate some of the beauty and wonder of our earth. Ellen's images are included in collections in several countries. Her images are also represented by the Jaynes Gallery and are available on www.ellenanon.com. Her photos have been showcased in galleries, used in numerous publications including the Sierra Club's *Mother Earth*, the prestigious Yogananda Inner Reflections calendars, and as one of the Apple TV screensavers. In addition, she has been Highly Commended by the BBC Wildlife Photographer of the year competition as well as Highly Honored in Nature's Best Windland Smith Rice Competitions. Ellen is the co-author of seven popular books (including several with Josh, as listed above) as well as numerous video training tapes. In addition, she is a writer for the highly esteemed www.dpreview.com.

She is honored to be part of Nik Software's Team Nik, the SanDisk Extreme Team, Wimberley Professional Services, and Paramo's Nature Pros.

About the Authors

First and foremost we both want to thank our family members for their continued support and encouragement. Neither of us would be where we are today without each other, Jack, Seth, and our grandmother/mother Miriam Lurie.

We have wanted to write this book for a long time, and are very thankful to the people at Focal Press, especially Valerie Geary, our acquisitions editor, Emily McCloskey, our project manager, and Siân Findlay, our production editor. They remained impressively calm, no matter how vehemently we stated our opinions. We also owe our gratitude to our technical editor, Lou Lesko, for making sure that we're telling you accurate and useful information.

We are especially grateful to many of our friends and colleagues who graciously donated images, and we hope this is a book that they'll be proud to have a role in creating. Major thanks to: Lindsay Adler, Art Becker, Clay Blackmore, Peter Burian, John Paul Caponigro, Jeremy Lasky, Margaret Livingstone, Charlotte Lowrie, Arthur Morris, Mallory Morrison, Freeman Patterson, Kirk Paulsen, Patty Raydo, John Ricard, Robert Silvers, Steve Simon, Daniel Simons, Nevada Wier, and Art Wolfe!

Josh: I also owe my thanks to my friends and co-workers at Pixar, including Jeremy Lasky, Patrick Lin, Matt Silas, Adam Habib, Mark Shirra, and Trish Carney. All of you are always inspiring and just plain fun to talk to, even if some of you still prefer film. I owe special thanks to Ralph Hill for his input, which helped make the book better. To my friend Michelle Safer, thank you again for providing moral support and motivation. And of course, how could I not thank my high school English teacher, Claudia Skerlong, for teaching me to write well. A little birdie told me that when she heard I was writing a fifth book, her reply was, "Yeah, right, and I'm going to go dig a hole to China."

Ellen: I'm so fortunate to meet so many people along the way, at workshops, at talks, in life, who are inspiring. There's no way to mention everyone by name but each one of you has a role in whatever I create and I am grateful to you. I do want to specifically thank a few people who are always there for me, including Art Becker, Peter Burian, Dee Cunningham, George Lepp, Charlotte Lowrie, Michael Lustbader, Kirk Paulsen, and Patty Raydo. Thanks as well to Cliff Oliver who also played a role in ensuring that I can still "See It!" I also want to thank Josh—if anyone had told me when you were a teenager that down the road we'd be co-authoring books together, I'd have thought they were nuts. Now I just know that I'm a very, very lucky mom!

Acknowledgments

Over the past few years, we've seen a huge surge in the number of people interested in photography. A big part of this newfound interest has been because of the convenience and accessibility of digital photography. Unfortunately, this has led to everyone talking about the technology of photography and Adobe Photoshop. The average person on the street could probably even tell you how many megapixels her cell phone's camera has!

There is certainly something to be said for knowing your gear and understanding how it all works. We would even say that understanding the basics of your equipment and exposure are prerequisites to getting the most from this book! When you're in the heat of the moment, you don't want to have to pull out your camera's reference manual.

Yet technology is not the heart of photography. No camera, no matter how advanced, has ever composed and exposed an amazing image all by itself!

Photography's an art, and being able to create a shot that effectively conveys the statement we want to make is the heart of that art. Typically, composition books fall into two camps—those that give you a list of rules and then tell you to feel free to break the rules, and others that arbitrarily state what the author feels the photographer must be trying to convey without giving any insight into how the author deduced that story or what you can do to convey your stories. In our opinion, neither of these is very helpful.

We think that by using our visual intensity-based approach, we can help you create compelling images that people will want to look at and that will help you convey the story you're trying to tell. And the best part is that you can apply this overall concept in the field while shooting to capture better images, while editing to help you select your best images, and in the digital darkroom, to help you make your best images even better. If you follow our advice and apply visual intensity, we are confident that you will become a better photographer.

Preface

Learning to See

- Cameras are Everywhere 2
- Our Compositional Progression 3
- Eye/Brain Disconnect 7
- Visual Intensity 14
- Being Aware of Everything In Your Frame 19
- Exercises 21

Every image starts as a black frame. The things that we photographers choose to put into the frame are elements that either add to or take away from the unique image that we're creating. It takes a myriad of considerations to make sure that the image we're creating conveys the idea we intend because what our brains perceive is different from what the lens records. In this book, we'll explore how to create images that capture our creative vision.

FIGURE 1 Photography is one of the most popular hobbies in the world, and thanks to cell phones, millions of people have a camera on them at all times.

CAMERAS ARE EVERYWHERE

Nearly every cellphone has a camera, computers have built-in web cameras, millions of people own point-and-shoot cameras that they keep with them almost all the time, traffic lights and stop signs have cameras, and a select group of people own a single-lens reflex (SLR) camera.

One reason that cameras are so popular is because they make it easy to capture and preserve moments from our lives long after the memory has evaporated from our minds.

Do you remember exactly what you looked like for your high school graduation? How about for your first date? If you had taken a photograph, you could capture that moment and memory exactly. Of course, sometimes our memories are fonder than the actual event, and we don't want a photo of what it was really like (you wore *that* to your senior prom?)!

Another big reason, though, is that images are very powerful and a core part of our world. Human society has been dominated by images, whether we're looking at images in caves painted 17,000 years ago or images of celebrities in embarrassing situations in the tabloids. A good image can convey an idea on its own more uniquely than any other medium, no translation required, and anyone, in any corner of the earth, can easily share an image with a potential audience of billions of people with only an Internet connection. Those images can be very powerful and world-changing, such as photos of victims of war, or very silly, such as a funny cat photo. Either way, images are a powerful and efficient way to universally convey ideas.

Since their availability to the general public via the Kodak Brownie, cameras have made it easy to create an image. Digital cameras have really lowered the bar

for taking a technically perfect photo, with better automatic exposure systems and flexibility to adjust exposure because of how much information a RAW file captures, and instant histograms that tell you if your shot will be correctly exposed before you take the photo. Once you've purchased your digital camera and accessories, the only cost when you press the shutter is your time to process the image. We've come a long way since the film days when you'd take multiple exposures of the same subject to be sure you nailed it perfectly and then had to pay to get each roll of film developed.

However, what cameras haven't automated is figuring out what to put into your frame, or, more specifically, what to put where in your frame to create the image that you've mentally set out to create. That's a lot harder, for many reasons, and we're going to help you learn to do that better in this book. Fortunately, it's a lot cheaper to learn these skills by trial and error now than it was back in the film days! The other big thing we're going to show you is how to use the same techniques you're using while shooting to determine what (if anything) you should do at your computer to optimize your image.

If you've read composition books in the past, you'll find that they typically fall into two categories. The first is a list of rules, which sometimes takes the form of clever chapter titles, yet really boils down to a list of rules. If you were to take the time to write down all these so-called rules, you'd find that they conflict with each other. Inevitably, every composition book says somewhere that you shouldn't be afraid to break the rules, which pretty much says the "rules" are meaningless. Yes, once in a while these rules will help you get a better photo (and by "better," we mean one closer to your vision), but without understanding why your image is better when you do something, you're sort of taking a blind-squirrel-finds-a-nut approach to photography—take a lot of shots, and eventually you'll get a good one.

The other type of composition book is one that gets very new agey and talks about how the photographer was feeling— insert arbitrary emotion here—and how the photography really conveys said arbitrary emotion, without talking about how the photographer created the emotion. That's not usually helpful, either, because it doesn't teach you to take a better photo or really explore what's appealing to a viewer about the image and how the photographer conveyed that experience.

Now, prepare yourself for something different. We're about to delve into how our brains perceive images, and, no matter what your skill level, we're going to do our best to make you into a better photographer.

OUR COMPOSITIONAL PROGRESSION

The very first step toward making yourself a better photographer is not a rule, but a question. Before you pick up your camera, even before you put your lens on your camera, ask yourself something: **What about this scene is interesting to me?** That simple question, which really drives at the essence of what you want to convey with any image you're about to take, should drive every compositional choice you make, from what lens you use to where you stand to which exposure settings you want to use. Yet, for some reason, many photographers often seem to press the shutter button on their cameras without any thought as to why they're taking the shot or what's in the frame.

Let's take a concrete example. Yosemite is a popular national park in California. During the spring and summer months, the park runs a tour where they put everyone on a large, roofless bus and drive around the valley roads, with guides pointing out interesting things to see. At one point, there's a small waterfall by the side of the road, and if you listen closely as the bus passes, you hear the sound of fifty cameras going "click" at once (and smell the wonderful odor of diesel fumes). Most people end up with a photo like Figure 2.

Since we naturally put the most important thing at the center of the image, the waterfall will be roughly centered in nearly every person's shot. Chances are that the people shooting were so focused on the waterfall that they didn't even pay attention to

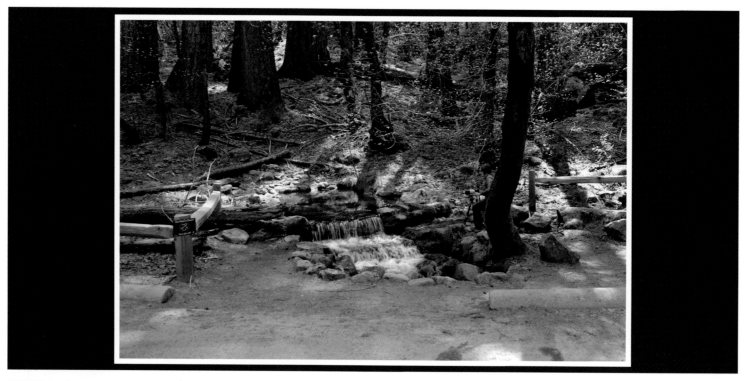

FIGURE 2 A snapshot of a small waterfall in Yosemite National Park.

how big it would be in the frame, or whether anything else, such as a fellow tourist, was also included in their epic waterfall photo.

Occasionally, someone who may have read a compositional "rule book" will be on the tour bus. She'll remember being taught a rule that the subject should always fill the frame! She'll press the zoom button on her camera and end up with a shot like the one in Figure 3. It's definitely a better image, and it will still help trigger her memory later on. By zooming in, she won't have to remember what she was taking a picture of! But in the end, it still has the same flaws as the first shot and makes the waterfall look like a tiny puddle and not something that belongs on a tour (of course, if you're trying to express your unhappiness with the tour, that might be exactly what you want, but we're going to assume that's not the case).

When there is someone on the bus focused on improving his photography, he'll get off the bus, walk up to the waterfall, and remember what he was taught in his photo class. He'll remember a rule that vertical subjects should have vertical framing. He'll be looking for S-curves (lines that curve and meander around, roughly resembling a big "S") because some other rule told him that S-curves are good. And he'll follow the rule that says fill the frame. He'll take an image that looks like Figure 4, and even though it's a little better than the first two, it's nothing to write home about. While it's better than the earlier shots in that it's clear the shot is about the waterfall, it's unclear what's interesting about this waterfall and why he took a shot of it. If anything, the previous shot (Figure 3) was better because it gave a sense of scale and a tiny bit of silliness because this tiny waterfall was part of a tour of a humongous valley.

FIGURE 3　Zooming in on the small waterfall lets it fill the frame, but the shot still isn't as good as it could be.

If our intrepid photographer were to walk a little bit closer to the waterfall, he'd notice many gentle curves as the water cascades over the rock and see a neat interplay of light and color with the green moss and the white water. Many people (the authors included) find those details the interesting part of this scene. Next it becomes a question of making the technical choices to support this vision. Picking a long lens would let him isolate that part of the falls from the surrounding area, and a slow shutter speed would emphasize the water's motion by letting it flow through the image. In the end, you'd get something like Figure 5.

Since photography is subjective, it's possible that some of you reading this book will prefer one of the earlier shots to the later one. That's perfectly fine, but ask yourself why you like the earlier shots better. What captures your attention in this scene? What's more interesting about one shot over another? What would you have done to emphasize that aspect? There are certainly multiple good shots of a single location, and everyone has a different vision of a scene, but the point remains that you should ask yourself what's interesting to you before picking up your camera.

If it's hard for you to identify what's interesting, try this. Imagine you're about to paint your image rather than taking a photo. As a painter, you can explicitly pick what to include and not include in your painting. Then, figure out what you can do with your camera to include only the things you would have in your painting in the photo.

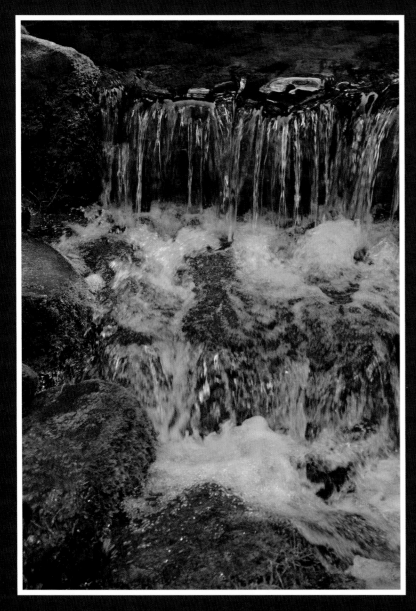

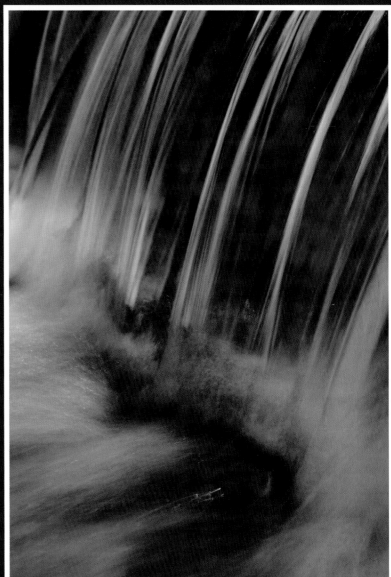

FIGURE 4 Using some of the traditional "rules" results in a slightly better photo, but it's still not capturing what's really interesting about the waterfall.

FIGURE 5 By focusing on what interests you about a scene and using your camera and lenses to emphasize that, you'll get a better photo than if you just try to follow the traditional rules.

FIGURE 8 Star trails are an effect that our camera can record via a long exposure but that our eyes never see.

Let's think about a specific time when simply expecting our cameras to automatically capture an image in the way that our brains perceived a scene failed us. How many times have you waited a while before downloading the images from your camera, and then, when you look at your pictures, there are some where you just don't remember why you took the shot? We can almost guarantee that if you look closely at the image, you'll eventually see a very tiny subject, and when you took the photo the subject probably seemed a lot more obvious to you.

Our brains are really good at focusing on something specific and ignoring the rest of the world. Often in national parks you'll see people pulled over by the side of the road, pointing at an animal, like a bear, way off in the distance. Because the bear's moving,

it's easy to see it, even against a similarly colored background, and you'll probably keep your attention on it for a while, ignoring everything else. If you have a camera, you'll probably take a bunch of shots of the bear. However, unless you take steps to focus the viewer's attention onto the tiny subject (we'll discuss how to do this throughout this book), it might be really hard to spot the bear in the shot later, because it's not moving.

Where Do People Look?

Let's take a quick look at where our attention naturally goes in different images. You might think it's easy to figure out where people look, just by asking them. However, our eyes are moving a lot without our being aware of it. In fact our eyes move about

FIGURE 9 There are really two moose in this shot, and they were easy to see while shooting! They're harder to see now that our attention isn't fixated on them, because they're so small in frame.

three times a second on average. By using eye trackers that can tell where we look, scientists have figured out that there are two main types of places that we'll look in an image.

Some photographers, when asked to discuss their image, will always start by saying "your eye enters from…" Unfortunately, it's impossible to tell what part of an image people look at first. For example, if you shut your eyes and someone places the image right in front of your face, you might start looking from the center. Alternatively, if it's in a slide show, when someone advances the slide to the new image, you'll probably start off looking where you were looking at the last slide. Figuring out where our eye "enters from" isn't very useful. What is useful is finding out where people look.

The first place that we'll look is what one psychologist termed the "useful or essential" parts of an image. Specifically, these are the parts of an image that our memories, experiences, and knowledge tell us will contain useful knowledge. If we see a sign with text on it in a photo, even if we don't recognize the language, we'll look at the sign because we know signs convey knowledge. We're also incredibly good at focusing on faces, both human and animal, because faces can convey everything from emotion to where the subject's looking. For example, if we see an image like Figure 10, our eyes quickly go to the face of the cheetah on the left (the one that's looking back at us), and once we realize we're not in any danger, no matter how real the photo looks, we'll look elsewhere in the image.

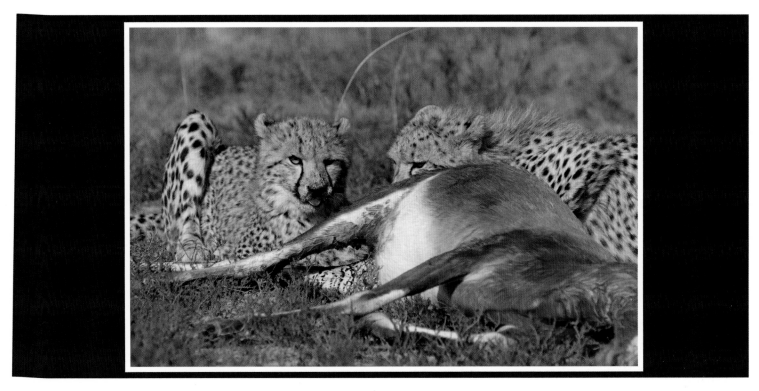

FIGURE 10 We quickly look at the cheetah on the left because if we saw this scene in real life, and it's looking back at us, our lives might be in danger!

WHY DO OUR EYES MOVE SO MUCH?

One theory is that it's a result of evolution. With our eyes, set side by side and capable of moving quickly in many directions, we have a very large field of view in front of us. Only a very wide angle lens can come close to matching our eyes' complete field of view. It's a challenge to create a high-resolution representation of the view in our brains! Over the years, evolution made it so that, rather than having "high-resolution sensors" (forgive the crude analogy; we'll be more scientific and precise in Chapter Two) over the entire eye, overloading our brain's "buffer," we have a small, concentrated, very high-res area in the center of our eye with a smaller field of view (50-mm lenses are very popular for 35-mm cameras because their field of view is similar to our field of visual attention). Then, by constantly moving the eye and adjusting its lens (refocusing and adjusting its exposure settings), we're able to always have a high-resolution view of the world available to us, in which everything has detail and is in focus. On the whole, it takes fewer resources to construct the detailed image, compared to always processing a very high-resolution image for the entire field of new.

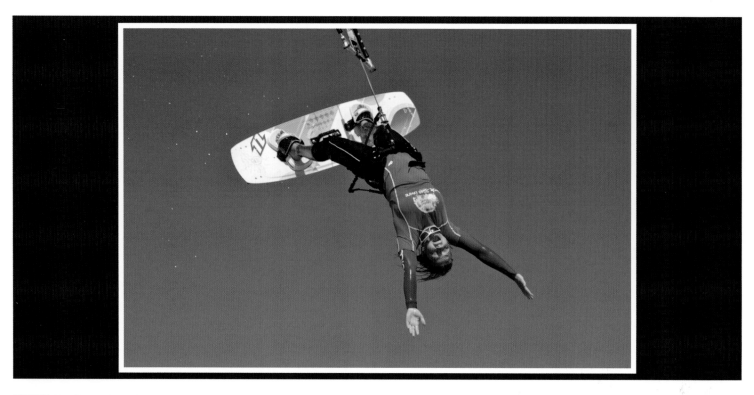

FIGURE 11 Regardless of culture, we're really good at recognizing what a person is feeling in a photo—something our brains detect by focusing on a face. This kiteboarder's pretty thrilled to be up in the air, in the middle of a trick!

As a photo tip, if your subject's eyes are visible in the frame, you'll almost always want to make sure they're in focus. The reason for this is that if the subject's eyes are clearly visible in a shot, our brains will cause our eyes to look there. However, if some other part of the subject, like a foot, is in focus instead of the eyes, this will create conflict in our brains between what we think should be in focus and what is in focus. We also create a definitive visual path as our eyes go back and forth between the sharp foot and the subject's eyes. Even if the eyes aren't visible in the shot, we know where they should be and will look there anyway.

Painters have known about how critical it is for the eyes to be in focus for a long time. Renoir, a painter in the late 1800s, for example, would only draw detail in his subject's faces and eyes, letting everything else blur out (sometimes only giving a hint as to the rest of their body), but because his subject's eyes are detailed, our brains accept his paintings as perfectly normal and complete.

Something else interesting about the importance of faces is that facial emotions are universal in photos. In 1971, two psychologists (Ekman and Friesen) showed forty pictures of faces that, according to their Western standards, showed specific emotions to a group of over three hundred people from New Guinea. The New Guineans had never seen a movie or magazine, didn't understand English at all, and had never lived in any Westernized location. They were reliably and

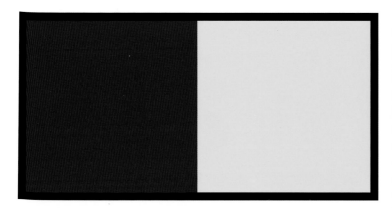

FIGURE 12 Rather than looking at just the left or right side, you look at the center boundary between the two colors, as this is where there's information in the image.

consistently able to recognize and relate to the emotion that the faces were conveying. In Chapter Seven, we'll look at ways to use these "useful" parts of an image to help tell a story with your photo.

To understand the second type of place our brains look, let's look at an example. Take a look at Figure 12—two rectangles next to each other, one blue and one yellow. Where do you look? Chances are, you look right at the boundary between the two rectangles.

We'll look in more detail at what's going on here in Chapter Two, but the essential bit is that we look where there's some type of contrast. This doesn't just mean lighting contrast (something dark by something bright). This includes any type of contrast, whether it's shape, texture, color, or whatever. In fact, we look at these points of contrast before we've con-sciously processed what's going on in the image, and some people call this type of vision "preattentive vision" because cells in our brain are making us look at these points without our actively controlling it.

These points of contrast and "useful" points of information don't just affect where we look in an image, though. The more

CULTURAL DIFFERENCES VIEWING IMAGES

Although where we actually look in an image is partially hardwired into our brains, how we look at images varies fairly significantly between Eastern and Western cultures. Specifically, Western viewers spend more time looking at the interesting points that our higher-level cognitive processes draw us to, such as a person in the picture. Eastern viewers, on the other hand, tend to focus more on the background: their viewing time is split between the subject and the background and they form a more holistic impression of the image.

Neither viewing style is better than the other. A Western viewer, by looking more at the subject(s), is able to be more analytical. She can assign the image to a mental category more readily. At the same time, an Eastern viewer can be more holistic. His judgments about the image are based on relationships between parts of the image. More concretely, in a study by Masuda and Nisbett in 2001, when the experimenters asked people to comment on what they noticed in a series of underwater images, U.S. viewers were more likely to talk about a fish, whereas Japanese viewers were far more likely to comment on the background (the color of the water, rocks, etc.).

places for us to look, the more energy an image has, because these points are causing us to move our gaze around it. Too much energy in an image can make it unappealing, and too little energy can also make it unappealing. But it turns out that it's not just how many places we look in an image which determine its energy. Everything from what type of lines are in the shot to how the image is presented can affect how we perceive the energy in an image. We call this notion of looking at an image based on the energy in a frame *visual intensity*.

VISUAL INTENSITY

To understand the concept of visual intensity, let's think about music for a second. If someone's just playing a single note over and over, the music will be pretty boring, and you won't want to listen. Conversely, if you're listening to five different songs at the same time, each one with its volume as loud as it can go, the music's just going to sound like noise. There's a happy medium where the music isn't just a monotone and isn't just noise, but is rather something appealing that we want to listen to.

Photographs work in much the same way. There's also a happy medium in the amount of visual intensity needed in order to create an appealing image. Now what exactly this appealing image looks like is going to vary a lot from person to person. In the same way that you like music that your friends don't, you might prefer a shot of a person's entire face, whereas your friend will prefer a shot of just the person's eye.

Throughout this book, our goal isn't to tell you which shot you should take. Photography, like other art forms, is really a matter of personal taste. What we are going to do is to teach you how to make whatever shot you want to take as appealing as possible and to represent what you actually perceived when looking through your viewfinder. Furthermore, the way we're going to do that is by looking at the energy—the visual intensity—in an image.

Focusing on Components in an Image

Let's look at an example of visual intensity in action. We're going to draw a simple image with colored shapes and focus on just changing two components, the color of the shapes and what shapes are in the image. In Figure 13A, all the circles are the same color. The image has fairly low visual intensity. In Figure 13B, the circles have varied color, and the image is more interesting. In Figure 13C, we've also added a lot of shape variation, and the image is on the verge of being overwhelming. There is a sweet spot in every image, where we've balanced the different components in such a way that the shot is interesting without being overwhelming.

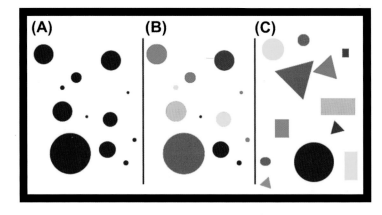

FIGURE 13 Just changing the colors and types of shapes in an image changes the overall intensity for the image, going from too low to too intense.

We'll explore this idea of looking at the components of an image throughout this book, but something to point out right up front is that we do not mean you must have equal intensity levels for every component in your image. Rather, a great way to think of the visual intensity concept is if you were to break an image down into all of its components and rank each component's variation as being low, medium, or high, keeping in mind that you don't want every component to be the same. If many components fall into the low ranking, you'll want one or two components to have high rankings to help balance the low ones. And if every component has a medium ranking, the shot as a whole will probably be on the verge of being too intense because every component is contributing a moderate amount of energy.

While not scientific at all, if you look at the graph in Figure 14, we've broken three sample images into some of their components and plotted how much energy each component contributes to the image. Two of the images, represented by the orange and green dots, have an overall good energy level despite being very different. The third, represented by the purple dots, has a very low energy level, and we'd consider it to be too dull. The take-away here is that there's no magic, absolute, and measurable energy level that you

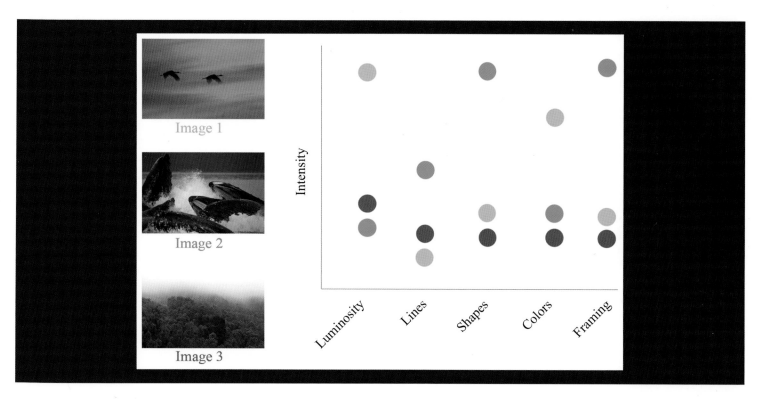

FIGURE 14 Plotting the visual intensity of the components from three different images. Two Images (1 and 2) have good overall intensity, whereas intensity in Image 3 is too low.

should strive to hit but rather a good balance of the components.

Let's look at another real example. Compare the shots in Figure 15A and 15B. Figure 15A has a lot of contrast in a lot of components! Between the flowers and shrub, there's color contrast, changes in texture, shape variation, and luminance contrast. We've all taken shots like this one, and they just don't work. Although some people would tell you that using a diffuser to limit the luminance contrast would fix the shot, we guarantee that it still wouldn't be an outstanding shot—there's still too much visual intensity. At the same time, in Figure 15B, we still have a lot of color and shape contrast, but there is

almost no luminance or texture contrast. It's a far more pleasing image.

Shooting with Visual Intensity in Mind

When we were starting to develop visual intensity as an approach to composition, one thing that convinced us we were on the right path is that looking at a shot with a visual intensity mindset actually explains some of the traditional photographic "rules"!

As a case in point, consider the rule of thirds. This rule says that, if you divide your image into thirds vertically and horizontally (imagine putting a tic-tac-toe grid over your image), your

FIGURE 15 Here are two versions of a similar subject, one with too much intensity (A) and one with a pleasing intensity (B).

image will be a lot better if you put your subject on one of the points where the gridlines intersect instead of the center.

There's actually nothing wrong with placing your subject in the center of an image. People instinctively spend a lot of time looking at the center of objects (one theory essentially says that our brains just assume the center of objects will be the most important, causing us to instinctively look there). The problem with centering a subject, though, is that it doesn't create much visual intensity; the center of the frame is a very low-energy position. Therefore, if you are looking to add visual intensity to a shot, don't center your subject! Yet if your shot is very dynamic as-is, centering the subject will help prevent it from being overwhelmingly intense (Figure 16). We'll explore this idea more in Chapter Five when we talk about framing.

Although being aware of visual intensity might seem a bit awkward at first, think of it as being like finding your balance when you learn to ride a bike. You think about it consciously at first—you're tipping to one side and therefore must lean to the other—but after a while, it becomes second nature. Furthermore, as you go over different terrain and at different speeds, you must adjust your balance on the bike. You can't do the same thing all the time and expect to ride smoothly. Plus, you can't just focus on one element, such as where on the pedals your feet are, to ride a bike well; you have to think of the sum of the parts.

Like riding a bike, using visual intensity will become second nature to you over time, and the exercises in this book will help. In fact you're already a natural at visual intensity, even if you don't know it. Our brains are wired so that different parts of the brain process the different components, such as color and shape, that go into visual intensity. There are even a number of ways to automatically create a "saliency map" of a

photo that will map out where we're likely to look in a given image. We'll delve more into what's going on in our brains in Chapter Two, but the short of it is that thinking of images in this manner puts us one step closer to making it easier for people to perceive our images in the way that we want them perceived.

The other benefit to thinking about visual intensity is that it helps us determine what digital adjustments we should make to an image. Very often, after people finish shooting, they have no clue what to do with their images in the computer. It's amazing to watch the different reactions people have when they realize they don't know what to do. Some people literally change every slider that their RAW converter gives them for each image. This is a bit impractical, especially if you're shooting a lot of photos! Other people take a vehement stance that they don't manipulate their images and refuse to touch any slider. That's also impractical, because, as we have already established, your camera works differently than your eyes, and what you captured doesn't necessarily reflect what you saw.

We believe that the right answer is really somewhere in between. Your goal is to get the right intensity in the image and to make sure that the subject is more intense than the background, so that a viewer's focus goes to the right place. By looking at the components in your image and thinking about how each one contributes to the overall intensity, you will develop a game plan that will guide you to increase, decrease, or leave alone each of those intensities. Doing this will help make your shot look a lot more like what you saw in the viewfinder rather than what your camera captured.

Using Visual Intensity to Edit

An idea that we want to really emphasize is that this book focuses on exploring and looking at

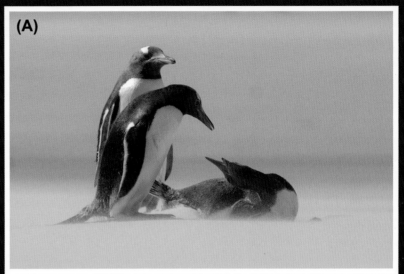

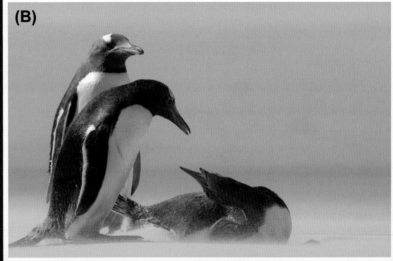

FIGURE 16 By cropping this image, we can shift the subject from being centered (A) to being towards the edge of frame (B). Because the shot has a fair bit of energy, the uncropped version with the subject more centered helps keep the overall energy slightly lower and is more pleasing than the cropped shot.

FIGURE 17 You learn by shooting, making mistakes, and trying new things. Don't be afraid to shoot a lot, even if you eventually delete a lot of what you shoot! Digital photography has significantly reduced the cost of shooting, and you should use that to your advantage, to learn.

photography differently than you have before. We thoroughly expect that you will make mistakes and take a lot of shots that you never want to show anyone else (we do that too!). There's nothing wrong with that, and the way we grow as photographers is by trying new things instead of using the same approach over and over. Don't feel as if you have to take perfect shots all the time! If you take one shot out of every thirty-six that you really like, you're doing well. Even professional photographers have been known to throw away countless images and keep only one out of a hundred; they just shoot a lot more and therefore get more keepers!

Please do resist the temptation to throw all of your images away immediately, especially now that you are able to see and

delete them right on the camera (some images are obviously bad, perhaps out of focus, and it's safe to delete those). Often when we're editing, whether we like a picture or not could simply depend on our mood. For example, if we were trying to capture a particular shot and got close but didn't nail it precisely, we might be disappointed and want to just throw away everything we took. If we wait a while before making that final "delete" decision, we might be in a better mood when we edit and more able to appreciate what we did shoot!

Furthermore, we want you to try something as you edit your shots. Delete the ones that are clearly bad, such as those that are out of focus or not properly exposed. For the other

shots, though, think about the overall visual intensity in each shot. Is it too high, too low, or just right? Here, it is the gut-level reaction that is paramount. Is the subject more intense than the background and not competing with the background for attention? Rather than deleting the images you don't like right away, consider keeping them for now, going back to them after you've finished reading this book, and seeing if you can use your digital toolkit to turn images that you would've previously deleted into images you're really happy with!

BEING AWARE OF EVERYTHING IN YOUR FRAME

One of the hardest things for many photographers is also something essential to improving your composition, and that's being aware of everything in your frame. How many times have you taken a shot of something and then later, when looking at the image, noticed something obnoxious that you completely missed while shooting? A great example is when you see a portrait of someone, and there's a tree or lamp post that looks like it's growing out of their head.

What's really hard about being aware of what's in our frame is that our brains are almost always conspiring to prevent us from being aware of what's in front of us. They suffer from what's called inattentional blindness, where they're completely unaware of important things happening right in front of our eyes, because they're focused on something else.

Now you might be scoffing and laughing at the idea that you're not always aware of what's happening around you, but it's true! You'll even ignore a gorilla pounding its chest at you! Two scientists, Daniel Simons and Christopher Chabris, conducted a study where they played a video of players wearing black shirts or white shirts passing a basketball, and asked their subjects to count how many times the players wearing white passed the ball. The subjects usually counted that correctly, but they never noticed the black gorilla that walked through the frame, even when it turned to the camera and pounded its chest. Search online for the video if you want to try for yourself!

As we're going about our lives, usually this inattentional blindness isn't an issue. But when we're creating an image, it becomes a challenge because we've taken a tiny part of the world and frozen every detail of it into an image, and a viewer will have as much time as he wants to look at all of the details in the image.

Painters, sketch artists, and other artists who draw their images almost have it easy compared to photographers (well, that is if you ignore how hard it is to draw well!). When you're drawing an image, you can pick and choose what to include in your frame, capturing only the details you want people to see.

Really, what a painter's doing is picking what details she thinks contribute to the essence of an object, and capturing those details. As a simple example, draw a house. Chances are you drew a square with a triangle on top, maybe with a door and a window. That house probably doesn't look anything like your house, and it's missing lots of detail (e.g., does it have brick or siding on the walls?), but you captured the essence of a house, and anyone looking at your drawing would know it's a house.

Photographers naturally have all the detail everywhere in every object in each shot. It takes effort to use our tools—such as being able to limit our depth of field—to reduce what's in the frame and focus on conveying the essence of an object, bringing the right amount of visual intensity to the subject as opposed to the background.

Being aware of everything in your frame goes beyond making sure the subject has the right amount of visual intensity. As we mentioned previously, every component in your image, from the lines in the background to the colors on the subject, even to the matte you use when framing the printed image, contribute to the image's overall visual intensity. Achieving the

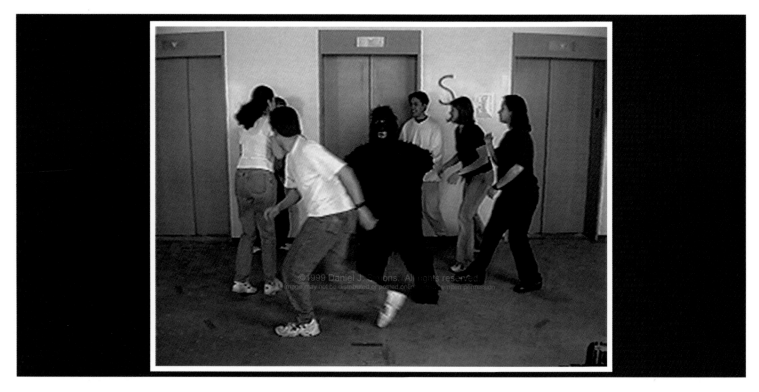

FIGURE 18 The gorilla in the frame, which none of the subjects noticed. Figure provided by Daniel Simons. Simons, D. J. & Chabris, C. F. (1999). "Gorillas in our midst: Sustained inattentional blindness for dynamic events." *Perception*, 28, 1059–1074. See http://www.theinvisiblegorilla.com for more information.

intensity we want starts with being aware of everything in the frame.

Furthermore, in addition to contributing to the overall visual intensity in an image, each type of component in an image has inherent properties. Color, for example, contributes a lot to emotion, whether or not you're aware of it. The colors in your image affect your perception of the image's tone.

For example, think about the Disney classic *Snow White and the Seven Dwarfs*. In every shot with the wicked queen, the artists use green, black, purple, and other dark colors. At the same time, in the forest and with the dwarfs, the color palette switches to reds, blues, and browns. This wasn't an accident! As you'll see in Chapter Four when we discuss color, color has certain emotional meaning (such as green with jealousy and red with passion). The artists were taking advantage of our subconscious reaction to color to emphasize the story.

A great example that quickly shows off just how much extra meaning our brains add to a shot without being aware of it is the image in Figure 19, of two slashes. This entire image is two oblique lines. Without even meaning to, you automatically perceive the left line as aggressive and the right line as passive (assuming you read left to right). As we'll discuss in

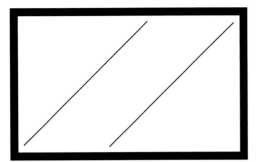

FIGURE 19 We automatically attach emotional meaning, even to just two lines, perceiving one as passive and the other as dominant.

Chapter Three, lines and shapes affect our perception of images and have their own inherent properties.

Clearly, it's important to be aware of everything in our frame, even though our brain's actively trying to hide detail from us. To start learning to be aware of your frame when shooting, before you press the shutter, take your eye off the subject and take time to consciously look around the rest of your frame. Being aware of everything in your frame is the first step to being able to control those elements to help you capture the image that you see in your viewfinder, and not the one your camera captures.

Exercises

1. Watch your favorite movie, and pause it when you notice yourself feeling a certain way, be it happy or sad. Think about how the director might have been manipulating you to feel a certain way. Take note of the framing, lighting, what music was playing, what lens the shots were filmed with, whether the camera was moving, and anything else you notice.

2. Look at some of your favorite photos in a book or on the web. What is it that you are attracted to? Is there a certain type of photo that you prefer? As an example, do you like images with lots of bright colors or do you prefer black-and-white photos?

3. Browse through the art section at your favorite bookstore, or go to a local art museum. Photography is a relatively young art, and it's worth focusing on other art forms. What other works of art attract you? Perhaps Renaissance paintings, with their use of realistic detail, are more interesting than Impressionist paintings? Think about what attracts you to certain images, and, as your read future chapters, consider how to use your camera to achieve the look you desire.

4. Go out and take ten different images of anything, anywhere. They can be shots around your house, in your yard, at a coffee shop, and so on. As you shoot each, take a note about what you're shooting. Then randomly pick five of the images and look more closely at the frame. What do you notice now that you didn't while shooting? It could be an object in the frame or a way that objects relate to each other.

5. Pick five shots from your portfolio, including ones you don't like, and rate each image's overall intensity as to whether it's too low, too high, or about right.

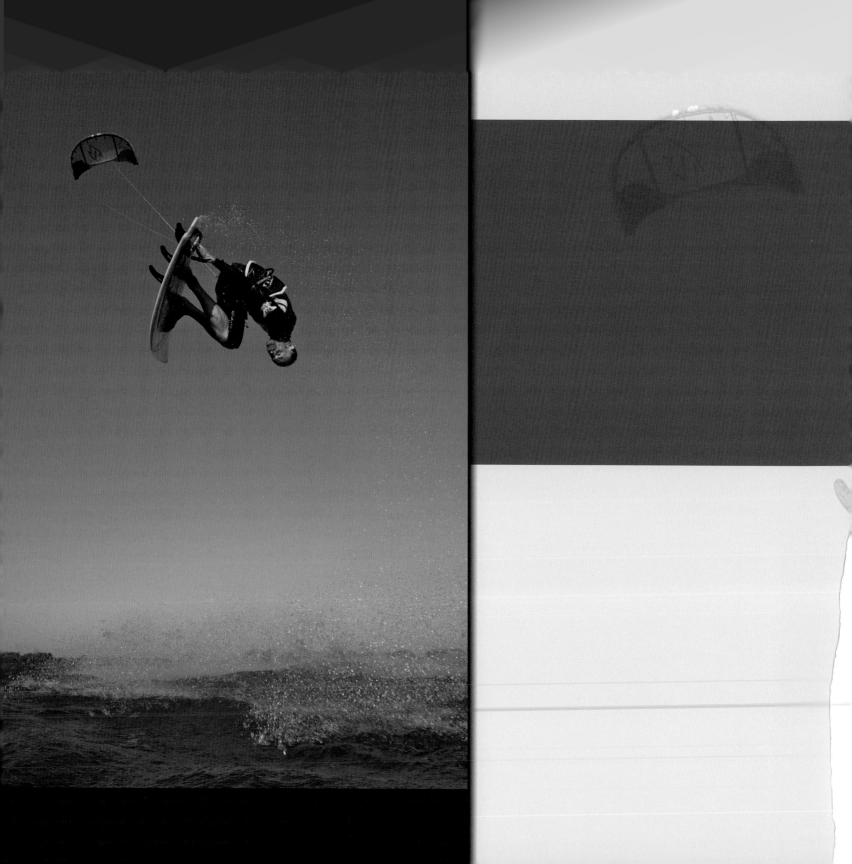

Light and Perception

- What is Light? 24
- How Our Eyes Detect Light 25
- How Our Eyes and Brains Record Light 29
- How Our Brains Process Light (We Think) 35
- Aging and Vision 44
- Exercises 48

Photography literally means "painting with light." Most photographers have spent a long time learning about the mechanics of how their cameras work to record light. F-stops, shutter speed, and all the other technical terms sometimes dominate our discussions because they're critical to getting a properly exposed image. Similarly, understanding how our eyes and brain work in tandem to perceive light from the world around us is key to developing our sense of composition because that knowledge helps us determine how someone will perceive our images.

Before we can start discussing how our brains perceive light, we need to look at what light is, how our eyes detect light, and how they efficiently send it to our brains.

WHAT IS LIGHT?

For all intents and purposes, light is a special type of wave that comes from a light source, like the sun or a flash. It bounces off objects, and eventually falls on our eyes or cameras to be turned into something meaningful.

Visible light is actually a tiny part of something larger, called the electromagnetic (EM) spectrum. See Fig 1, page 25. This spectrum contains many types of waves, ranging from radioactive gamma rays to radio signals and beyond.

We differentiate these various types of waves by talking about their wavelength. *Wavelength* is a measure of the distance between peaks of a wave. If you've ever watched surfers, you'll notice that sometimes waves are really far apart, and other times, they're really close together. A short wavelength means that the waves are close together. In the EM spectrum, gamma rays have very, very tiny wavelengths, hundreds of times thinner than a piece of paper. AM radio waves have very long wavelengths, around a thousand feet per wave.

Visible light only takes up a tiny part of the EM spectrum. The difference in wavelength between red and violet light, the two ends of the visual part of the EM spectrum, is less than the width of a red blood cell. Yet in that range, our eyes and cameras can perceive millions of colors with very subtle differences between tones. That's pretty amazing! Our eyes and brains are pretty incredible, given how specially adapted they are to visible light.

Something special about cameras is that the part of the EM spectrum they record can be changed. Although our sensors are typically tuned to the same visible light that our eyes see, it's possible to make a digital sensor that records ultraviolet or infrared light for special purposes, such as shooting at night.

WHY DO WE SEE THIS RANGE OF LIGHT?

One question you might have is why, given how big the EM spectrum is, do our eyes see the tiny portion of it that they do? After all, many fish, reptiles, and insects can see ultraviolet light. Why can't humans (or many other mammals)?

A recent idea is that seeing visible light lets us read each other's minds. Well, sort of. As Mark Changizi points out in *The Vision Revolution*, think about skin for a second. It's really hard to pin down specifically what color it is, and when asked to count the colors we see in a Target ad, for example, where everything's red and white, we never count the actors' skin colors. We're all tuned to accept skin as a generic, baseline color, no matter how light or dark.

However, the blood flowing beneath our skin can cause our skin to change color, from red when we're flushed to yellow/green when ill to purple when bruised. Even very dark-skinned people can see these subtle changes in their own skin.

The colors that blood can cause our skin to change to, conveying information about our health and mental state, correspond quite well to the colors our eyes see. Furthermore, mammals with color vision like ours tend to have less hair in visible places, like our faces, making it even easier to see the skin, whereas mammals without color vision tend to be covered with hair, hiding the skin.

In other words, it's possible that the reason our eyes see the colors they do is to let us quickly tell how someone else is feeling—for example a mother can tell if her baby's healthy at a glance—giving us an evolutionary advantage. There's even research showing that color-blind doctors are less effective at diagnosing certain disorders, as they don't see changes in skin color that are obvious to a normal-seeing doctor.

Our eyes are hard-wired to record visible light, and although we can't change what wavelengths they see, they have some pretty amazing hardware!

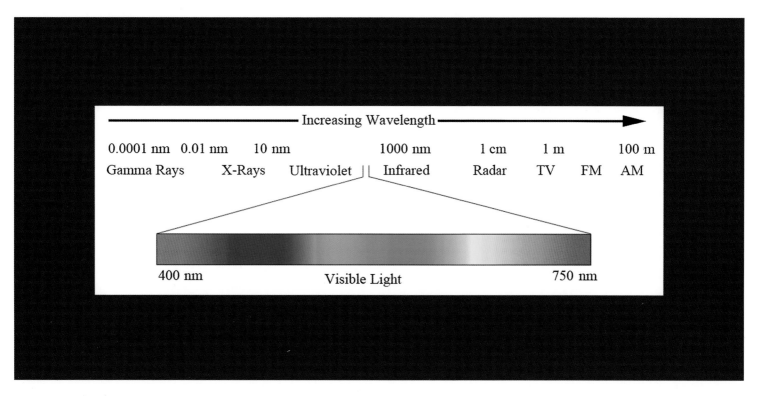

FIGURE 1 The EM spectrum with the approximate wavelengths for each part of the spectrum, in meters. All of the visible light we perceive takes up only a small fraction of the spectrum!

HOW OUR EYES DETECT LIGHT

Camera sensors are pretty straightforward. There's a grid of sensors designed to detect red, green, and blue light, with the sensors next to each other. Some sensors, like Foveon, are a bit more complex, as they actually have sensors layered on top of each other. Our eyes are more complex, and capable of more, than any camera's sensor.

Light enters our eye through the cornea, the clear front part of the eye, and the lens, a transparent disk that sits in the opening of the eye (the pupil), suspended in a ring of muscle that can shape the lens to adjust its focus. Ideally the changing shape of the lens causes light to focus perfectly on our retina.

The retina is where the eye's light "sensors" are. As a quick aside, not all of the light that enters the eyes is recorded by the brain—some bounces back out. That's why red-eye occurs in photos. The light from your flash bounces off the blood cells in your subject's eyes and is reflected into the camera.

Unfortunately, not everyone's lenses are perfect, and sometimes their focal length is just too short or long in relation to the position of the retina. That's what makes someone near- or far-sighted. When the muscles surrounding the lens are relaxed, we're focusing about ten feet away, and when those muscles are tight, we're focusing up close. As we age, we are less able to change the shape of the lens to focus up close; hence, many people need reading glasses as they get older.

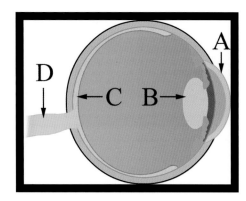

FIGURE 2 Rough drawing of eye, highlighting the cornea (A), retina (B), and optic nerve (C) which connects the signals from the eyes to the brain.

Unlike a camera sensor, which only has one type of light sensor, our eyes have two types, called rods and cones. Furthermore, we have three types of cones (some women actually have four), and we'll see why that matters for color vision shortly.

Rods

Rods are very long and thin—hence the name "rods"—and we have roughly 100 million of them in each eye. They are very sensitive to light, working well in dim lighting conditions, and chances are that at some point in school someone told you that rods handle black-and-white night vision and cones handle color vision. This is not quite correct, as it's the variation in type and sensitivity of cones compared to rods that gives us these types of vision.

We only have one type of rod in our eyes, and it's only capable of telling if something is light or dark. It's sort of like if you only look at a single channel in a photograph, as illustrated in Figure 3—we can tell how light or dark each pixel is, but we don't know what color the pixel is until we add the other types of sensors. As such, if our eyes are only using our rods, the world appears to be black and white.

Rods are more sensitive and numerous than cones, so when cones stop being able to sense the light, rods take over, letting

us see in less light. At night, we're mainly relying on our rods to see light. During the day, our rods basically say to our brain, "It's too bright for us, use the data from the cones instead."

Cones

Cones are shorter and thicker than rods, shaped more like a cone, but there are far fewer of them in our eye (only six to seven million total). Cones are less sensitive to light than rods, meaning that they need brighter light to be able to detect the light coming into our eyes. In photographic terms, you could say that rods are so sensitive that it's like shooting at ISO 6400, whereas cones are less sensitive and more like shooting at ISO 50.

What's special about cones is that most people have three types of cones, and each is sensitive to a different wavelength of light. By combining the information from our yellow-, green-, and blue-sensitive cones, our brains make the world show up in color (as long as there's enough light to be using our cones instead of our rods). Interestingly, our cones are most sensitive to greenish-yellow light, which is why emergency signs are often green, and least sensitive to blue light (blue text is hard to read, for example).

When people lack a type of cone, we say that they are color blind because they are unable to perceive a difference between a certain two colors—there's not enough information available for them to determine some wavelengths (there are also other causes of color blindness, aside from missing cones). In extreme cases of color blindness, when a person only has one type of cone, both their day vision and night vision will only show brightness; they see in black and white. Because the yellow and green cones are defined on the X chromosome, it's more likely for men, who have only one X chromosome, to be color blind.

How Our Eyes are Laid Out

Camera sensors not only have just one type of light sensor, they're also laid out in a very regular fashion. Our eyes have a more complex arrangement of rods and cones.

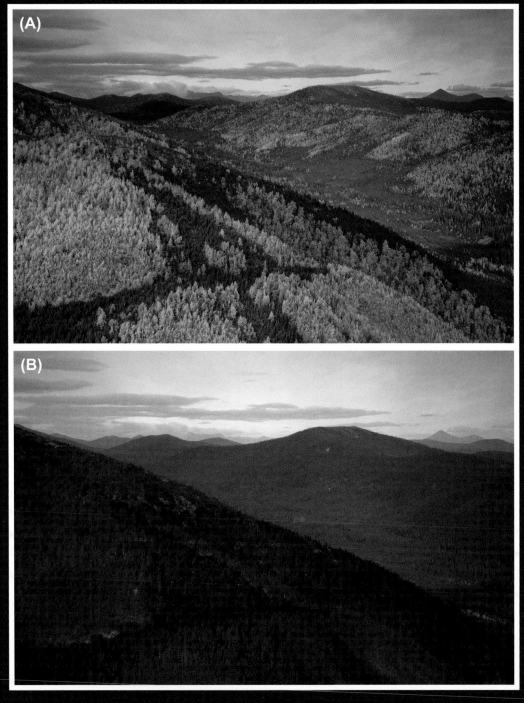

FIGURE 3 A color image made up of three channels (A) compared to only the blue channel (B).

PURKINJE SHIFT

As the sun sets and the amount of light decreases, you might have noticed that the contrast in the world around you changes—a yellow flower that shone brightly against its green leaves during the day changes so that the leaves appear brighter than the flower. Jan Purkinje noticed this change during his daily walks in the early 1800s, and determined that our eyes must have two systems for seeing light, one for when it's bright out and one for when it's darker. This change in contrast as our vision shifts from cones to rods, with their different sensitivities, is called the Purkinje shift in his honor.

Interestingly, studying this effect led to using red light to see when night vision is important. The rods in our eyes are most sensitive to bluish light. In fact, if we look at a blue light and a red light at night, we'll perceive the red light as many times darker than the blue light. This is why night photographers use red flashlights—we perceive that light as darker and it doesn't cause our pupils to dilate as much as a white light flashlight. Since our rods aren't as sensitive to red light, we can use red light to read things such as camera settings while not interfering with our dark-adapted vision. Give red light a try the next time you go shooting at night!

First, cones are concentrated in an area called the fovea, and there are almost no rods in it. The fovea is an area in the center of the retina that's responsible for sharp vision. The cell layers in front of the retina (the ones light has to pass through before hitting rods and cones) are even shifted away here, allowing our photoreceptors to be more exposed to the incoming light, providing sharper vision.

The fovea is very small. It's less than 2 mm across (that's less than one-fourth the thickness of your iPhone) and provides only about two degrees of our field of view (for scale, with our two eyes, our field of view is about 180 degrees horizontally and 130 degrees vertically). Despite all that, about half of the vision-processing parts of the human brain are devoted to the fovea—the information from the center of our retinas is very important!

During the day, in good light, the fovea provides the best vision. But, what's a little weird is that, because our fovea is primarily cones and few rods, you'll find that your vision's better at night and in dark places if you look just to the side. Astronomers and Boy Scouts have known this for years! Unfortunately, our vision gets blurrier further away from the fovea, making it hard to focus on objects in our peripheral vision without looking more directly at them.

Using Blurriness to Create More Engaging Images

Impressionist painters took advantage of this blurriness so that, when you see part of one of their paintings out of the corner of your eye, it looks like a solid form with a lot of detail. Yet when you actually direct your gaze to that part of the painting, the lack of detail becomes clear. Confusing your brain further, your peripheral vision still tells your brain that there is actually more detail just to the side of where you're looking, because its less-detailed vision gives the impression that this is so. Each time you look away and then look back at the image results in your brain "filling in" a new version of the painting, making it seem more like an ever-changing scene.

Compare this to a photograph or painting where there is extreme depth of field and everything is visible. This type of image almost feels static and unrealistic because it's always exactly how you saw it last time, with nothing to fill in.

As another example, have you ever wondered why Mona Lisa always seems to be smiling? As Margaret Livingstone found, Leonardo da Vinci took advantage of our limited peripheral vision to paint the Mona Lisa, creating her famous smile (although it's likely he did so without realizing what he was doing!). Viewers typically look first at her eyes. Our peripheral vision is responsible for seeing her mouth. We pick up subtle shadow clues in her cheekbones, and it looks like she's

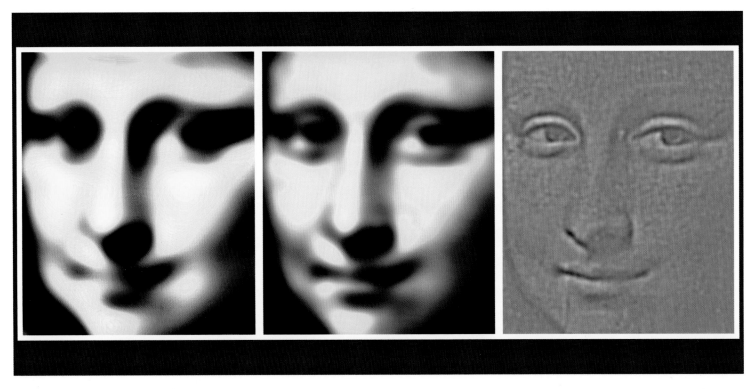

FIGURE 4 The Mona Lisa blurred to represent what our peripheral vision (left), near peripheral vision (middle), and central vision (right) see. Image courtesy Margaret Livingstone.

smiling. Yet when we focus on her mouth, our peripheral vision is no longer picking up those shadows and seeing only a hint of a smile. As you move your eyes around, her smile changes because you're using different parts of your vision to process her smile (see Figure 4).

It's rather amazing to consider the tricks artists have used to create amazing paintings just by taking advantage of how our rods and cones are arranged in our eyes.

Soft-focus filters can achieve a somewhat similar effect (as can tweaking in the digital darkroom, which we cover in Chapters Ten and Eleven) that takes advantage of our peripheral vision to make our images more intriguing.

HOW OUR EYES AND BRAINS RECORD LIGHT

If you've ever held down your shutter button to take a burst of photos, eventually you hit a point where your shutter slows down because your camera's buffer is full—it can't store the image data fast enough to let you fire at the maximum rate anymore.

Now consider your brain. Whether you look around quickly or slowly, your brain's almost always able to keep up, processing what your eyes are seeing. Our eyes and brain have some special optimizations to let us process all the light our rods and cones are registering, re-encoding things like color, and doing some special preprocessing to emphasize parts of the scene that matter to our brains.

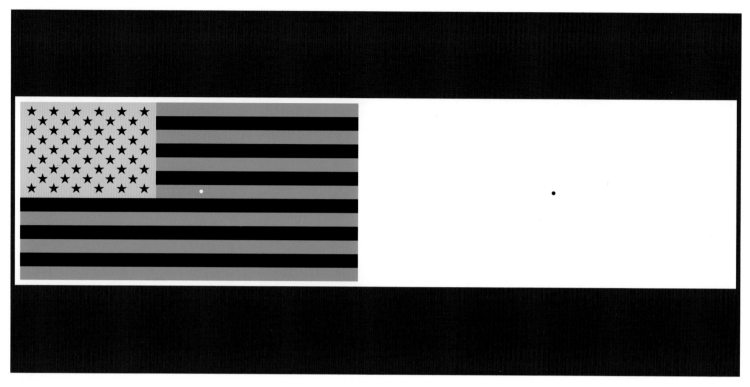

FIGURE 5 A color-inverted American flag and its afterimage. Stare at the dot in the flag on the left and then look at the dot on the right to see the afterimage.

Representing Color

The first way that our eyes efficiently record what they see pertains to how they store color information. Think about a normal, three-channel red/green/blue (RGB) image for a second. We mentioned before that we have three different types of cones, and the obvious answer is that the brain must have three different color channels, recording an absolute number in each channel, just like in computers. In addition to letting us represent color, this would also let us store data from the rods, as we could just add a fourth channel to store brightness. Unfortunately, the obvious answer isn't always the correct one.

Have you ever noticed how you sometimes describe a color in terms of two colors (a bluish green, say), but there are some colors you don't describe together at all, like a reddish-green? Plus, if you stare at a color for a while and then look at a white background, you'll see an afterimage with the color's complement (e.g., if you were looking at a red image, you'd see green)? If you stare at the white dot in the middle of the color-inverted American flag in Figure 5 for at least 30 seconds without blinking and then look at the black dot to the right, you can observe this effect for yourself.

It turns out that our brain does two things to process light and color. First, it separates out luminance—how bright or dark the light is—from the color part of light. Many parts of our vision system are color blind (more on this soon), and only having luminance to deal with lets them work faster. Second, the

brain stores color data in what are called color opponent pairs. Specifically, it stores color in terms of how red versus green it is and how yellow versus blue it is.

As you have probably guessed, the way our brain encodes color into opponent pairs leads to some interesting effects in terms of how we perceive colors. We've already mentioned afterimages, the first of these effects. More applicable to photographers, though, is that placing opponent colors next to each other enhances our perception of those colors. Why is that?

To put it into camera sensor terms, the cells in our brain responsible for processing the color falling onto a particular pixel aren't just aware of that pixel, they're aware of the surrounding pixels, too. The technical term for this type of cell is a double-opponent cell. If the light falling onto a pixel is yellow, it will suppress the blue side of its blue/yellow scale when converting the data for our vision system. Furthermore, if the surrounding pixels are blue, the yellow pixel's cell will emphasize the yellow side of the scale even more, enhancing the color difference. This helps optimize the data that our brains receive—we don't care about where the color is the same, rather we care about where it changes.

These double-opponent cells also help explain afterimages. When you look at a yellow image, your yellow-sensitive receptor cells are being stimulated and suppressing your perception of blue. Over time, your brain adapts to the yellow cells being over-stimulated. When you look away, the situation changes, your brain is still expecting a higher level of yellow stimulus, blue isn't being suppressed anymore, and you see a blue afterimage.

Thinking of cells being suppressed and activated might be a little odd, so think about it this way. Imagine that you have a group of people, with half saying "yellow" and the other half saying "blue." When you show the group a yellow picture, the "yellow" people start shouting louder. And if the yellow picture has a blue frame around it, not only do the "yellow" people

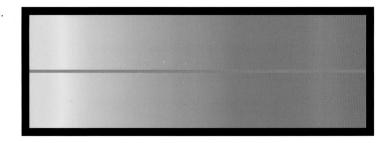

FIGURE 6 The solid gray line is the same color, but the yellow-to-cyan background gradient and our color cells' double-opponent nature makes it seem cyanish on the left and yellowish on the right.

start shouting even louder but they start muffling the people saying "blue." After a while, you start mentally ignoring how loud the "yellow" people are shouting. You know they're still there, but you're not paying as much attention to their shouts.

Then, when you take the picture away, everyone returns to their normal volume, but because the "yellow" people are suddenly quieter and because you're mentally tuning them out a little bit, you can hear the "blue" people more easily for a moment. In fact, there's a brief moment where you hear "blue" and not "yellow" that's like an afterimage. The people saying "yellow" louder is like when our cells fire and become activated, and muffling the people saying "blue" is like suppressing the cells.

Another oddity with how our brains encode color data is that we have many fewer double-opponent cells, and they're much larger, which makes our color vision lower resolution when compared to our luminance vision. It's sort of like comparing a 5 MP sensor to a 25 MP sensor of the same size. One example of how this affects vision is watercolor painting. Often, the outline strokes are clearly done with solid, darker edges. Then, the colors are loosely painted on top, not always filling in the stroked areas. However, they appear completely filled because our brains fill in the interior regions up to the painted outlines. Similarly, if you've ever noticed color appearing to bleed past a line onto the surrounding area, like in Figure 7, it's because the resolution of our color system is not high enough to precisely define the color's boundary. We take advantage of

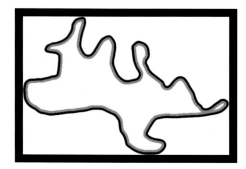

FIGURE 7 The inside of this shape appears slightly green, even though it's the same white as the paper around it.

this when painting in color or masks in the digital darkroom—we don't have to make our color brushes perfectly precise, because our brain's color system is lower resolution.

Handling Luminance with Center/Surround

Even though color vision is more advanced—only some animals have it—our eyes' luminance-processing system (again, luminance is how bright or dark the light is) does some even more amazing tricks with the light our eyes perceive before sending it to our brains, and this is responsible for some unique illusions.

In order to be as efficient as possible, our brains only respond to light that matters. For example, let's imagine that you were looking at a white circle inscribed in a green circle. The part that matters is where the two meet—the area where the color changes.

Our brains have some special wiring to detect the parts of a scene where something changes. The rods and cones in our eyes are connected to other cells with a special layout. These cells are arranged into a small circular "center" and a larger "surround" ring. Essentially, what happens is that light from a particular area falls onto this ring. If the light's the same across both the center and the surround ring, the cells say to the brain, "Move along, nothing to see here, just keep using the same data you've been using for the other areas." But if the

LAB COLOR SPACE

Chances are that if you've dealt with photography for a while, you've had problems with color. For example, maybe you've found that a certain RGB value on your screen isn't the same as an RGB value on someone else's screen, unless you've done extra work to make sure all of your devices are constantly color-calibrated. Or perhaps you've tried to manipulate your image but ended up affecting its colors somehow. Wouldn't it be nice to be able to separate the two out, just like our eyes do, using luminance plus the color-opponent axis to provide an exact definition of a color?

LAB color provides just this precise definition, as well as other benefits for adjusting images. Think about sharpening an image. If you're working in RGB color space, then any change you make to a pixel's luminance value will also affect its color. If you switch to LAB color, though, you could sharpen just the luminance channel, L, which contains all the structural detail of an image, leaving the hues defined by the A and B channels alone (A represents the red–green component axis and B the blue–yellow one). Similarly, if you blur the A and B channels, you'll remove color noise from your image, as frequently only noise is very detailed, varying from pixel to pixel, whereas color tends to be smoother.

light on the center is different from the light on the surround area, the cells become activated, start firing, and say, "Hey, the light changes here! Brain, pay attention to this part of what the eyes see."

Remember that really weird scintillating grid image from Chapter One? It's also in Figure 8. Center/surround explains why it happens. First, pay attention to where the white lines intersect. Because there are vertical and horizontal lines intersecting, there's more white at those points than in the other parts of the image, where there are just single white lines between black. When our eyes look at the non-intersection parts of the grid, their cells are more activated (because

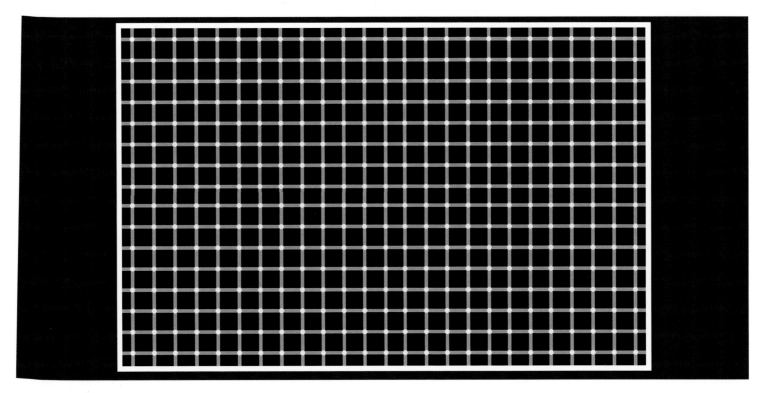

FIGURE 8 The scintillating grid is due to center/surround effects in our vision.

there's more difference between the white and black) than when they look at the intersection part (where there's more white). The area that causes more activation (the straight, white lines in between black) appears as brighter white to our brain, causing the white areas in the intersections to appear darker. The reason the spots flicker is because not everything is instantaneous in our brain—there is a small delay between activations, causing the less-activated regions to dance around.

One implication of center/surround is that we are very good at seeing contrast. Figure 9 contains an illustration of the Cornsweet illusion. Which side is darker? Now take a strip of paper, cover the center area, and again judge which side is darker. Our brains pay attention to the area in the middle

where there's a small gradient. Center/surround effects make it so that we "fill in" the areas where there isn't a significant change (the area to the left or right of the center) based on what we see where there is a lot of difference and sometimes our brains fill in that detail incorrectly!

If you've been in snow country, have you ever noticed how during a white-out the world often appears darker? Since there is no contrast for our eyes to perceive and everything is white, center/surround causes our cells to fire less. When our light-sensing cells fire less, our brain perceives that the world is darker.

Also in Chapter One, we pointed out that our eyes are drawn to points in the image where there is some type of contrast,

FIGURE 9 You can see the Cornsweet illusion in A, the actual luminance of the image in B, and our perception of the luminance of the image in C.

and that more of these points lead to more visual intensity in the image. Center/surround explains why we're drawn to contrasty points—our cells are literally firing and saying "look here" to our brain. *The more they fire, the more energetic the image and the higher its intensity*.

Another aspect of the center/surround, similar to the Cornsweet illusion, is that the surrounding area influences our perception of inner brightness, an effect called simultaneous contrast. Consider, for example, the two inner gray boxes in Figure 10. Which is brighter? They actually have the exact same luminance, but the surrounding brightness influences our perception, and our contrast-encoding brain exaggerates the brightness difference.

Furthermore, encoding contrast information allows our eyes to see a greater dynamic range (the ratio between the brightest and darkest points). Our eyes do not have cells that can register every possible luminance level. Instead they adapt and then encode the differences between smaller areas. It's much more efficient if our eyes say to our brain, "This area's ten units brighter than this other one" rather than, "This area has a

brightness of 1,000 units and that one has a brightness of 1,010 units."

Painters have known for years that people's vision depends on smaller local differences, and use this information to make their images appear to have a greater dynamic range. Rembrandt was a master of this technique, clearly seen in his painting *Meditating Philosopher* (Figure 11). Here, although the window appears significantly brighter than the shadows, if you actually measure the luminance of the window and of the shadows, you'll see that it's only ten to twenty times brighter. Since the area surrounding the window is so dark, center/surround makes the window appear even brighter, and it makes the subtle change of tonalities in the shadows seem even more subtle and dark.

Believe it or not, as a photographer, you've taken advantage of center/surround without being aware of it whenever you've used a split neutral density filter. A scene will often have a huge difference between the brightest and darkest areas, but our cameras can only capture six to fourteen stops at most, depending on the camera. We encounter this problem, for instance, when trying to take a shot at sunrise or sunset that has a darker foreground and a brighter sky. To get both parts properly exposed, we use a split neutral density filter, which is a piece of glass that's darkened on top and clear on the bottom. Hold the dark part of the filter over the bright part of the image, as seen in Figure 12. Yet when we look at the final image, even though we've significantly reduced the dynamic range of the scene so that our camera could capture it, the photograph still retains the apparent dynamic range of the original scene, with a very bright sky and dark foreground.

This idea of local contrast also comes into play with high dynamic range (HDR) images. Often, people dislike HDR images because they somehow look over-processed (Figure 13). Typically, what's going on is that the photographer didn't choose natural settings for contrast. Something that should be brighter than something else, if you looked at the shot in the real world, isn't brighter in the photo, and this confuses our

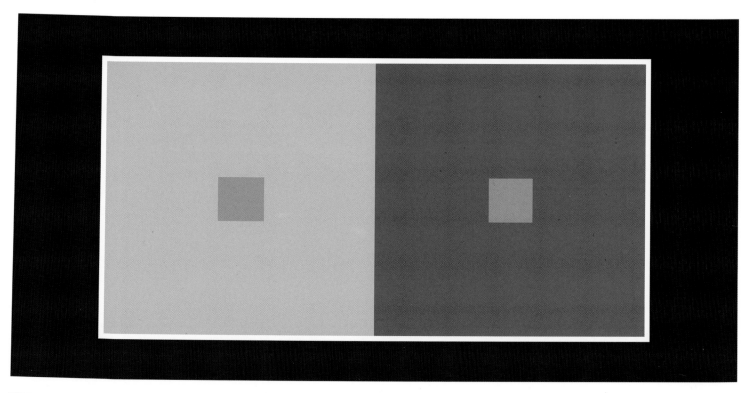

FIGURE 10 Simultaneous contrast is when an area takes on the complementary color of the surrounding area, as in this example of achromatic simultaneous contrast, where the inner box on the left appears darker and the inner box on the right appears lighter.

FIGURE 11 Rembrandt's *Meditating Philosopher*, oil on wood, 1632, Louvre, Paris, France.

brain. It's possible to create HDR shots that look perfectly natural just by making sure the right areas are bright and the right areas are dark, relative to each other. We'll discuss this more in Chapter Eleven.

HOW OUR BRAINS PROCESS LIGHT (WE THINK)

Clearly, center/surround does some information processing for us, reducing the amount of data our brain has to deal with. Even with center/surround, though, there is still a ton of data coming from our eyes for our brain to process. Fortunately, through a variety of experiments, some involving special machines to see which parts of our brains are active when doing certain tasks and others involving far more gory

FIGURE 12 Using a split neutral density filter to capture a scene with too great a dynamic range for one image. See Chapter Nine for more information.

methods, we have a rough idea of how our brain turns light into images.

Something that makes our brain very efficient and fast is its ability to process information in parallel, meaning that it can simultaneously process multiple aspects of the light our eyes see. Specifically, data about the light gets split up and dispatched to different parts of the brain (technically this starts to happen as soon as light reaches the retina).

The first thing for which our brain processes the light data is the "where" information. The "where" system, which other mammals also have, turns light from our eyes into our perception of position, motion, depth, and organization in a scene. This system is very fast and contrast sensitive, allowing us to catch a fast-moving baseball, for instance.

The "where" system also works with the thalamus, which is roughly in the center of the brain. The thalamus plays a role in a number of functions, including regulating our level of awareness, processing input from our senses (excluding smell), and controlling our motor systems. By sending the data here first, some scientists believe that this lets us react immediately to things we see, before we've had enough time to fully process the information. For example, if something's coming right at our face, we'll duck before we think about what the thing is.

One major detail to note is that the "where" system is color blind—it only uses luminance information from our eyes.

The second system, which exists only in primates and humans, is responsible for our object and color recognition, and it's called the "what" system. This system is fairly slow,

FIGURE 13 A natural-looking HDR image (A) and an over-processed one with unnatural overall contrast (B).

given it involves more complex processing. Furthermore, by studying people who have had strokes in certain parts of their brains, scientists have found that the "what" system gets divided further, into color and form (although the form system uses both color and luminance data). This division might explain why we accept black-and-white images as complete— color is somewhat of an afterthought, happening after lots of other processing has already happened to the data coming from our eyes.

We even perceive depth and three-dimensional shapes from luminance information only—as long as you don't change the luminance, you can pick any hue you want and we'll still be able to clearly make out and identify an object's shape. Henri Matisse took advantage of this in a big way with his painting *The Woman with a Hat*, seen in Figure 14. In that painting, he used a wide range of hues to paint the woman's face, but because the shading is correct, we still easily identify the woman and her shape.

The "what" system is also far less sensitive than the "where" system. If you look at Figure 15, a long exposure of water rushing over a crab (and with contrast reduced even more in processing), your brain will be able to identify whether something is there as well as its general shape, because you're activating the "where" system. But you cannot tell what the object is because there isn't enough contrast to activate the "what" system.

Our brains also do some special processing with color so that an object always appears to be the same color, regardless of what color light we're looking at it through, be it daylight, tungsten light, or ski goggles. This effect is called color constancy.

As an example of color constancy, a banana appears yellow at midday under white daylight and still appears yellow at sunset, when the light is redder. What's going on is that, because we are sensitive to the local differences between colors and not just the absolute value our eyes receive, our brain is able to

FIGURE 14 Matisse's *The Woman with a Hat*, oil on canvas, 1905, San Francisco Museum of Modern Art.

figure out what color the light source is and adjust accordingly. Specifically, when looking at a scene, your brain will figure out the reddest point and then adjust the image your brain is perceiving to make that point appear red. We are able to perceive the same color for the object even as the color of the light changes.

You've probably taken a photograph inside and noticed that it had a yellowish tint that your eyes were unaware of. Although our brains make us blissfully unaware of the color of a light

FIGURE 15 A very low-contrast shot in which your "where" system picks up on an object but the "what" system has trouble identifying what it is.

COLORS WITH EQUAL LUMINANCE

Once in a while, we encounter an image in which some part appears to shimmer and move. Although this effect is very hard to get naturally in a photograph, it's possible to create it if desired in Photoshop or in a painting, and many artists have used this effect. Monet, for example, made the sun in his painting *Impression, soleil levant* appear to shimmer by making it equiluminant with the background, meaning that both colors have the same luminance value (Figure 16).

What's going on, as Margaret Livingstone and David Hubel wrote in 1988, is that the two different shapes' colors are equiluminant. When your color-blind "where" system processes the image, it just sees a swath of the same luminance; yet when your "what" system (and specifically the form subsystem) processes the image, it registers that there are different shapes, creating a conflict between the two systems. Since your "where" system can't pin down specifically where those shapes are, as you continue to look at the image they appear to move around.

FIGURE 16 The sun appears to shimmer because our "where" system can't pin down its exact location (A). If we desaturate the image (B), which represents the data our "where" system processes, the sun disappears. Claude Monet, *Impression, soleil levant*, oil on canvas, 1872, Musée Marmottan Monet, Paris.

source, our cameras are not so lucky. They record absolute levels of red, green, and blue exactly as the light hits the sensor, with no adaptation to the light source's color. Under different lighting conditions, this can create some very weird color casts in our photographs!

To correct these color casts, photographers have the notion of "white balance" (or with film, we talk about film color-balanced for different light sources). Essentially, when you define the white balance, you are defining what color true white should be, giving the computer a value to use to "correct" the other pixels, compensating for the color of the light source. Being able to adjust the white balance after the fact is an excellent reason to shoot RAW—you might not be aware enough of the true color of your light source while shooting to think to change your white balance, but if you shoot RAW, you will be able to adjust it after the fact without losing any data.

Although this white balance correction brings a photograph closer to what our brains see, it's still not perfect—different lighting can sometimes slightly alter our perception of pairs of colors. For example, if you look at red and blue objects next to each other under daylight and tungsten light, the red object will look slightly lighter under the tungsten light.

One side effect of color constancy, though, is that if you look at shadows under different light sources, such as daylight and candlelight, you'll notice that they have a different color. Keep in mind that a shadow, by definition, isn't being illuminated by the light source causing the shadow to be cast—the object casting the shadow prevents it. For example, if the sun is shining on a tree, the sun is illuminating the tree, but the tree is creating a shadow on the ground. The shadow isn't perfectly black because it's being illuminated by indirect, diffuse light from the rest of the environment. Because it's being illuminated by a different light source, when we look at the shadow, we will see color contrast along the border of the shadow, giving the shadow an apparent color. If you're manipulating an image and creating a shadow of some sort, it is very important to create the correct color in your shadow to prevent it from looking fake.

Processing Faces

In addition to being able to "see" constant colors, our "what" system is also really good at recognizing faces. Our brains even have specific areas dedicated to processing faces, making us very good at recognizing upright human-like faces (it doesn't work as well when a face is at an extreme angle). These areas help explain why faces are so important in art over the centuries. Faces are literally a fundamental part of our minds, and a person today can relate to a portrait drawn hundreds of years ago.

In Chapter One, we mentioned that cultures across the world could consistently recognize what emotions people were expressing in photographs. Human faces really are something special, in that we don't have to be taught to understand them (although we do develop these skills when we're children). This universality might also help to explain the appeal portrait photography has: the photographer is able to capture a person's true, raw feelings that they're expressing in their face, and the image doesn't get interpreted and biased by a painter.

Once our brain has identified something as a face, it uses every part of the light it can find associated with the face to figure out everything about the other person. For example, you've probably heard that the eyes are the window to the soul, but it also turns out that eyebrows appear to be very important to recognizing a face and conveying emotion, perhaps more so than the eyes. We've also learned that our brain makes use of a head's shape to help identify faces. And even though you can recognize a face in black and white, our brain also uses color to help identify a face when we can't clearly identify its shape, such as when the face is out of focus.

Over the years, artists have found that, if a person's face is complete and detailed in a painting, we tend not to notice when other details are fuzzier. One theory about what is behind this is that we mainly look at a face and see the rest of the image via our peripheral vision. Since our peripheral vision has a lower resolution than our central vision, we don't

FIGURE 17 We accept this portrait as complete even though only Mrs. Badham's face is completely detailed. Jean Auguste Dominique Ingres, *Mrs. Charles Badham*. Pencil, 1816, The National Gallery of Art, Washington, D.C.

have a problem with the rest of the image being less detailed. One artist, Jean Auguste Dominique Ingres, even created drawings in which the subject's face was very detailed and high-resolution, yet the subject's body was just a handful of vague, sketchy lines (Figure 17). For photographers, this implies that, if you want to create a good portrait, it's important to have enough depth of field to cover the person's face and the other places in the photo a viewer's likely to look at, regardless of the depth of field in the rest of the person's body. If areas like the face, are instead blurry, you'll create a tension in the image because we want to see detail there.

Despite all the ways that our brains can recognize faces and the wide variation among people's faces, Christopher Tyler found something absolutely amazing about how we compose portrait art. Over hundreds of works throughout thousands of years, one eye was almost always placed at the vertical midline of the image. From the Mona Lisa to George Washington on an American dollar bill to Pablo Picasso paintings, if you draw a line vertically through one of the subject's eyes, you will almost always split the painting into two equally-wide halves.

Although we as artists always like to say that rules are meant to be broken, this eye placement is one compositional preference that we all fundamentally seem to share, whether we realize it or not. When shooting portraits, try to take at least one shot with this composition!

Understanding Action

In addition to portrait photography, photography showing social action of some kind, in which we're watching a living person doing something, from sports to sleeping, is very relatable and understandable even if we've never done the action we're watching (take a look at the image of the surfer in Figure 19 and think about how you react to it). This understanding of action creates the intensity we perceive from an image's subject. If we see an action that we know is more extreme, such as surfing, the image has more intensity.

Why is that? Clearly there is something fundamental in our brain that helps us understand action and intent. You could easily imagine this being useful to our ancient ancestors trying to figure out if the animal they see in the distance is hunting them or ignoring them. Currently, there are two competing theories about how our brains detect and understand social action.

The first theory involves something called mirror neurons. Mirror neurons are cells that many animals have (and we think that we humans have, too) that fire both when we do something and when we see someone else doing that

FIGURE 18 When shooting portraits with one dominant subject, we universally tend to position one eye at the vertical midline of the frame.

same action. That's a little weird, so let's look at a specific example. If a monkey called Mark touches his nose, some of his brain cells involved with touching his nose are firing. If Mark sees another monkey, Jack, touch Jack's nose, the same brain cells that fire when Mark touches his nose will also fire, even though Mark isn't at the time touching his nose.

Some scientists believe that mirror neurons can help us understand others' emotions as well as understand and relate to others' actions. If we see someone doing something, and then our brains react as if we're doing the action, then that should help us understand why that action's taking place and what will happen next.

The other idea about how our brains process action is the social networking theory. The idea here is that different parts of our brain are responsible for processing different aspects of things we see, such as an area that sees motion, an area that recognizes forms, and areas that activate when they recognize emotion. These pieces are then integrated to create a mental image of a living being, one where we can relate to and understand on some level what's going on. In this theory, we understand action because we can construct a mental representation of the other being and what it's doing, not because we imagine ourselves doing the same action.

The full answer is probably a mix of the two, but we do know for sure that all parts of the brain's social network function

FIGURE 19 A big-wave surfer at Mavericks in San Francisco.

together when watching and imaging a person doing something. This is important because it means that the parts of our brain that are responsible for our social interactions are also responsible for recognizing that something we see is alive and developing an understanding about what is happening.

For example, when viewing the image of a kite-boarder in Figure 20, even if you've never kiteboarded before, your brain is able to piece together that there's a person in the shot, how high off the water he is, how the parts of the scene are moving, and so on, forming a mental representation of what he's experiencing, and allowing you to understand the adrenaline rush he must be having. By providing appropriate pieces of context to our viewers' brains (such as implied motion), we can help our viewers create the mental representation we want them to, evoking emotions, making our photography more appealing and meaningful.

AGING AND VISION

Everything we've discussed so far in this chapter has been about fully healthy people with fully healthy eyes. Unfortunately, as we age, our vision system degrades over time, and our risk of certain age-related eye diseases increases.

A common age-related condition is cataracts, which occur when the crystalline lens in the eye starts to fog up, making it harder to see sharp details, lowering overall apparent brightness and adding a yellow tint to vision. All of these factors directly impact your images and the processing decisions you make: it's quite possible that you could inadvertently end up over-saturating blues in your shots, making them too bright, or making them too contrasty in post-processing.

Asking for a second opinion from someone without cataracts and then figuring out how to adapt your perception of an image to what the rest of the world sees is a simple way around some of these potential perception problems. Cataract surgery is also becoming safer and more common, and if you opt to have it, you may be surprised how different your images look!

Another fairly common disease is macular degeneration, which most often affects people aged sixty or older but also occasionally affects younger people, even children. This disease causes the loss of cones in the fovea. As mentioned earlier, the fovea is the area near the center of our eye that's densely packed with cones and responsible for sharp vision. People with macular degeneration start to lose the ability to see detail when they look at things, and over time they can lose their central vision entirely (functional blindness). Consequently, they need to learn to see using their peripheral vision, which is nowhere near as sharp. Before reaching that extreme, macular degeneration may also make a grid of straight lines appear to be wavy, and it can lower sensitivity to contrast changes, and make it more difficult to discern similar colors (e.g., light red looks very similar to light orange).

If you have been diagnosed with macular degeneration you may want to periodically check to see whether you can still discern all colors. One way of doing this to look at a color checker used to color calibrate a printer, as seen in Figure 21. If you can see the differences in all the colors, you can still accurately color adjust your images. But if some of the colors look the same, those may be colors that you are no longer seeing accurately and you may need to ask someone for help when optimizing images. Fortunately, new drugs as well as stem cell research offer hope that in the near future this disease will no longer be as potentially devastating.

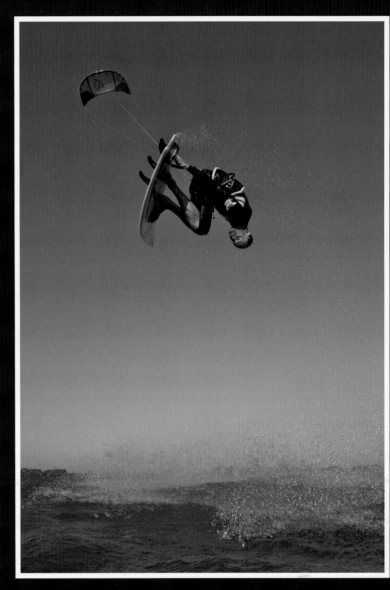

FIGURE 20 How much of a mental representation can you form about what this kitesurfer's experiencing?

reference color checker: Adobe 1998

FIGURE 21 A sample calibration pattern.

Glaucoma is another common disease that affects peripheral vision. Fortunately, photography mainly relies on central vision, and if you have glaucoma it's still possible to take great photos. Just make sure you're really taking the time to look around your viewfinder at everything in the frame, and not just relying on your peripheral vision. As you might expect, glaucoma can make photography with fast-moving subjects quite difficult, because when shooting sports or fast-moving wildlife you have to rely more on your peripheral vision and don't have time to look around the entire frame.

There are other fundamental, non-disease-related changes to our vision as we age, too. For one, even if we don't have glaucoma, we start to lose our peripheral vision. We also start to lose the blue-sensing cones in our retina, making blues appear less saturated. As you age, if you start always increasing the saturation of blue in your images, have someone with younger eyes check your changes. It's possible that the image looked fine as it was and it's just your perception that's changed.

When we get older, we also begin to lose other cells, such as the ones in our color-opponent processing system, making it even harder to do fine color work with images. As we suggested for people with macular degeneration, it's a good idea to periodically look at a printer color chart to ensure that you can discern all of the colors.

There is also evidence that, even if we adjust for these physical differences—for example, by showing an older

FIGURE 22 An image with a normal blue saturation (A) and with a reduced blue saturation (B). The reduced saturation significantly changes the overall intensity of the image.

person an image with larger text than a younger person—our higher-level vision processing also takes a hit as we age. For example, it's harder to determine depth perception via stereopsis (combining the images from our two eyes to figure out how far away things are). This can make it harder to leverage depth, an image component that contributes to visual intensity.

But there is some good news in all of this. The base-level processing that our vision system does, like figuring out which parts of a scene are darker or brighter, is not affected. Aside from some issues with color and depth, as you get older you'll still be able to apply the principles of composition using visual intensity effectively in relation to nearly all of the components that we talk about in this book.

Next up, we'll start looking at some of the components of the world around us and how we perceive those components, both in terms of their energy and their implicit emotional qualities.

Exercises

1. Go through your image collection, and each time you find a portrait shot of just one person, take a look at where their eyes are. Count the number of images in which an eye is placed on the vertical midline.

2. Find at least two different images that have shadows within them, taken in two different lighting conditions. Measure the RGB values in the shadows and see how they compare.

3. Pick an object and photograph it (ideally in RAW mode) under different lighting conditions, with your camera set to a certain white balance (don't set it to "auto"). When you look at your images on the computer, measure the RGB values of different parts of the object and see how they compare. Then, adjust each image's white balance so that each appears correct, and again measure the RGB values. How do they compare? What adjustments did you have to make for the different light sources?

4. Try creating an HDR image, and experiment with settings where you do and don't keep the right overall contrast. For example, can you make something that should be shadowed and darker brighter than something that's being lit? How does it compare to a conversion that keeps the right overall contrast?

Lines, Shapes, and Textures

- Lines 52
- Shapes 57
- Groups and Gestalt 63
- Visual Rhythm 69
- Texture 71
- Exercises 80

Lines and shapes make up the world around us. At its core, every photograph is a juxtaposition of shapes, and those shapes contribute to an image's visual intensity. Surprisingly, shapes, their placement, and the relation among them also have inherent meanings! By learning about the intensity and meaning that lines and shapes create, we can unlock the door to a new level for composing and critiquing photographs.

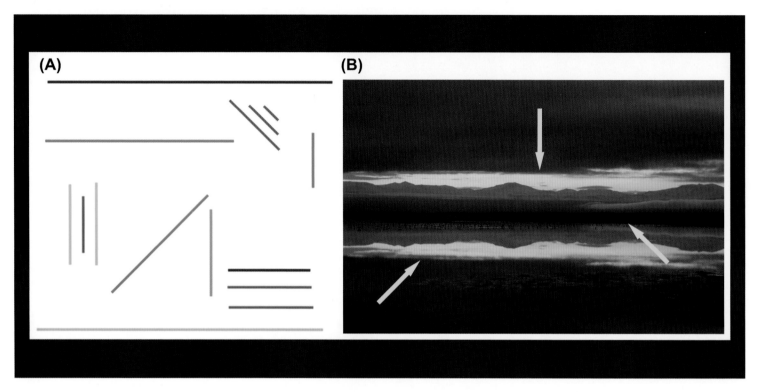

FIGURE 1 Some random lines that we drew, which are really rectangles with a very thin width (A). Arrows pointing at the lines we perceive in an image, at the boundary of two different things (B).

LINES

When you think about a line, you most likely imagine a single stroke across a page. But if you look at a photo, you never actually see a line like that. The reason is that the line you imagine is really a rectangle with a very small width, whereas lines in images are often formed from contrast, where two different things meet. As mentioned in earlier chapters, this is also where our brains are tuned to look in an image, making lines very important to composition.

Lines are also a great first component of visual intensity to look at because they're simple. Let's think about a straight line. You can have three types of straight lines, as seen in Figure 2. They can be horizontal, vertical, or oblique.

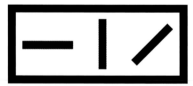

FIGURE 2 Horizontal, vertical, and oblique lines (graphically, not photographically).

Horizontal lines have the least visual intensity because they appear to be at rest. If you think about when you go to bed or relax, you're often lying down flat. There's no real potential energy in these lines. Vertical lines have more intensity than horizontal lines. They're standing up straight, and we all know that it takes more energy to stand all day than it does to lay in bed all day!

FIGURE 3 A photo made up of horizontal and vertical lines (A) and an image with primarily oblique lines (B).

Vertical lines have the potential to fall down, but because they're stable they don't have as much energy as oblique lines. Oblique lines have the most visual intensity because they're unstable; they look like they could fall over any minute and thus add a sense of action to an image. Zig-zag lines have the most energy, because they're unstable but also change throughout their length.

In addition to contributing to an image's visual intensity, different types of lines also have their own emotional meaning, which affects the story we're telling with an image (more on storytelling in Chapter Seven). Did you ever hear the fashion guideline about how horizontal lines make you look fatter whereas vertical lines make you look taller? The more horizontal a line is, the more it emphasizes something's width. The more vertical a line is, the more it emphasizes height. You can use this to affect someone's perception of your image: if you want to make your subject feel very wide, look for horizontal lines!

Straight lines (we're including zig-zagging lines here) often have a direct quality to them, making them more intense than a curved line traveling in the same direction (compare, for example, a curved horizontal line to a straight horizontal line). Furthermore, because we rarely see perfectly straight lines in nature, straight lines feel more manufactured and artificial than curved lines, which feel more natural and soft. And within curved lines, the greater the curvature the more intense it is. Imagine a small tree in the wind. If it's only a little windy, the tree will bend a little, creating a slightly curved line. Yet if it's really windy, the tree will be bent over a lot, and this extra bend creates more visual intensity.

FIGURE 4 In these two similar aerial shots, compare the softer and more natural feeling of the winding road in A to the more manufactured feeling created by the straight boundaries around the fields in B.

S-SHAPED CURVES

You may have heard people talk about "S-curves" before. This idea originated back in 1753 with the painter William Hogarth's book, *Analysis of Beauty,* in which he discusses how wavy, S-shaped lines are the basis of all great art. His argument is that beauty doesn't come from simple geometry (squares, circles, ellipses) but rather from "the Line of Beauty," an S-shaped line that helps you move from shape to shape.

While straight lines are more intense than curved lines, as Hogarth points out, S-shaped lines often feel more lively. In the world around us, we see S-curves in things that are alive and moving, which is why S-curves are often more visually pleasing than straight lines. Conversely, we associate straight lines with manufactured, rigid, inanimate objects, such as a building or a road.

As we'll discuss more in Chapter Five, lines can be used to separate ideas in an image by placing them on opposite sides of the line, or they can be used to connect two ideas by touching both things with the line, creating a visual connection. As a simple example of how a line divides space, think about the ultimate line, the horizon. This line is formed at the boundary of ground and sky and separates the two (Figure 6). Later, you'll learn that when this imaginary line is in a frame it can affect overall visual intensity as well as helping to determine what's supposed to be the subject and the background.

Implied Lines

In addition to lines created when two different objects are next to each other, images contain implied lines,

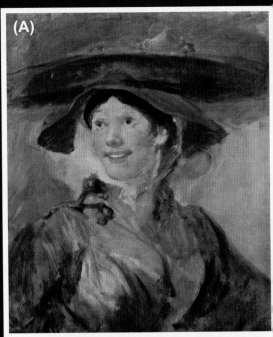

FIGURE 5 Hogarth's *The Shrimp Girl* (A) with the line of beauty h (B). William Hogarth, *The Shrimp Girl*, oils, 1740–1745, National Ga London.

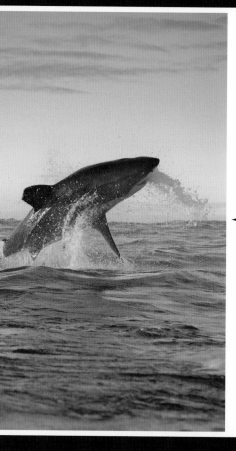

The horizon line, indicated with an arrow, divides an image ...ven and earth.

that is, lines that our brains discern when we look at a photo. For example, in Chapter One, we discussed how our brain looks at certain points in a photo, such as faces. When the eyes move between different faces in a photo, an implied line is created, and all of the visual intensity guidelines we just mentioned for lines apply to this line as well. If you're taking a shot of two people and both are at exactly the same height, this image will be less energetic than one in which the people are shown at different heights. Your brain creates a horizontal line when your eyes travel between faces at the same height, compared to an oblique line when your eyes move between faces at different heights.

What's arguably the most important implied line in an image is an eye line. We're really good at figuring out where someone's eyes are in an image, how the subject's head is angled, and where their eyes are looking. Eye lines guide our brains to where they should look next (where the subject's looking) because there's probably some information there we should know (e.g., "All those people are looking at something, what is it? Oh, it's a lion sleeping in the grass! We don't want to disturb it when we're out hunting for dinner").

You see this in movies all the time to help make cuts between shots—which are inherently unnatural and jarring—more acceptable. If a character's looking down and to the left in the first shot, then the subject in the next shot will almost always show up in the lower left part of the frame.

The implied line from the subject's eyes to where he's looking contributes to a shot's visual intensity as well. For example, an eye line that's flat and to one side is less energetic than one that's diagonally up and to one side (Figure 7). As a quick preview of a topic in Chapter Five, when an eye line is directed to the side

and parallel to your sensor, you're creating flat space, which has less visual intensity than when the subject's looking out of the picture toward the camera; in the latter case, you're creating depth and dimensionality with an eye line (Figure 7).

If you have a moving object in your frame, or something that has a natural direction of travel associated with it, such as a parked car, there's also an implied line of motion. How's the object going to move next? As you might have guessed, it'll have more energy if it's going to move at a diagonal than if it were to move straight across the frame. Similarly, if it's going to move towards the camera, it'll have more energy than if it's going to move parallel to the camera (Figure 8).

Conflicting eye lines and directions of implied motion can create dynamic tension in a shot, adding energy to it. In Figure 9, the kiteboarder's passing directly overhead, and the water droplets imply that she's traveling from right to left. But her eye line is looking down and to the right, the opposite of the direction she's traveling. That conflict adds intensity to the image.

SHAPES

When lines start to bend and connect with each other, they form shapes. Shapes are two-dimensional regions with well-defined boundaries. There are three primary shapes we're going to address: rectangles, circles, and triangles.

Rectangles have the least visual intensity. They're very stable, rigid, and well-balanced. Their emotional meaning is rigid and boring as well. Calling someone a "square" means that the person isn't particularly interesting, and that he likes to stick to the rules and is somewhat formal. However, the stability of rectangles can be comforting. To make a rectangle have more energy, you can tilt it, causing its horizontal and

FIGURE 7 An eye line to the side, parallel to your camera's sensor (A), is less energetic than one going out of the frame toward the camera, creating depth (B).

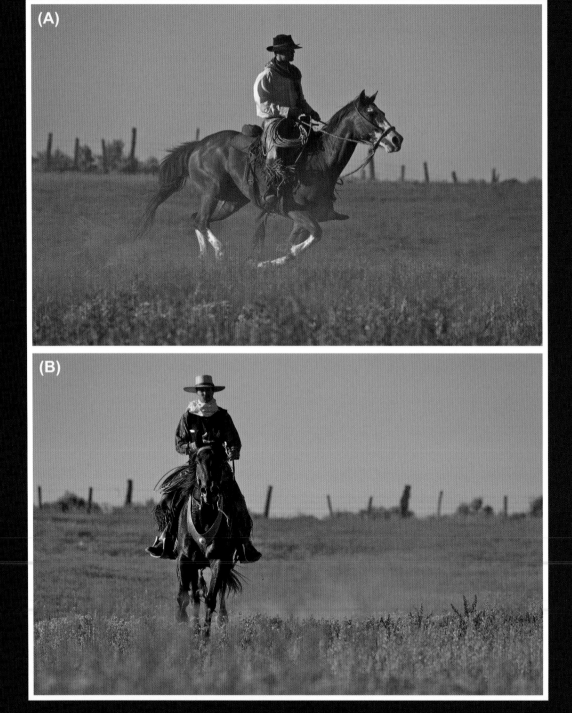

FIGURE 8 In each of these shots, there's an implied direction of motion. Since (A) has an implied line parallel to the film plane, it's less energetic than implied motion toward the camera in (B).

FIGURE 9 A kiteboarder with conflicting implied motion (to the left) and eye line (to the right).

vertical lines to all become oblique. Rectangles also tend to be manufactured and lead to a constructed rather than natural feel in images (Figure 10).

Circles have more energy than rectangles. Whereas a rectangle, like a building, is not going to move, a circle has the potential to move. They also have a very positive emotional appeal. We often tend to draw smiley faces as circles, and we think of rounder people, like Santa Claus, as jollier. We also associate babyish qualities with rounder faces and see rounder people as needing more protection.

Circles are also interesting because they have no beginning or end, and their curves often make them feel more feminine and graceful. We also see circles as safe and providing a sense of grouping and protection from everything outside their boundaries.

In a photograph, you can easily create circles by using a fisheye lens, which makes the whole image circular (Figure 11). In addition, even if your subject isn't circular, you can imply circles through the curves in bodies and forms in the image.

Triangles have the most visual intensity. One big reason is that triangles typically point in a particular direction, which implies movement. Equilateral triangles, in which all three angles are the same, are the least energetic triangle because they don't point in a specific direction. Isosceles

FIGURE 10 A primarily rectangular shot with fairly low intensity.

triangles, which have two equal sides and two equal angles, are the most energetic because they strongly imply a direction. Furthermore, triangles can move between being stable and strong (if they're resting on a base or on a point) and unstable, which creates a dynamic tension. They are often used to express ideas such as growth and progress, as well as conflict, and they're often seen as a more masculine shape.

Triangles are arguably the most useful shape for photographers because they're easy to create or imply. For example, if you walk up to a building's corner, tilt your camera up, and take a picture, bingo, you'll have a triangle because of how the perspective lines converge. They're also easy to imply

because any three points of interest, as long as they're not in a straight line, will form a triangle (Figure 12).

You might be reading this and thinking, "Okay, I stuck with you for Chapter One, and Chapter Two did have some neat things about the brain and the eyes. But really? Shapes and emotions? I'm not sure I buy this." Amazingly, scientific studies, such as one by Irena Pavlova, Arseny Sokolov, and Alexander Sokolov in 2005, have shown that we consistently assign emotions to static shapes. This helps explain why abstract art is appealing. What might at first look like arbitrary shapes can in fact be carefully constructed to evoke emotions. Similarly, in 1988, Aronoff and others discovered that triangles and diagonal lines are far more prevalent in threatening drawings.

FIGURE 11 A primarily circular shot taken using a fisheye lens. The strong, vertical lines placed near the edge of the frame have been distorted by the fisheye lens into dominant lines that create a circle. The rounded horizon, also due to the fisheye lens, helps emphasize the circular shape.

As another example, part of the reason we associate happy emotions with circles and angry ones with triangles is most likely due to how our faces move when we express emotions. In 1978, a scientist, Bassili, put glowing dots on people's faces in a dark room. When they put on happy faces the dots expanded outwards, making a more circular shape, and when they made angry faces the dots formed a V-shape.

As crazy as this might seem, there is a lot of scientific research showing that lines and shapes have associated energy and emotion, and even better for photographers, those emotions are consistent across cultures. Viewers around the world will have the same reaction to components in an image.

Joy, Anger, and Stable Shapes

In addition to inherent emotional properties, Pavlova and her colleagues discovered a few other significant correlations between shapes and emotions. First, take a look at the shapes in Figure 13. Which appear to be more fearful or timid?

Pavlova and her colleagues discovered a number of things about emotion and shapes. First, the more unstable a figure, the more likely that we will associate a negative emotion (fear or discomfort) with it. The reverse is not true, though—we're not likely to say that a stable shape is automatically joyful. And if we see a smiling face in an unstable position, the smiling

FIGURE 12 An image with a strong triangular shape, formed by the bike, that gives it a pleasing overall intensity.

face (compared to no face or a frowning face) won't make us perceive the shape as more stable.

Furthermore, there are relationships between shapes' vertical orientation and their associated emotions. For triangles, ovals, and lines, the more vertical the shape is, the more joyful it appears to be. But if we've decided that the shape expresses anger, then the less vertical it is, the angrier the shape.

If you think about your body, all of these relationships make sense. If we're happy or surprised, we jump upright. If we're fearful, we fall over or need to sit down. And if we're really angry and shouting at someone, we tend to lean forward a lot, becoming less vertical.

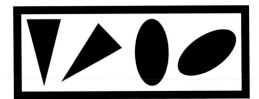

FIGURE 13 A stable and unstable triangle and oval.

A really simple way to think about this, if you have a dominant shape in an image, is to imagine that the shape is a human body—perhaps a ballet dancer who is trying to express something via dance and the shapes her body can create. What emotions would that dancer be conveying? There's a good chance that another viewer will perceive those emotions

in the shape, something that scientists believe is partially due to the mirror neurons we covered in Chapter Two.

GROUPS AND GESTALT

Thus far in this chapter, we've primarily been focusing on lines and shapes in isolation. When we put multiple lines and shapes together, our perception of the overall intensity and emotional quality changes. We might also see new shapes— even though the world doesn't always have clear shapes, our brains sometimes create them.

We've already touched on how oblique lines relate to one another, where we start attributing aggressive and passive qualities to each line. It turns out that the emotions we attribute to lines in an image are very similar to the emotions we associate with body language, which makes sense, given that a simple way of representing a person is a stick figure. To step out even further, we need to look at a part of psychology called gestalt psychology.

"Gestalt" is a German word that roughly means "configuration," and "the whole is greater than the sum of the parts" is often mentioned when discussing gestalt psychology. Essentially, gestalt says that you can't just look at something as a collection of lines and curves in isolation, but rather you need to look at the entire collection of lines and shapes because the way the pieces are arranged has meaning. In fact emergence, the idea that complex patterns come from simple elements, is a key element in gestalt systems.

Furthermore, our brains have a natural tendency to group things, and the gestalt "laws" help categorize how we group them (the original gestalt theory even stated that forms in our brain mimic various parts of the theory, although since then that part has been found to be mistaken). Gestalt matters for composition because those natural groups will affect the perceived intensity of an image. For example, we might group the objects together into a shape such as a triangle, which is more visually intense than if we grouped them into a rectangle.

FIGURE 14 What emotions do you attribute to these flower stems if you imagine them as human bodies?

Also, when everything in an image coalesces into an ordered group, the image will lose some of its intensity. For example, take a look at the row of doors in Figure 15. The people breaking up the group of doors add energy to the shot, making it more interesting and providing a point to look at (and more often than not the element that breaks up a pattern will become your subject). Now put your fingers over the people sitting in the doorway. It's not a bad shot technically, but the overall intensity is too low if we just see a group of doors with nothing breaking it up.

Proximity

The first gestalt law of perceptual organization we'll discuss is proximity. Simply put, when things are near each other physically, we tend to group them together perceptually, too. For example, in Figure 16, we perceive different overall visual

FIGURE 15 The people breaking up the ordered group of doors makes this image more interesting than if they hadn't been in the shot.

balances in the image just by moving the circles around. The image with five circles close together and one apart appears to have more energy than the balanced image with two groups of three circles.

To give a more concrete example, take a look at the photograph in Figure 17 of two groups of penguins. Because the penguins on the left are close together and the penguin on the right is away from the group, we see this image as having two distinct groups of penguins and begin associating emotions to each group. You might see the penguin standing by himself as a loner and perhaps as braver than the other penguins.

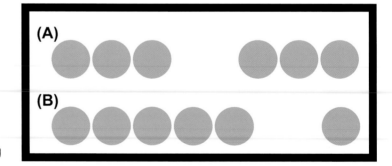

FIGURE 16 Two groups of three circles (A) and a group of five and a group of one (B).

FIGURE 17 We mentally divide these penguins into two groups, the group on the left and the individual penguin on the right.

Similarity

Grouping by similarity means that when we see similar things we tend to group them together. For example, *this text is part of a group* whereas this text is another group, and your brain created those groups because of the differing typefaces. This is a very common way that our brains group items, as you can see in Figure 18. Even though the entire shot is of sunflowers, we see the larger ones in the foreground as one group and the smaller ones in the background as another.

What's also interesting is that, even if we see the same item at the same size and color in an image yet slightly different in a minor way, for example how it's rotated, our brain will see different groups. For example, in Figure 19, we're looking at

two sides of a frond with sand covering each side. The only difference is the angle of each side, but we clearly see two groups, one on the left and one on the right (the stem in the middle further emphasizes this division).

Common Fate

Although "common fate" might sound like something more fit for a crime show or religious text (or maybe some combination of the two), the idea's simple. If we see things moving in the same direction (or if there's implied motion in that direction), we group them together. Furthermore, if the moving objects are different (e.g., bird A and bird B) and there's a similar stationary object in the shot (e.g., another bird A), we'll group the moving objects together before we group the similar

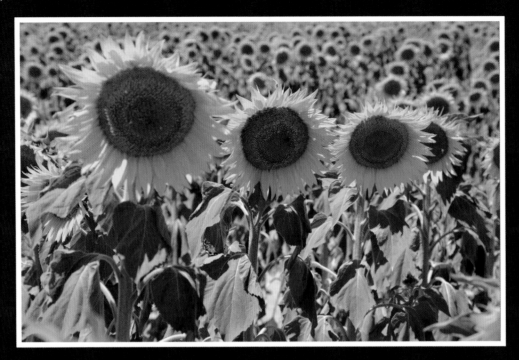

FIGURE 18 The larger sunflowers in the foreground form one group and the smaller ones in the rest of the image create another.

FIGURE 19 We mentally group the parts of this frond together by angle.

FIGURE 20 Backlit birds in corn dust. We group the two flying to the left together, and see the one flying to the right as a group of one and the stationary birds as another group, even though there are different types of birds within the stationary group.

objects (see Figure 20, for example). Part of the reason for this could be that your brain is performing threat assessment—are the flying birds going to attack me?

Continuation

The gestalt law of continuation relies on our ability to predict trajectories. If we see an object moving in a certain way in a particular direction, we expect it to continue along that course. Our eyes will naturally follow a line or a curve, and we'll group objects following that trajectory together as a single object, rather than seeing each one as separate.

For example, in Figure 21, rather than seeing two half-circles, we see a continuous sine curve with a line running through it.

Similarly, in Figure 22, rather than perceiving multiple parts of the plane's float and wing meeting in the middle, we perceive a wing and a float.

Closure

Closure is closely related to continuation. Gestalt theory says that we'll perceive elements that don't actually exist to create a more regular, closed figure. If we see a shape that's almost a rectangle or almost a circle but is missing just a few parts of a line, our brains will naturally continue the existing lines and close the shape. This is helpful because it lets us suggest shapes, and the emotion and intensity of those particular shapes will add to a composition, even if those shapes don't actually exist. In Figure 23, the rainbow and its reflection

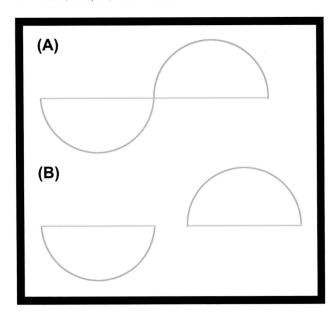

FIGURE 21 We perceive this shape (A) as a sine curve interrupted by a line rather than two half-circles (B).

appear to be one curve, even though there's a mountain in between. Furthermore, even though we only see the right half of the circle formed by the rainbow and its reflection, our brains can mentally compute where the rest of the circle would be. And although the mountain on the right and its reflection is bisected by some greenery, we perceive the connection between the two and create a triangle.

Closure is also interesting because you only need to imply a shape, and our brains will complete it (this is also called *amodal perception*, when we perceive an entire object even if only part of it exists). A famous example of this is the Kanizsa triangle, seen in Figure 24. We perceive a white triangle on top of three black discs and an outlined triangle, even though the image is actually three discs with wedges cut out of them and three angled lines. This also plays with the idea of negative space (which we'll discuss more in Chapter Five): the space around a subject can also influence our perception of an image.

Prägnanz

One of the more controversial parts of gestalt theory is *prägnanz*, which boils down to saying that we prefer solid and "good" forms. This is controversial because it's tough to define what a "good" shape actually is. We feel a better way to interpret prägnanz is to assume that the simplest explanation or grouping in an image is what your viewer's going to see. For example, going back to Figure 21, logically it's simpler that there are two objects overlapping each other, rather than four objects (two straight lines and two semicircles) meeting at the middle. In Figure 25A, we show a simple, graphic figure, and then 25B, 25C, and 25D all provide possible explanations for what the shapes that make up 25A actually are. Since 25B is the simplest possibility, it's the one our brain is most likely to infer.

Grouping and Our Brains

In Chapter Two, we talked a little bit about how the "where" system in our brain is color blind and how an object painted an in equiluminant color to its background appears to move around a painting because our brain can't pin down its location. The gestalt psychologists observed this same effect in the 1930s. Specifically, they noted that many of these grouping effects just don't happen when using equiluminant objects and that having objects with different luminance values is more important in helping our brains group objects together than having objects with different color values. Additionally, because these grouping effects go away when we have equiluminant objects, this type of grouping probably happens in a fundamental structure in our brains and not as part of a higher-level process that requires us to think. If these groups resulted from our brain spending a lot of energy analyzing the scene, it would most likely take all data that it receives into account, including the color data, and not just the basic luminance data. That means these groups are universal, and you should already be quite good at recognizing them and putting them into practice, even if you're not aware of it!

The important take-away here is that, visually, the brain groups parts of images together and creates shapes, such as the circle in Figure 23, even if those groupings and shapes don't actually exist. Being aware of them lets us perceive larger parts of the image—the results of those groups and shapes—so that we can look at the overall energy in an image.

It's also important to be aware that conflicting groupings can create dynamic tension in an image, adding intensity to a shot. In Figure 26, there are two penguins on the right, facing right, two on the left facing left, and one in the middle whose body is facing right but whose head is facing left. Since he's standing a little more to the right, we might initially group him on the right. But since his head is facing left, we might also group him with the two on the left. This tension makes a simple shot of five penguins in a row more intense.

VISUAL RHYTHM

Rhythm is a repeating pattern through time (in music) or in space (more useful for our purposes). Whether you have a repeating individual element, such as the lines in the sand in the Figure 27A, or repeating groups such as the rows of magnets in Figure 27B (and remember, our brains will create groups using gestalt principles, even if we didn't intend them to be there), it's important to think about the energy that this repetition adds to an image. Rhythm can be used to add peace and regularity to an image, and it can also be used to help a subject that interrupts the rhythm stand out.

If the rhythm is very spaced out, then it's a very slow rhythm and has a low energy. If it's a frequently repeating rhythm, then it has a faster tempo and more energy. But even if you have a rhythm with a fast tempo and a lot of repetition, if it's completely even

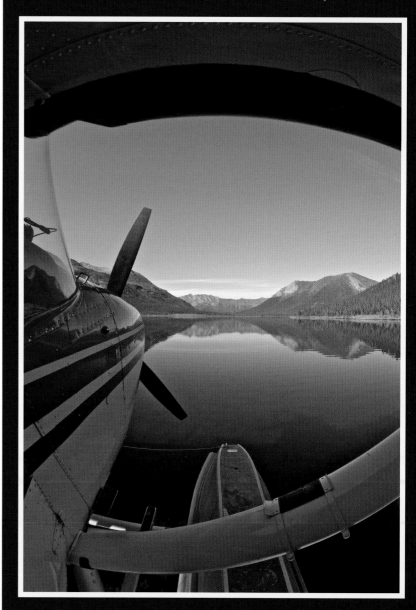

FIGURE 22 A float plane. We perceive the float as a whole, even though it's interrupted by part of the wing. Similarly, we perceive the wing as a whole, even though only parts of it appear in shot.

FIGURE 23 Rainbow, mountain, and reflections (A) with the shapes highlighted (B).

FIGURE 24 The Kanizsa triangle illusion.

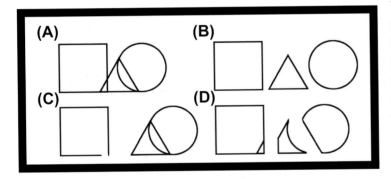

FIGURE 25 A sample shape (A) and three possible explanations (B through D) for the shapes we've combined to make it.

and regular, it'll still be lower energy than a shot with an irregular rhythm. For example, imagine a metronome ticking off a constant beat compared to one that skips one out of every four or five notes. The skipping metronome will grab your attention more than the regular one.

However, just having an irregular rhythm doesn't necessarily create a shot with enough energy to be interesting. Our brains are good at recognizing rhythm, regular or irregular, and what really stands out is something that completely breaks a

rhythm. Look at Figure 28 as an example. Here, there's nothing technically wrong with the image, and we have a regular pattern of coffee cups and filters. They're also on a diagonal to add more energy to the image. But it's not a particularly energetic image because the rhythm is so regular. There are three strong beats, and that's it. This regular rhythm often causes our brains to perceive this type of image as low intensity and not interesting.

Compare this to Figure 29, where we've extended the visual rhythm by showing more coffee cups in a row, again along a strong diagonal, but we've also interrupted the rhythm with a stream of water pouring into a cup. This interruption adds intensity to the image by creating contrast—we're breaking up a rhythm—and it gives us a clear subject—the pouring water.

Visual rhythm can also make an image more dynamic by not showing the beginning and ending of the repeating beats. For example, in the shot of an inside of a subway train in Figure 30, because we only see where the handles start but not where they end, and they have a strong and fast visual rhythm, we can infer that they keep going for a long time and that the train car is a lot longer than it actually is. If the visual rhythm suddenly dropped off, and there were very few handles on the right, then it would imply that the end of the train car is just outside the frame. To further enhance this feeling of repetition and endlessness, one or two handles partially visible on the right side of frame would have implied that there were far more handles to the right than we see in the photo.

TEXTURE

When a pattern repeats a lot in an image, the pattern tends to read as a texture, or part of an image that is detailed but comprised of very similar details. Sometimes, this pattern comes from the surface properties of what you're photographing, such as the rough bark on a tree.

FIGURE 26 Five penguins in a row, with the middle one potentially belonging to either group.

GESTALT THEORY AND MUSIC

In Chapter One, we introduced the idea of visual intensity by talking about musical intensity. What's rather fascinating is how similar our perception of music is to our perception of images. An obvious example is that when we hear music we can often identify its rhythm, and a slower tempo has less energy than a piece with a faster tempo. If the rhythm suddenly changes, it grabs our attention more than a piece with a constant rhythm.

As another example, have you ever been listening to a song on the radio when you could barely receive the station? Even if there's a lot of white noise, you can typically recognize and fill in the melody. Does that sound a little similar to the ideas of continuation and closure we discussed earlier in this chapter?

And how about when you hear a drummer tapping out a rhythm? Do you tend to listen to each individual beat, or is the overall rhythm more important than the individual beats, as the gestalt psychologists suggest?

One idea that Robert Solso puts forward in *Cognition and the Visual Arts* is that we may abstract the stimuli in the world around us, be they visual or auditory, into a "limited number of elementary patterns," and our brains are predisposed to process those patterns. If you're having trouble understanding a topic in this book, try thinking about music and whether there's an analogy for the visual topic we're talking about. See if it helps make the topic more intuitive and easier to understand!

FIGURE 27 Regular lines in the sand create a visual rhythm (A) and regular groups also create a visual rhythm (B).

FIGURE 28 Three strong beats of coffee cups create a regular rhythm.

Often when people talk about texture, they only think about an object's surface. Texture also comes from other high-frequency repetitions when you're at the right scale. Imagine that you took a wide-angle shot of a very urban city. The buildings and windows would read as texture in the image. Be careful of this effect when you're photographing a group of repeating elements—if you show too many, the group will read as a texture, and your eyes will skip over a lot of it (e.g., Figure 31). If you get closer and focus on the details making up this pattern, the texture will disappear.

An overall texture will have less visual intensity than if you got closer and saw a small portion of the detail making up the texture. That's because our brain groups all of this small detail together ("small" depends on the scale of the photo) and treats it as the same thing. But textures can still have high or low intensities, depending on what pieces make up the texture. A texture made up of alternating bright and dark areas will have more intensity than one made up of neutral gray and slightly-darker-than-neutral gray areas. The details of a texture don't have to be perfectly the same either. As long as the individual pieces are close or related, our brains will group the whole thing into a texture (Figure 32).

Typically, photos of just textures are too low energy and not appealing (although they do make for decent background

FIGURE 29 Pouring water interrupts the visual rhythm of the coffee cups, creating a more intense image.

FIGURE 30 Inside a subway car in Japan. The visual rhythm implies that the handles go on for a while, making the car seem bigger.

images on your computer because they're not very distracting). You'll usually want something to break up that texture and add intensity to the photo as your subject (Figure 33).

Interestingly, texture and our implicit desire for gestalt-style groupings can also create depth in an image. We sometimes perceive two separate textures overlapping each other rather than a single overall texture, as in Figure 34.

In future chapters, we'll discuss gestalt theory in more detail. For now, you should have a good understanding of the energy and emotions that lines and shapes contribute to an image, as well as how we perceive their interactions.

FIGURE 31 Your eye skips over a lot of this city detail, reading it as a texture.

FIGURE 32 There are many birds flying in different ways in here, but we still read them all as one texture.

FIGURE 33 With both regular (A) and irregular rhythms (B), these beads just read as a texture. We need something to break the texture up and become the subject (C).

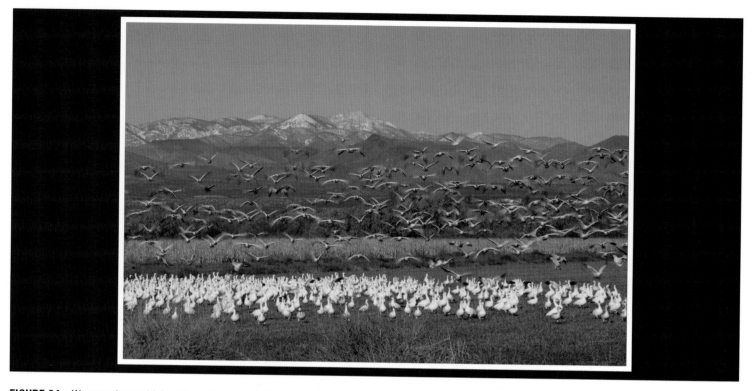

FIGURE 34 We perceive multiple different textures in this image (white geese in front, geese in the sky, corn in the distance, trees in the distance), and the overlap of different textures adds depth to the image (the flying geese are in front of the corn).

Exercises

1. Find a variety of images that you like and run a blur filter on them in your image editor of choice (or squint at them). Can you identify the primary lines and shapes in the image? What are they and how does the energy they contribute align with the image's overall intensity?

2. Try thinking up a simple story that you want to tell and use simple shapes to tell that story, whether in Photoshop or by drawing on a pad of paper. Note that this doesn't mean putting a triangle on top of a rectangle and calling it a house, but rather using triangles to imply a conflict, for example, or differently sized shapes to imply various relationships between stronger and weaker objects—using some of the implicit emotional qualities of shapes.

3. Find a repeating pattern and try shooting it so that you group it differently in different shots. For example, in Figure 27B, by showing many columns of magnets, we perceive the columns rather than repeating rows within the columns. If we'd used a telephoto lens and taken a photo of just one column of magnets, we would see a regular rhythm of individual magnets without the overall grouping.

4. Go to a park and try shooting groups of pigeons or seagulls. Look at the images on your computer: see how you visually group the birds and look for implied overall shapes.

FOUR

Color

- Where Does Color Come From? 84
- Colors and Their Impact 87
- Matching Colors 89
- Visual Effects of Your Color Palette 93
- Black-and-White Versus Color Photography 98
- Exercises 100

Color makes the world truly come alive. No other fundamental component can evoke feelings of happiness, passion, jealousy, and serenity so effectively. While it's certainly possible to take an amazing black-and-white photograph being aware of how we perceive color mentally and emotionally will give you a powerful tool in your photographic utility belt.

Color plays a huge role in our lives. The entire spectrum of visible light is very narrow, as we discussed in detail in Chapter Two, yet we are finely tuned to see it. For example, there's roughly a one percent change in wavelength from a green-yellow color to yellow, but we see it clearly. We typically don't even notice if we gain or lose one percent of our body mass!

Color can also affect our brains and physiology. Red or black placebo pills are perceived as stronger medicine than white ones. When we see red, scientists have observed that our brain's electrical activity picks up, as does our heart rate. Blue has been proven to bring down blood pressure and lower our heart rate. There's even an entire type of alternative medicine called color therapy that tries to treat various ailments by having people look at different colors.

In an article titled "Emotion & Design: Attractive things work better," Don Norman, a famous user interface guru, noted that the first time he used a color monitor, it didn't add any "discernible value for everyday work." Color was mainly used to highlight text or add other screen decorations. However, he didn't want to give up his color monitor because of some un-articulate-able emotional need that color fulfilled for him.

Over hundreds of years, artists and scientists have studied color and how we relate to it. Many great books, such as Harald Mante's *Color Design* and Michael Freeman's *Color*, go into much more detail than we will cover in this chapter. However, we will give you the important foundational information and cover how color affects your image's visual intensity. If after you've read this chapter you find yourself in love with the intricacies of color theory, we suggest you check out the books mentioned here.

WHERE DOES COLOR COME FROM?

Color comes from many different places. In nature, you see it in pigments, and even in bioluminescence such as with fireflies. It can come from a side effect of light traveling through a medium, such as the colors on a soap bubble that also give an indication of how thick the bubble is, or appear as a rainbow, when light is affected by water in the air.

Leaves appear green because of chlorophyll, and in the fall when the chlorophyll breaks down, the yellow and red pigments masked by the chlorophyll the rest of the year start to appear, creating a beautiful display of color.

Color can also serve many purposes in the world. Sometimes it's a warning of danger. Black, yellow, and red often warn that a particular insect will make a dangerous snack rather than a tasty one. Sometimes color lets animals and insects blend in and camouflage themselves in their surroundings. Other times color can even be a defense, such as a squid squirting ink.

Even though you might have learned in grade school that grass is green and the sky is blue, color and our perception of it is actually a lot more complex than that. First, objects appear to have specific colors because of the light that they absorb and reflect. For example, an apple appears red because it reflects red light and absorbs green and blue light. The color we see for an object also depends on what colors the light source is giving off. If you look at an apple under a light that's not giving off any red light, the apple wouldn't look red, it'd look dark, because it would be absorbing the light falling onto it and there's no red in that light source to reflect. Lastly, as we discussed in Chapter Two, our perception of light also depends on the cones in our eyes and the processing system in our brains converting the light falling onto the retinas into a form that our brain can understand.

Properties of Color

In grade school, you might have learned that you can use a prism to separate white light into a rainbow, and that rainbow has all the colors we can see. That's not quite right. It doesn't contain every shade possible, as you can see for yourself by looking around and thinking about which shades are and are not in a rainbow. Instead, the rainbow contains pure hues for most colors (Figure 2).

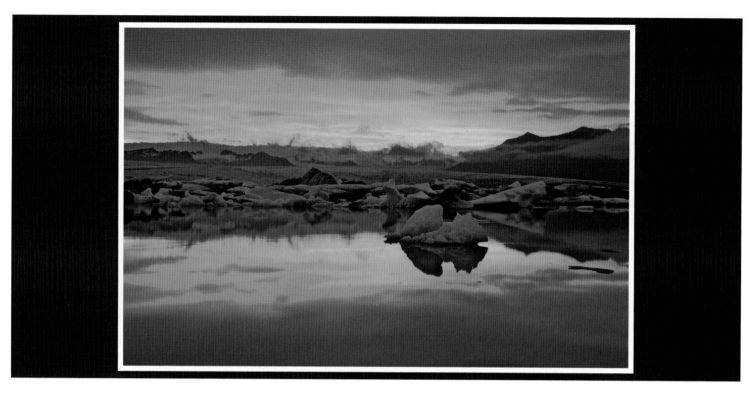

FIGURE 1 The world around us is full of color, and that color comes from many sources, such as a sunset, and serves many different purposes.

FIGURE 2 A simple rainbow model of color.

Hue is the first property of color. Usually when people talk about color, what they're actually talking about its hue, as the hue is most closely tied to the light's wavelength. There are higher-level structures in the brain ("globs") beyond the cones in our eyes that are sensitive to various hues. If you're talking about pure colors, such as "green" or "red" without any modifiers such as "light" or "dark," then you're talking about a color's hue.

Saturation is the next property, and this refers to a color's purity. Low saturation means that the color looks fairly dull or grayish, whereas high saturation means that the color looks very pure. As you might expect, saturated colors contribute more energy to an image than unsaturated ones (Figure 3).

Brightness is the last property we'll discuss, and this is a measure of our perception of how light or dark a color is. Often lighter colors are called tints, whereas darker colors are called shades. All highly saturated, pure colors have a medium brightness value. Sometimes changing a color's brightness will

FIGURE 3 Different saturations with the same hue and brightness values.

FIGURE 4 Different brightnesses with the same hue and saturation values.

cause it to have a very different perceived color, such as an orange that changes to a pale, almost skin tone when it has a brighter value to a deep brown when it has a darker value (Figure 4).

The Color Wheel

A rainbow is also a poor representation of color because it doesn't help us describe relationships between hues, and it also doesn't capture purple, which is between red and blue (purple is technically different from violet because purple contains a mix of red and blue whereas violet doesn't contain red—we'll discuss this more in depth shortly). Instead, we're going to connect the two ends of the rainbow to form a color wheel. By arranging colors in this manner, we'll be able to clearly see various properties of colors that artists have taken advantage of for centuries.

In the late 1800s and early 1900s, Ewald Hering started advocating the idea that, rather than seeing colors as a mix of red, green, and blue, colors are made up of a mix of four perceptually pure hues: red, green, yellow, and blue. Furthermore, Hering came to the conclusion that red and green, and yellow and blue, are perceptual opposites because they can't be combined to form another color, and you never describe an object as greenish-red or yellowish-blue. Knowing that these

FIGURE 5 A color wheel, with purple in between red and blue.

are opposites, we can put them across from each other on a color wheel, and we now know how to space the wheel out so that we can see the various combinations of hues that our eyes can perceive. You might recognize these combinations from Chapter Two. It turns out that not only was Hering right, but we have structures in our eyes and brain that process color using this opponent method.

It's also sometimes helpful to think of color perception in terms of the two axes defined by red/green and yellow/blue. If you know a color is purple, then it'll be towards the blue side on the yellow/blue axis and the red side on the red/green axis. This helps to give a more precise definition of a color and is how the LAB color space works, separating out luminance from color data (L stores luminance, A stores red-green opponent information, and B stores blue-yellow opponent data). If you look closely at the white balance controls in your favorite RAW converter, you might note that these are roughly

FIGURE 6 We can create a three-dimensional color wheel by adding a vertical axis for luminosity.

Color	Energy	Emotional Connotation
Red	Moderate	Anger; passion; love; danger; warning
Orange	High	Fire; heat; dryness
Yellow	Very high	Happiness; cheerfulness; radiating light like the sun
Green	Moderate	Growth and progress from an association with plants; jealousy; money; sickness
Blue	Low	Calm; rest; peaceful; quiet; reminders of sky or water
Purple	Low	Noble and wealthy; elegance; sacred
White	High	Pure; clean; honest; innocent; simple
Black	Low	Heavy; death; strong; mysterious; powerful

As you might expect, many of these colors have their emotional connotation because we see them in nature, such as with a yellow sun, orange/red fire, and blue sky or water. When we see the color, we think of the natural object and the meaning we associate with that object.

Sometimes colors have meaning because of historical context. White became a popular wedding color after an image of Queen Victoria's wedding dress was publicized in the mid-1800s. Before then, other colors, including black, were popular wedding dress colors.

Purple is also considered a royal color for historical reasons. Tyrian purple, also known as royal purple, was made from sea snails, and the dye became more intense over time instead of fading. The dye was very expensive and it became a status symbol, making it so that only wealthy people and important religious figures had royal purple clothing.

In addition, purple is special because while it is commonly made from a mix of red and blue, there are some rare instance, such as the purple you see in a butterfly's wings, that actually emit spectral violet light where the object reflects light at a shorter wavelength than blue, which is truly violet light and not a mix of red and blue. When you visit an art store, note how some purple paints that visually appear similar to other purples are ten times more expensive. The more expensive purple paints are not a mix of red and blue.

the two axes provided to let you manually adjust your white balance as well. By making our color wheel three-dimensional, adding a vertical axis for luminosity as you see in Figure 6, we can also express muted and darker tones of each hue.

COLORS AND THEIR IMPACT

Whether you consciously realize it or not, we associate emotions with colors. For example, have you ever felt green with jealousy or so mad that you turned red? The following table summarizes the common emotions that people in Western cultures associate with colors, as well as the visual intensity associated with each.

FIGURE 7 The greens of the plants in this shot create a feeling of growth and nature (as does the setting) and the yellow flowers add a sense of happiness. Together, these help bias the viewer to feel that the woman working in the field is happy to be there.

Cultural connotations also play a role. For example, in Thailand, purple is a color of mourning (worn when someone close to you dies). In the United States and other Western cultures, black is a color of mourning, but in China and South Africa, white and red, respectively, are colors of mourning.

Religions also have meaningful colors. In Hinduism, a number of gods have blue skin. Judaism is often represented by blue and white, and green is a holy color of Islam. Many religions use white to represent peace.

Pastel colors, such as pink and pastel green, which are less saturated, are often seen as more youthful and sometimes feminine than fully saturated colors.

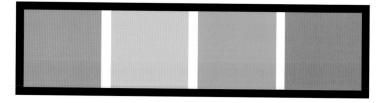

FIGURE 8 Pastel variants of colors, which feel more youthful than the fully saturated versions.

The particular shade variant (how light or dark a color is) can also affect how we perceive a color. For example, we often associate dark blue with restful and mature feelings whereas light blue is youthful and masculine. Light green reminds us of nature and growth whereas a vivid green reminds us of nausea and sickness.

Whew, there are a lot of meanings here, aren't there! Fortunately, you have a very powerful tool to help you: your instinct. You know what you think of when you see certain colors. Unless you have a very specific, personal connotation for a color (e.g., you were wearing a magenta shirt when you first met your significant other), there's a good chance most people in your culture will react the same way you do to a color. That's how you can determine the emotional meaning that a color adds to your image.

Unfortunately we just have to accept that not all cultures view each color the same way, and a viewer from another culture might miss some meaning in your photo if the color is critical. On the other hand, since the energy that each color contributes to a photo is related to how our brains perceive color, which is culture neutral, someone from another culture will perceive a similar energy level in your image.

MATCHING COLORS

Just as visual intensity is about finding the right balance of energy from the components in an image, matching colors is about finding the right combination of colors that fit together and the right amount of each. Learning how to pick colors that go together well will help your photography, your fashion, and even your interior decorating, and it turns out that it's pretty easy to learn. Later in this chapter, we'll discuss what happens with our perception of an image when colors aren't balanced.

Complementary colors are the easiest to understand. Complementary colors are located across from each other on the color wheel, and these colors look good together. The specific pairs are red and green, reddish-orange and bluish-green, yellow and purple, yellowish-green and reddish-violet, orangish-yellow and bluish-purple, and orange and blue. These pairs are said to be balanced when neither color appears more prominent than the other.

Fortunately for us, Johann Wolfgang von Goethe (yes, this is the Goethe who wrote *Faust*) came up with an easy way to balance colors in his *Theory of Colors*, and this work is the basis of a lot of modern color theory in art. In fact, it was Goethe who first proposed expressing color using a wheel instead of in a straight line like a rainbow.

What Goethe proposed is that each color has a specific number associated with it, as seen in this table.

Color	Goethe's Light Value
Red	6
Orange	8
Yellow	9
Green	6
Blue	4
Violet	3

When you take complementary pairs, such as yellow and violet, you get a ratio, in this case 9:3. To make this color combination feel balanced, there must be three times more of the image that's violet than yellow, as three times three is nine. Red and green is the only complementary combination where you want equal amounts of each to feel balanced.

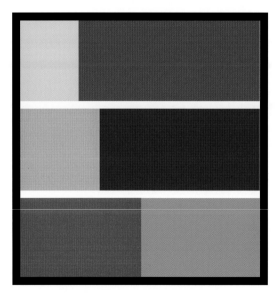

FIGURE 9 Complementary pairs in balanced mixtures.

FIGURE 10 Split complementary pairs on a wheel (A) and a sample image with those colors (B).

What's interesting about these numbers is that they match the energy level that the colors contribute to the overall image. An image with a lot of yellow is far more energetic than a similar image with the same amount of violet.

Three-Color Mixtures

It's actually quite easy to figure which combinations of three colors work well together by using a color wheel, too. There are two ways to do so, producing different sets of results. The first way is by selecting split complementary colors.

We just discussed how complementary colors, such as yellow and purple, are located across from each other on the color wheel. Select one of those colors, say yellow. Now, select the colors to either side of purple. For this group of three colors, we'll use yellow, bluish-purple, and reddish-purple. Similarly, if we'd decided to select purple as our initial color, then we would pick the colors to either side of yellow on the color wheel, giving us purple, yellowish-green, and orangish-yellow (Figure 10).

The other way to select combinations of three colors is to draw an equilateral triangle (where all sides are the same length) on the color wheel and rotate it around. The points of the triangle will pick colors that go well together. The main combinations you'll find this way are red/yellow/blue, orange/purple/green, yellow-orange/blue-green/red-purple, and red-orange/blue-purple/yellow-green.

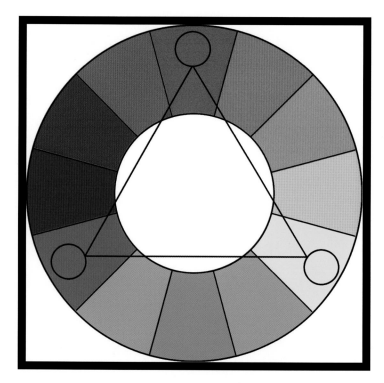

FIGURE 11 Using an equilateral triangle on the color wheel to pick color combinations.

FIGURE 12 Goethe's color triangle.

The Color Triangle

Goethe came up with another way to represent colors that helps us pick four or five colors that work well together. That's the color triangle (sometimes called Goethe's triangle). As seen in Figure 12, this triangle is formed by putting smaller triangles of the primary colors at the vertices of the large triangle, putting triangles with the additive mixture of those colors between each primary (such as purple between red and blue), and then filling the rest of the space with three further additive combinations (purple and orange give a reddish-brown, green and purple give olive, etc.).

Once you have a color triangle, either pick four colors that make up a smaller equilateral triangle, such as purple, indigo, green, and blue (Figure 13A) or the four triangles that make up

one side of the color triangle (Figure 13B), and you'll have a mixture of four colors that look good together.

To add a fifth color to your palette, pick the color opposite your selection in the color triangle, as seen in Figure 14. This color will stand out against the other hues.

Also keep in mind that, as you add more color combinations to an image, you're adding to its overall visual intensity. An image with five colors has more energy than one with two colors.

Cool and Warm Colors

Periodically, you'll hear colors described as cool or warm. If you draw a line right down the middle of the color wheel, as seen in Figure 15, you'll bisect the wheel into warm and cool colors. Cool colors tend to have a calming effect, although they can sometimes make an image feel

Two ways to select four colors that match from the color triangle, either from a smaller triangle (A) or from a side of the larger triangl

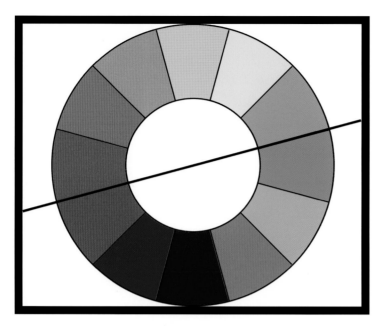

FIGURE 15 Cooler colors are below the line and warmer colors are above it.

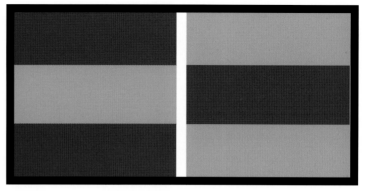

FIGURE 16 The warm orange against blue appears to come forward whereas the cool blue against orange appears to recede.

VISUAL EFFECTS OF YOUR COLOR PALETTE

We've discussed how to make colors balanced and find ones that match. However, an unbalanced color or a contrasting color will stand out and add more visual intensity to the image (the amount will vary depending on how extreme the contrast is). For example, a tiny amount of red in a green image is very unbalanced and makes the red part energetic. You'll almost always want the red item to be your subject, as your eye will go straight to it because of its contrast. The same would be true if you had a tiny amount of green in a red image: you'll want the green object to be your subject because your attention will go to it.

With a balanced mix of colors, such as red, yellow, and blue, if you add something into that image of a different color, such as something green, it'll stand out and draw your attention.

If your image has only cool or only warm images, it'll have a strong overall cool or warm tone. There will still be some contrast between the different tones, but it'll be much less noticeable than if you add one of the other types of colors, for example adding a warm tone into a cool image. You can pick these hues using the techniques we described previously for finding matching hues, as long as they're from the other side

impersonal. Warm colors convey stronger excitement, optimism, and even anger. Sometimes, warm colors are called "active" colors and cool colors are called "passive." Ironically, the actual color temperature of the cool colors — that is the temperature of a black-body source radiating light at a similar hue—is higher than the color temperature of the warm colors.

Interestingly, marketing studies have found that stores painted red or blue are perceived as the most active, and people have a more positive reaction to blue stores than to red. Green and blue colors are usually the most preferred colors, too. Maybe that's why some people prefer Walmart to Target!

Warm and cool colors also have an interesting effect on our depth perception. Warm colors placed against a cool-colored background appear to come forward. Cool colors appear to recede when placed against warm colors.

IGURE 17 By not balancing the colors in this image, we make it more visually intense.

of the warm/cool line. Dusk is actually a very appealing time for city shots because you get warm lights against a cool sky. This is sometimes called "blue hour."

There are other factors that affect our perception of colors, such as the light we're viewing it under. For example, a red rose appears bright against the plant's dark green under

COLOR CALIBRATION

In our photographic workflow, there are many different devices that deal with color, ranging from your camera that captures color to a monitor that displays the image to a printer that outputs it to paper. Given how these devices work, the red you see in an image on your monitor might look different than the exact same image on my monitor. In fact, that image will look different on your monitor with the lights in your room off than it does with the lights on.

A color calibration tool will help generate a color profile, which provides instructions to your monitor or printer on how to adjust the colors in an image so that they appear perceptually correct and consistent across devices.

Typically, you'll hang this device on the front of your monitor, and, as special software displays "known" colors (specific values of various colors), the device measures what color you're actually perceiving and creates instructions for the computer about how to give you the right output. You'll need to make a color profile for each device (every monitor, every printer, etc.) for which you want consistent color, but this small amount of work will save you the headache of not knowing whether what you print will look even close to what's on the screen. Of course your print will never perfectly match what you see on your screen because a print comes from mixing inks, whereas a display comes from mixing light, but color calibration will get you much closer to a match and you will be able to reproduce results consistently.

daylight. At dusk, the red appears far darker than the leaves. This is also related to white balance and color constancy, which we discussed in Chapter Two.

Simultaneous Contrast

It turns out that two colors side by side change our perception of the colors. For instance, colors against a black background look more brilliant, as you can see in Figure 19 (colored objects against a black background also appear slightly larger than against a white background). This is another reason that dusk and night-time shots with artificial light are appealing—the subject's colors appear more brilliant.

Similarly, take a look at the inner squares in Figure 20. The two on the left and the two on the right have the same color, but the surrounding squares affect our perception. The square on the dark background looks lighter than the one on the light background.

What's going on here is that the inner squares are taking on some of the complementary color of the surrounding hue. As Michel Eugène Chevreul, a French chemist whose research led to the idea of simultaneous contrast, put it, if two colors are placed side by side, each color shifts as if mixed with the visual complement of the contrasting color. A gray square surrounded by red will look slightly more green (the complementary color for red) than if the red weren't there. In Chapter Two, we discussed why this effect happens in terms of center/surround.

This can be a tricky effect to actually see because your eye tends to make deep reds and blues appear lighter than they are as well as making some yellows and greens seem darker than they are, but in Figure 21, the inner square on the right should appear slightly bluer (the complement of orange).

The effects of simultaneous contrast are most visible when you have a mid-valued, unsaturated color surrounded by a very saturated color.

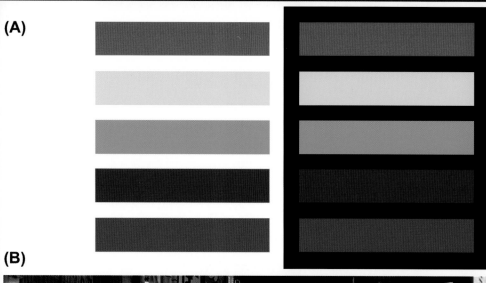

FIGURE 19 Colors against white and black appear to have different sizes and brilliances (A). This is a big reason why night shots are more appealing

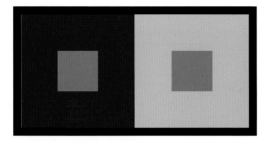

FIGURE 20 The inner squares are the same color, but the surrounding color influences our perception.

FIGURE 21 The magenta square against orange appears slightly bluer (the complement of orange).

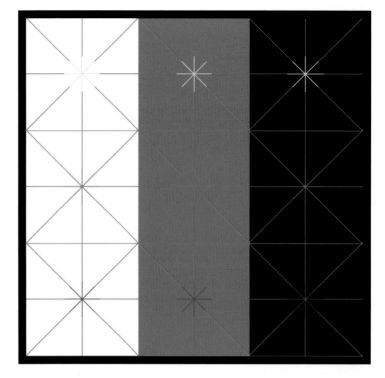

FIGURE 22 If our brain decides that the colors are part of the same overall form, they'll blend together such as the lines bleeding to form colored discs.

Color Blending

Once in a while, rather than taking on properties of the complementary color, colors appear to blend together. Current scientific thinking is that we have a high-resolution, color-blind form system that determines what something is and a lower-resolution color system that colors in the form (this is similar to the "where" and "what" systems we discussed in Chapter Two). If our brain decides that the colors are part of the same overall form, they'll blend together.

As you can see in Figure 22, adapted from an example in Margaret Livingstone's *Vision and Art*, the colored lines bleed into the background, forming a circle, when the color is close to equiluminant with the background. It seems likely that in this case the "where" or form systems associate the lines with the background more than the other diagonal lines, and the

gestalt-oriented groupings we discussed in Chapter Three cause us to see discs.

Robert Silvers' Photomosaics® take advantage of this. A photomosaic is a large image (often a portrait) made up of smaller images that, when viewed from a distance, looks like the desired, large image.

By identifying strong illusory borders in the large image and placing small images that create these borders in the mosaic, Silvers takes advantage of our form system so that the colored images within these borders bleed together. As you get closer to the image and the details in the small images become clearer, the form system shifts between identifying the overall form and letting the colors bleed to identifying the individual images. This adds to the visual intensity in the image and helps keep it engaging.

FIGURE 23 A Photomosaic® of aerial- and space-related images by Robert Silvers, www.photomosaic.com.

BLACK-AND-WHITE VERSUS COLOR PHOTOGRAPHY

If color is so great, then why is black-and-white photography so popular? One simple reason is that it removes color as a component completely, removing any visual intensity and extraneous subtext that the color contributed to the image.

If your image is a little too intense, removing the color might put its visual intensity back into the right range. Sometimes after you remove the color you'll find that you need to increase the intensity in other components, which you often see in black-and-white landscape photos with dramatic skies.

Also, by removing color, any emotional context associated with the colors or interactions between the colors goes away.

Earlier, we discussed how color accents draw your attention. If there's a color accent in the photo, and the accented object isn't the subject, then switching to black and white can help keep the viewer's attention away from that object and let you focus it onto the subject through other components.

Color contributes a broader effect to an image, too, as it helps us judge time. Autumn leaves are yellow and red, as opposed to green in the summer. Early morning and late evening light is more golden than midday light. Removing color de-emphasizes time, which is useful if time doesn't matter to your vision for the photo.

Mark Changizi, in *The Vision Revolution*, puts forward another interesting idea about why black-and-white photos are

FIGURE 24 The same photo in black and white (A) and color (B). In this case, the color wasn't contributing anything useful to the image, and in fact the muted colors on this rainy day were lowering the overall energy. Converting to black and white and increasing the contrast helped raise the energy.

appealing. He points out that the way we process color is very simple, and because of that we see similar shades of color in multiple objects; this expands on his idea that we see the colors we do because those are the colors that our blood creates in our skin (as covered in Chapter Two). For example, the red in a ruby gemstone can look like the red of your face when you blush. Therefore, black and white can be said to be a truer representation of an object because any animal, even one without color vision, would perceive the image the same way. Removing the color removes the biases that our color vision system adds to how we perceive the image.

Ignoring the technical details as to why, sometimes black and white just makes an image more appealing, especially when the color's not contributing anything. Fortunately, with our digital toolkit it's very easy to experiment with converting an image to black and white. We'd recommend trying it when you have a very intense image and need to lose some intensity, when you have an image with very muted colors that's almost black and white anyway (such as on a snowy day), or when you want to draw the viewer's attention more to the lines, shapes, and lighting in the image.

Exercises

1. Pick out three images or paintings that you like (your own or others') and identify the color palettes in each.

2. Find an image that uses color to offset the subject from the background. Are the subject and the background perfect opponent pairs? If not, how close are they? If you use a hue adjustment in a digital toolkit to change one of the colors to be a perfect opponent of the other, does the subject stand out more or less?

3. Try changing the saturation on three different images (one should already be fairly saturated and another should be fairly desaturated) and see how that affects your perception of each image. Note the importance of the role that color plays in each image.

4. Find a color image you like and convert it to black and white. How do the two versions compare? If you increase the contrast, which increases the overall visual intensity, does it become more appealing?

5. Find an image you dislike because it has too much intensity. What happens when you convert it to black and white?

Framing

- Figure/Ground 104
- Seeing Depth 105
- Lens Choice and Depth of Field 111
- Assembling the Frame 122
- Exercises 138

While we've spent a fair bit of time discussing the components in an image, we have yet to look at how the pieces go together. That's what framing is all about! Framing is more than just putting things next to each other, though. Each choice we make, from the lens we pick and where we stand to where in the frame the subject is, affects our perception of the image.

FIGURE 1 The Rubin vase, which can be perceived as two faces or a single vase.

Framing has three key components. The first is making it clear to the viewer what the subject is (or if it's a landscape shot, which part of the landscape is the focal point). The second is creating the appropriate amount of depth in the image to make it either feel very three-dimensional or very flat, with everything seemingly the same distance from camera. The third is positioning the subject relative to the other components, picking positions that help to provide the right intensity and support the feeling you're creating.

FIGURE/GROUND

One of the biggest issues we see in students' photos is that there's no clear subject (or subjects). Sometimes, the student doesn't even know what the subject is! A concept the gestalt psychologists (remember them from Chapter Three?) came up

with is called figure/ground. This is the perceptual process in which we identify which part of the image is the subject (or figure) and which part is the background. Keep in mind that our brain uses contours and contrast (and, as we talked about before, even enhances the contrast) to separate objects, and it uses the gestalt principles discussed in Chapter Three when figuring out which pieces will be connected to the figure and which to the ground.

A classic example of figure/ground is the faces versus vases image, called the Rubin vase, seen in Figure 1. When you look at it, do you see two faces looking at each other or a vase in the middle? We've actually given you two versions, where we inverted the colors. Do you find it easier to see a figure in one of the images compared to the other? The issue here is that the visual intensity of the faces and the vase is nearly identical,

and since there are no hints as to which you should perceive as the figure and which as the ground your perception of the two will switch back and forth.

Once you've settled on a figure, can you make your vision "flip" to see the other object within the same image? Because our brain appears to reinforce the perceptual groupings it made initially, switching between seeing one object as the figure and the other as the ground can be a mental challenge!

Obviously, to help the viewer easily pick the right figure, we need to make sure that the thing we want to be the figure has more energy than the background. If they have the same energy, it won't be clear what your image's subject is (and worse, it might create an illusion where the figure and ground swap like the Rubin vase), and if figure and ground are reversed, your viewer will pay more attention to the background than the subject. If you can't do this while shooting, the digital darkroom chapters (Chapters Ten and Eleven) will give you some great pointers on how to achieve a good figure/ground separation in the darkroom.

However, the ground is still very important to an image. You might have heard of a concept called "negative space." This is an artistic term used to refer to the space around and between subjects in an image. It's considered an area for the eye to rest and helps define the shape of "positive space" or the figure. The margins and white space between words in paragraphs in this book can even be considered negative space, and it helps define the positive space, or the text. In a silhouette image, where you don't see detail in the subject, it's the empty, negative space that defines the shape of the subject.

If you want to get a better idea of what negative space is, we recommend an exercise that we borrowed from the book *Drawing on the Right Side of the Brain*. Take an image, flip it upside down, and try drawing it on paper. Because it's much harder to identify an upside-down image, you'll be focusing on

what shapes the figure and the ground make to work out how to draw the image yourself.

The moral of this story is that in every image you need to make it clear what your subject is by providing a good figure/ground separation and giving the subject/figure more intensity than the ground, such as in Figure 2. This is true even in landscape shots—although you might think that the entire shot is the figure, there is most likely a specific part of the landscape that's the focus.

SEEING DEPTH

When you stop to think about it, it's amazing that our visual system can construct a three-dimensional view of the world around us just from the light falling onto our two-dimensional retinas. To do this, our visual system uses many different cues, some of which come from our having two eyes, which we call binocular depth cues. Fortunately for people who only have good vision in one eye, depth can be perceived very well with just one eye. We call the cues that don't need both eyes monocular depth cues.

An advantage that photographers have over painters is that cameras can capture the perspective and depth cues that we're seeing in a scene perfectly, instead of having to recreate them on an empty canvas. However, by being aware of what the various cues are, we can manipulate them to create more or less depth in a scene. More depth creates more visual intensity, and less depth (a flatter image) is less intense. You'll sometimes hear people say an image has deep space or flat space. Deep space means that there's a lot of depth, flat space means there's little depth, and ambiguous space means that a viewer can't determine how much depth there is in an image (as in a shot taken in heavy fog, for example).

Binocular Depth Cues

There are two binocular depth cues, convergence and binocular disparity. Because there's a small distance between

FIGURE 2 A sample image (A) with highlighted positive (orange) and negative (blue) space (B). The negative space helps define the shape of the positive space and makes it clear what the positive space is.

your eyes, the image arriving at each eye is slightly different—this is binocular disparity. Our brains naturally synthesize those images into a single three-dimensional view, which we take for granted. An easy way to see the different images is to see if you can view your nose. With both eyes open, it's very hard, as our brains let us "look through" our nose. But if you close one eye, you'll be able to see your nose on the right side (from your left eye) or on the left side (from your right eye), clearly showing how each eye sees something different. Fusing those images together creates depth.

Convergence refers to the angle between your eyes when you focus on something. If you're focused on something far away, like the other side of a room, there will be almost no angle between your eyes. If you focus on something right in front of your face, your left eye will be looking to the right a lot and your right eye will be looking to the left a lot. If you hold your finger up by your nose and try to focus on it, your eyes will converge so much that they might even cross. By knowing how far your eyes have to converge to focus on a point, your brain can recreate depth in an image.

Interestingly, 3D movies and images fool our brain's sense of disparity to create depth. For example, many 3D movie theaters currently give you special glasses, which are polarized, and then display a separate image for each eye very rapidly, and polarized appropriately. Many people are then able to fuse these two images together into a 3D image, although for some people this just gives them a headache. There's also some research questioning how beneficial this effect is for our visual system, given that our eyes are always converged at the same point (the movie screen), and we're effectively training our perception to depend more on disparity and less on convergence.

Monocular Depth Cues

There are two primary groups of monocular depth cues. The first are sometimes called *kinetic cues*, and you see these either when you're moving or you're looking at something that's moving. Things that are closer to you appear to move

more in the same amount of time than things farther away. When you're in a car or train, do you notice how things close to you pass by very quickly but things far away appear not to move at all? To achieve this effect in an image, use a slow shutter speed so that objects in motion become blurred. You'll see more motion blur in things close to the camera and almost no blur in things far away, such as in Figure 3.

The first of the pictorial clues, which are monocular cues not based on motion, is occlusion. This is one of the strongest monocular depth cues and easy to understand. Things closer to you block things farther away. Hold up your hand in front of your face. Chances are, it's now occluding a good part of what you can see, and it's clearly the closest object to you. Being able to correctly identify an object's form via clear boundaries and grouping is key to identifying depth correctly, as then you can figure out which objects are in front and which are behind.

The next depth cue is one that photographers can often take advantage of via lens choice and camera position, and that's perspective. Parallel lines tend to converge as they get farther away, as seen in Figure 4. Perspective is easiest to see when relatively parallel, straight lines start close to the lens and extend into deep space. It's hard to see if the lines start far away from the camera, go only a short distance, or aren't straight (it's tough to see wavy lines converging). Perspective is great because it is fairly easy to show (stand at a corner of a building and point your camera at it), and it creates a lot of intensity in the scene by creating depth and triangles (as discussed in Chapter Three).

Something key to note about perspective is that if we have a strong perspective in the frame, especially if it's a single-point perspective, where all the lines tend to converge to a single vanishing point, then our eye is naturally going to want to look into the space at that perspective point. If the subject's elsewhere in frame, your viewer will be fighting this natural urge, and might even miss the subject because perspective can have such a strong pull. If you put your subject along the perspective lines (for people who read left to right, try to put the subject on

FIGURE 3 In this relatively long exposure, the people moving closer to the camera are more blurred than the people farther away.

FIGURE 4 Parallel lines in the buildings converge toward a point in the distance.

the left side, and vice versa for viewers who read right to left because once your eye hits the vanishing point, it won't want to leave), or even better at the vanishing point, then you'll emphasize your subject because the viewer will naturally look there.

An object's size in the frame helps us determine depth in two different ways. First, if we know two objects are about the same size, then we perceive the smaller one as farther away. An object ten feet away produces an image on our retinas twice as large as one twenty feet away. This is called relative size.

However, our knowledge of what the object is can come into play, too. For example, we know roughly how big a soccer ball is and roughly how big a tennis ball is. If a soccer ball appears to be the same size as a tennis ball in frame, we know that the soccer ball is probably three times or so farther away than the tennis ball (and we're not likely to think that this soccer ball is actually really small and at the same depth as the tennis ball). This is called familiar size, illustrated in Figure 5.

An easy way to add intensity to your image via depth is to take advantage of occlusion and familiar size. Specifically, if you're taking a landscape shot, find an object to use as a foreground framing element, like the flower in Figure 6. By having this element close to the lens, it'll appear big in frame but the thing farther away that we know is bigger will be small, creating a very deep image. Note that for this to work, you need a wide lens, which we'll talk about in the next section.

Our brains also naturally assume that light comes from above an object, and we use shadow and shading to infer depth. Take a look at the circles in Figure 7. All three circles are the same, except you most likely see the one that's brighter on top as being in front of the page and the one that's shadowed on top as being inset into the page (and the page is casting a shadow

FIGURE 5 We know that the monkey's hand is smaller than his head, and his head is smaller than the trees in the background. This lets us estimate how close the hand, the monkey, and the trees are to the camera.

FIGURE 6 By getting close to the flower and using a wide lens, it appears larger than the hill in the background, creating a very deep image.

on it). The last circle, while barely perceptible, indicates just how small of a luminance difference our brain can perceive.

The next two types of depth cues are very similar. As things get farther away, they have less detail. For example, you might be able to see the detail on a brick wall close to the lens but unable to see the detail on bricks that are far away. This cue is called a texture gradient. Similarly, due to light scattering, there's an atmospheric gradient that causes things farther away to be more murky and appear paler. Objects that are farther away also tend to look a bit bluer, although their exact color can change depending on the time of day and what's in the atmosphere. The important bit of this depth cue is that things that are farther away tend to be less detailed.

FIGURE 7 We perceive depth from shading information and are able to register very small changes.

One cue that many psychologists ignore because there's no perfect explanation for it, but which was observed by Robert Solso, is called orientation. The idea here is that, depending on how shapes are oriented, we perceive them as either 2D or 3D (this is a bit related to the gestalt idea of prägnanz that we covered in Chapter Three). In Figure 8, adapted from Solso's work, you'll see the same drawing simply rotated forty-five degrees. Yet 8A looks like a kite or some type of 2D shape, whereas we clearly see 8B as a cube. Try rotating the book yourself and seeing how your depth perception changes as your orientation to the shape changes! As photographers, we should also remember that our orientation to a shape also affects how easily a viewer can identify the shape's form. For example, if we photograph a mug but don't show the handle, a viewer might not realize it's a mug.

The last monocular depth cue we're going to discuss is a very simple one. Things higher up in the frame tend to be farther away. Nearly every period of art, from prehistoric to Impressionist to some modern art, has used elevation as a depth cue, and this seems to be hard-wired into our brains, as children draw their art this way without ever being taught about depth.

How much you leverage each of these depth cues in your image is up to you. If you have an image with very low overall intensity (square shapes, horizontal lines, limited colors), try doing things to add depth to it. For example, put your camera close to a wall to create a strong perspective depth cue, or see whether you could incorporate any occluding items in your shot. Adding depth adds intensity. Furthermore, as we'll

discuss next, the lens you pick can inherently add depth to or flatten your image.

LENS CHOICE AND DEPTH OF FIELD

While we've talked about a number of components thus far in this book, you might feel a bit frustrated because sometimes those components, such as colors in a scene, are either out of your control or very difficult to control. Fortunately, lens choice and depth of field are both components that you can easily control, as they're affected by the lens you put on your camera and the aperture value you set on that lens.

Field of View

To understand lens choice, the first concept you have to grasp is field of view. Field of view refers to how much of the world the lens can see. You'll sometimes hear photographers talk about lenses as being wide or narrow (the latter is sometimes also called long or telephoto). They're referring to the field of view.

Wide lenses can potentially have a very, very wide field of view. Some fisheye lenses even have a 180-degree field. To envision how much of the world that lens might see, stand with your arms lifted up and out to your side. A lens that wide will capture everything between your arms in an image. Conversely, a long lens might only have a field of view that's only a few degrees. A super-telephoto lens has roughly a five-degree field of view, for instance. Figure 9 shows the field of view for a few lenses using a top view of a camera, as well as roughly what part of a scene different lenses would image.

If you stand in the same spot and take the same shot with a wide and then a narrow lens, as in Figure 10, you'll notice two key differences. With the wide lens, you see much more of the world but everything is smaller in the frame. With the narrow lens, you see much less of the overall world, but the things you do see are much larger and more detailed in the frame.

By moving your camera closer to or farther from the subject, you can make the subject the same size in the frame, but the

FIGURE 8 The orientation of this graphic affects whether we perceive it as a 2D shape (A) or a 3D cube (B).

FIGURE 9 The field of view for a few different lenses, shown in relation to the camera (A) and as approximately what you see in a scene (B, not to scale).

wide lens still creates a different look than a narrow lens. Consider the two shots in Figure 11. In each, the subject is roughly the same size. One was taken with a narrow lens from farther away, and the other with a wide-angle lens up closer. The key difference is how much of the rest of the world you see in each image. Again, even though the subject's about the same size in each photo, in the shot with the narrow lens, you see less of the surrounding world than in the shot with the wide lens.

Lenses with a wide field of view create a lot of depth in an image and add more intensity to a shot. A narrow field of view creates less depth and provides less energy. This is due to the relative distance from the lens to the subject and from the subject to other objects.

To get your subject filling the frame with a wide lens, you have to be close to it, say a foot away. Now, the distance from the subject to the next object in frame might also be a foot; with a wide lens that means the far object will appear significantly smaller in the image as it's twice as far from the lens as the subject, and our pictorial depth cues will tell us it's much farther away. Conversely, if we're using a long lens, we might be able to fill the frame with the subject from ten feet away. The second object is now eleven feet away from the lens, and it won't appear significantly smaller than the subject in the image. Our pictorial depth cues tell us that the second object isn't that much behind the subject because, relative to our camera's longer distance, it's not creating less depth compared to the wide lens (Figure 12).

Taken from the same spot, you can see the difference in fields of view for a wide lens (A) and narrow lens (B).

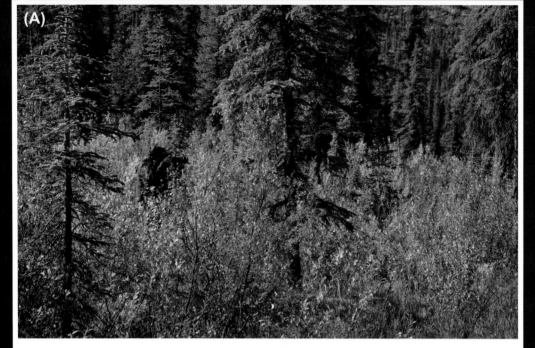

same subject shot at roughly the same size in frame with two different lenses: a narrow lens (A) and a wide-angle lens

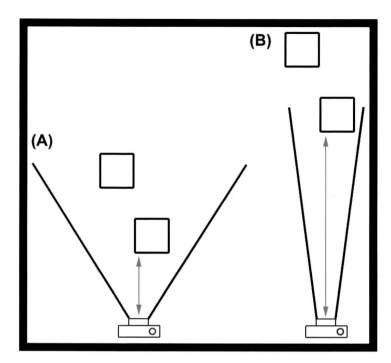

FIGURE 12 The relative distance (indicated in red) of the camera to two different objects with a wide lens (A) and a telephoto lens (B).

Unfortunately, when we talk about lenses, we don't talk about them in terms of field of view but rather in terms of their focal length. What makes this confusing is that, due to different sensor sizes, such as crop sensors or larger, medium-format sensors, the same focal length number might refer to an entirely different field of view on a different camera. Essentially, focal length is a measurement of the distance from your lens to the sensor, measured in millimeters. All the focal length numbers we present in this book, unless otherwise noted, will be for a full-frame, 35 mm sensor (36 mm × 24 mm). Practically, lenses with focal lengths of 35 mm and under are considered wide-angle lenses, 35 mm to 85 mm is for standard lenses, and 85 mm and up is for telephoto lenses.

You might be thinking that you should always try using a wide lens and getting close to your subject to create a lot of energy in your images; however, that isn't always the right choice.

MULTIPLICATION FACTOR, AND CROPPING IS NOT ZOOMING

Your lens produces a circular image, and your sensor records the light from part of this circle, capturing a certain view of the world. It used to be that every 35 mm single-lens reflex (SLR) camera captured the same part of that circle because each piece of film was the same size. Many SLRs now have a sensor that's smaller than a piece of film. That means that it captures a smaller part of the circular image, as you can see in Figure 13.

To capture the same field of view with a smaller sensor than a full-frame sensor, you need a wider lens. The ratio that describes the difference is called the multiplication factor (sometimes also called the crop factor). For example, a camera with a four-thirds sensor has a crop factor of two: a 50-mm lens on a full-frame camera produces the same image as a 25-mm lens on a four-thirds camera.

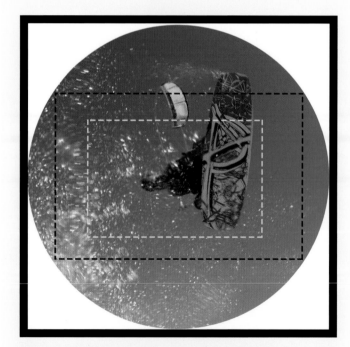

FIGURE 13 The round image produced by a lens and the regions that two sensors of different sizes capture in the image.

While this means you need special extra-wide-angle lenses with a smaller sensor camera, such as an 8-mm lens instead of a 16-mm lens, it's beneficial with telephoto lenses. A 300-mm lens on a four-thirds camera produces the same field of view as an expensive 600-mm lens on a full-frame camera. Long lenses can be very expensive (the Canon 800-mm lens was priced at over $13,000 at the time of writing), but mid-range long lenses are much less expensive (a high-quality 400 mm with a similar aperture costs just over $1,000). If you're doing a lot of extreme telephoto photography, for example with animals, you might be happier with your images and bank account if you purchasing a crop sensor camera. Of course there are many other factors to consider when buying a camera, but the extra reach is a nice plus for crop sensor cameras.

One last thing to note is that cropping an image isn't the same as zooming. Regardless of sensor size, if you shoot with a high-megapixel camera and a wider lens and crop in to the same part of the image that fills the frame with a long lens, the overall field of view will still be different. This is because field of view is a property of the lens (and imaging sensor), whereas cropping is a post-process for that image.

Wide-angle lenses often cause weird distortion around the edges, where straight lines aren't perfectly straight, and for some types of photography, such as portrait photography, wide lenses don't produce attractive results.

To understand why portrait photographers don't use wide lenses and why cellphone portraits never look attractive, think about relative distances for a second. To fill the frame with someone's face, we'd have to get fairly close to the subject. Now, the distance from our camera to the tip of the subject's nose is about the same as the distance from the tip of the nose to the face. That leads to weird distortion where the nose is much bigger in frame than we expect it to be compared to the rest of the head.

Many portrait photographers prefer to work with a narrow-angle lens and to get farther away so that the distance from the lens to the tip of the subject's nose is much greater than from the nose to the face, and so that there's less noticeable distortion. Figure 14 has essentially the same portrait shot with different lenses.

Also, getting close and using a wide-angle lens sometimes just isn't possible, such as when you're at the zoo or trying to photograph hunting lions in the wild. If you shot with a wide lens from farther back, you would have more depth in the image but your subject would be so small that it wouldn't stand out. In those cases, it's much better to use a long lens, which magnifies part of the image due to its narrower field of view. Figure 15 shows you what this looks like.

Lastly, something to consider when picking a lens is the size your subject is going to be in the frame, and how this contributes to the feeling you want in the image. Typically, you want the subject to be large and dominate the frame. But if the image is more about the relationship between the subject and the environment, it's okay for the subject to be small. If you're trying to create a sense of loneliness in the image, it's fine to have a very small subject. Just remember that, as the subject gets smaller, you really need to make sure that its visual intensity is increasing so that it's clear that the subject really is the subject and not part of the background.

Depth of Field

Related to lens choice is the depth of field that you choose to have in an image. Depth of field refers to how much around your point of focus is also in focus. A very shallow shot means that very little is actually in focus—everything aside from your focal point gets blurry quickly (Figure 16A). A very wide depth of field means that a lot of the image, both in front of and behind the point you focused, is in focus (Figure 16B).

FIGURE 14 Here are similar portraits at 16 mm (A), 35 mm (B), 50 mm (C), 80 mm (D), and 105 mm (E). Note how the wider shots are distorted, and the narrower shots, especially C and D, give the most attractive and least distorted results.

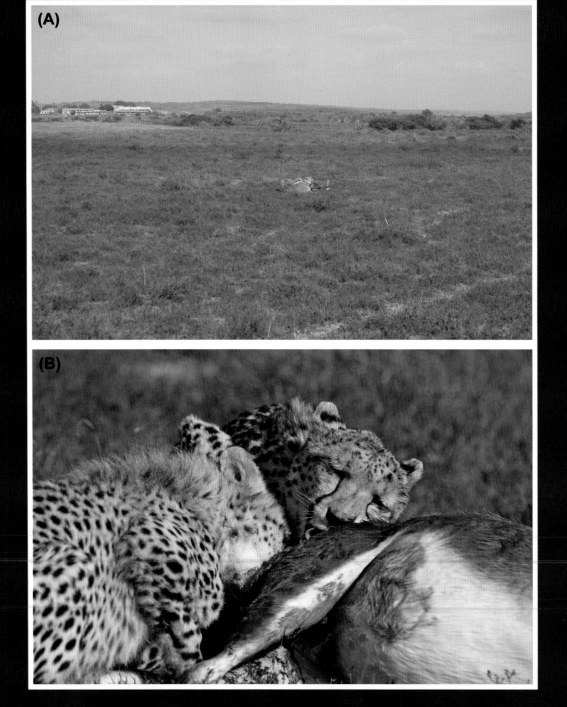

FIGURE 15 In this photo of animals taken with a wide lens (A), you can't really see what's going on, despite having lots of depth visually. Compare this the same subject shot using a very long telephoto lens (B).

FIGURE 16 A shot with very shallow, limited depth of field (A) and a shot with very wide depth of field (B).

FIGURE 17 The same shot with the same focal length but at f/4 (A) and f/16 (B), creating different depths of field.

As you might know, within your lens are aperture blades that close to change your depth of field. We'll discuss aperture in terms of f-numbers, which are ratios of the focal length to the size of the opening of the lens. Because they're ratios, f-numbers have a consistent meaning across lenses. Lenses have a physical limit for the smallest f-number (largest opening) they can have, and more expensive (and some fixed focal length) lenses tend to have larger apertures.

Depth of field has a range associated with it, meaning that an area in front of and behind your focal point will be in focus (technically we consider the sharp range to be the range where the blur on the image is less than the circle of confusion size, which is where the blur becomes perceptible and the image stops appearing sharp). Wide apertures and small f-numbers give a very shallow depth of field. Narrow apertures and large f-numbers give a large depth of field.

The exact range that's sharp in an image is a function of your f-number and how close you are to the subject. You can get a preview of the depth of field you'll get by pressing the depth-of-field preview button on your camera. This stops down the lens to the specified f-number, showing you what'll be in focus (your viewfinder image will also get darker since there's less light coming into it while the lens is stopped down and the aperture blades aren't wide open).

There is also a special point you can focus at, called the hyperfocal point, which makes it so that everything from a certain distance in front of the focus point until infinity will be

FIGURE 18 This shot has good bokeh because the background is very soft, with no sharp edges.

sharp. There are multiple charts online and apps for your smartphone that give you hyperfocal calculators to determine that exact point and how much in front of it will be in focus for your lens.

A shallow depth of field is beneficial since it helps isolate the subject by reducing the details in the rest of the image, which lowers the overall energy. Wide depth of field contributes to a high visual intensity because it leads to more distinguishable points in the frame.

Of course, some of the effect of shallow depth of field is dependent on your lens's *bokeh*. Bokeh refers to how your lens renders the out-of-focus area. Good lenses give a soft bokeh, where out-of-focus objects have indistinguishable

edges and are nicely blurred. Low-quality lenses often have poor bokeh and out-of-focus objects still have sharp edges. There are other factors that affect bokeh, including spherical aberration, but this simplification is good enough for now. In terms of visual intensity, poor bokeh is often frustrating because you're trying to limit detail in the ground and draw attention to the subject using a shallow depth of field. However, the lens is still keeping the edges of objects in the background sharp, and our brain goes right to those edges. The only thing you can do in this case, short of buying a new lens, is to use other techniques to lower the overall intensity of the image.

A common misconception is that depth of field is directly tied to focal length, and that longer lenses have less depth of

field. This is incorrect. Depth of field is a function of your aperture value, your focal length, and how close you are to the subject.

If you're at a specific aperture value and shoot a subject using different focal lengths, moving each time so that the subject always stays the same size in frame (Figure 19), your overall depth of field will also stay the same. (The distribution of the range and how much in front and how much behind the subject is in focus shifts as you move, though. When you're closer with a shorter lens, roughly 70 percent of the range will be behind the focal point and 30 percent will be in front of it, and when you're further back with a long lens, about 50 percent of the range will be in front of the focal point and 50 percent behind it.) Your perception of the depth of field might change due to the image's changing with the different focal lengths, but the actual depth of field doesn't.

If you stand at the same spot and use a longer lens, your image will appear to have a shallower depth of field because the subject is the same distance away, but you're using a greater focal length, and the subject now takes up more of the frame at a higher magnification. In addition, because narrower lenses enlarge the background relative to the foreground, they might appear to have a shallower depth of field since the blurred background is enlarged.

Smaller sensors, however, automatically give you more depth of field than larger sensors. With cellphone cameras and many point-and-shoot cameras, it's nearly impossible to achieve a shallow depth of field. This is because you have to use a lens with a much wider field of view for the subject to be the same size as with a full-frame camera. For example, if you put a 24-mm lens on a full-frame camera and frame a shot, a person standing next to you with a compact camera might need to be at 8 mm to frame the same shot. Because both of you are at the same distance from the subject and at the same aperture value, this difference in focal length leads to the other person having a much wider depth of field (roughly three times more). Even wide open at f/2, many cameras with very

small sensors only give a depth of field equivalent to f/8 or f/11 on a full-frame camera.

ASSEMBLING THE FRAME

After you've picked a lens, the next decision you need to make is whether you're taking a horizontal or vertical shot. Many people tend to shoot a lot more horizontals because that's how our eyes see (they're next to each other), it's what we're exposed to in movies and now on widescreen televisions every day, and that's typically how our camera's ergonomics are set up. But each choice has meaning. A vertical shot emphasizes height whereas a horizontal shot emphasizes width. Furthermore, some objects (such as a person or a building) are more vertical, and if you shoot with a vertical frame, you'll be able to fill more of the frame with the subject. In fact, a horizontal frame is called landscape orientation because landscapes are usually wider and a vertical frame is called portrait orientation because faces are usually more vertical.

Next, once you've selected vertical or horizontal, chances are that the only thing you've ever read or heard about where to put stuff in the frame is to follow the rule of thirds. The rule of thirds says that if you divide your image into thirds both vertically and horizontally, you should put your subject where the lines cross indicated in Figure 20. While artists have known for hundreds of years that we find these positions in a frame pleasing, there are many other positions in the frame that you should consider placing your subject to influence the visual intensity of your image.

Let's start first by looking at the intensity contributed by certain positions in the frame. In 1967, two Swedish psychologists, Gunnar Goude and Inga Hjortzberg, conducted an experiment in which they placed a black disk on a white square. They put the disk at various positions and asked the subjects to judge how strongly they felt that the disc was going to move in a particular direction. You can see their results in Figure 21. The length of each vector at each point

FIGURE 19 Here are four shots at 28 mm and f/4 (A), 105 mm and f/4 (B), 28 mm and f/16 (C), and 105 mm and f/16 (B) that keep the subject (the scoop) about the same size. Note how the depth of field/amount of blur is similar in each, even though the field of view changes.

FIGURE 20 The bird's head in this image is roughly at a rule-of-thirds point indicated by where the dotted red lines cross.

indicates how strongly the subjects felt that the disk was going to move in that direction.

The important thing to take away here is that, when the disk was at the center, to observers it felt balanced and static. When it was at a rule-of-thirds point, it felt like it was going to move along a diagonal (so in an oblique line) with moderate energy, and when the disk was near an edge, it felt like it was going to move with a lot of energy. In other words, if you want the subject's position in frame not to add significant energy to the scene, put it toward the center. If you need to increase overall intensity, move the subject toward the edges. Placing the subject at the rule of thirds points adds a moderate but pleasing amount of energy to the shot.

For subjects that have a natural motion (Figure 21), such as a person or animal or a nonequilateral triangle, you also need to take its potential for motion into account. If you have a person running left to right, if they're at the left edge of frame, they have a lot of room to move and the image will be about what's going to happen next in their motion (and of course, the more to the left the person is, the greater the intensity because the more speed he can accumulate over the frame). If the person's at the right edge then there's energy because he'll leave frame very quickly, but not quite as much as if he were at the left edge, because very soon he won't be part of the image. In this case, the image is about what the subject's passed, and you typically need more intensity in the other parts of the image.

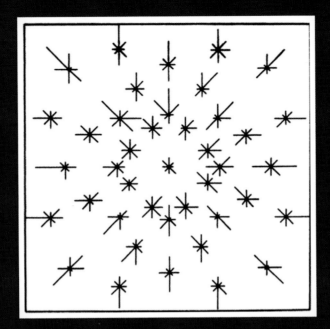

FIGURE 21 How much a disk tends to move at different points in a frame. From Gunnar Goude and Inga Hjortzberg, *En Experimentell Prövning...*, Stockholm University, 1967.

FIGURE 22 These flamingos have a very clear left-to-right direction because we see their heads and know that they're flying straight. The one at the left has a lot of room to move—the whole frame. If you cover the two on the left and look at just the one on the right, the image has lower intensity, since that flamingo is about to exit the frame.

Another study by Herbener, Tubergen, and Whitlow (1979) found that positions in frames also have inherent semantic meaning. If the subject's higher up in frame, the image is more active and more "potent." And when the subject moves away from the center, there's more emotional tension in the image.

Another way to find a pleasing position for elements in an image with moderate energy is to use the *golden ratio*. This is a specific ratio, defined numerically by the constant *phi*, or 1.618… (technically, two numbers are in the golden ratio if the ratio between the sum of those numbers and the larger of the two numbers is the same as the ratio between the two numbers). The reason it's special is because many artists and philosophers believe that humans naturally find this ratio pleasing, and it shows up repeatedly in nature. For example, in 2003 (confirmed in 2008), Volkmar Weiss and Harald Weiss suggested that the golden ratio underlies the clock cycle of our brain waves. There are many other examples of the golden ratio in nature, ranging from the ratio of the diameter of Saturn to the diameter of its rings to the magnetic resonance of spins in certain crystals.

The golden ratio can be used to construct a rectangle, the golden rectangle, and extended to create a grid (Figure 23). Part of the reason the rule-of-thirds points are appealing is that they're very close to the points defined by a golden rectangle, but it's easier to divide something into thirds than to draw 1.618:1 ratios. Following on from the previously mentioned theories where positions in the frame away from the center create emotional tension, some people feel that the golden ratio points have an "ideal" tension.

It's also possible to create triangles using the golden ratio that we find pleasing to compose with. First, draw a diagonal line in the frame going from one corner to another such as the bottom left to top right. We'll call that line 1. Then, extend a line from the other corners to this bisecting line, such as from the top left to that first line. We'll call that line 2. Now pay attention to where line 1 and line 2 meet. We want to make the ratio of one side to another be the golden ratio, such as

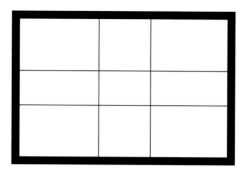

FIGURE 23 The golden rectangle, dividing a rectangle based on the golden ratio, and defining intersection points.

you see in Figure 24A. We visually find it pleasing if you place your subject roughly where lines 1 and 2 meet, as you see in Figure 24B.

Around the year 1200, a mathematician, Fibonacci, discovered that, with a specific sequence where each number is the sum of the two previous numbers (1, 1, 2, 3, 5…, where 2 = 1 + 1, 3 = 1 + 2, 5 = 3 + 2, and the next number in the sequence is 5 + 3 = 8), you can approximate *phi*. But what's more interesting to us photographers is that you can visually represent the Fibonacci sequence with the grid in Figure 25A, and you can also draw a spiral using the grid, as seen in 25B. Many objects in nature, such as a nautilus shell, have this type of spiral. Some software packages even include such spirals as an overlay alternative to the rule of thirds.

If you put your subject right around the root of the spiral, the inner point where the spiral starts, and then keep the key pieces contained within the spiral, you'll create a pleasing, moderate-intensity composition. If you want a way to arrange objects in your frame that creates a moderate and unobjectionable amount of energy, then this is a great framing technique to use. But remember, if your image has a low overall visual intensity, you'll probably want to put the subject closer to the edge to add energy, and if it has a high intensity, you'll want to put the subject toward the center to reduce the intensity.

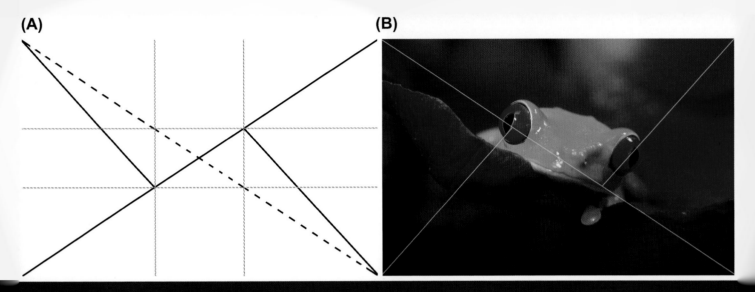

IGURE 24 Forming triangles to guide composition using the golden ratio (A) and composing an image (B) so that its focal point(s) are where diagonal lines isect the overall image diagonal into the golden ratio.

FIGURE 26 The water in this image is fairly similar and we recognize that it's one thing, making for a large "light-weight" area. The body surfer, although small in the frame, has high intensity due to his color and body shape and because he's in the air.

Visual Weight

You may have heard people talk about *visual weight* before. Visual weight is simply the idea that certain elements in frame attract our attention more than other parts. As we discussed in Chapter One, research into perception has shown that areas that convey information (especially eyes, faces, and text) always attract our attention, as do natural figures. In addition to the higher-level objects, larger objects, unstable objects, unusual objects, more saturated colors, warmer colors, darker tones, and more complex objects tend to be "heavier" and command our attention more.

Some writers talk about how it's important to balance all the objects in the frame, for example when you have a large, dark area, you should counterbalance it with a small, bright area, because humans find balance pleasing. We find it easier to think about visual weight using a visual intensity perspective. If you have a large, "light-weight" area with low energy (that area could be a light or dark color—if it's all a uniform color, as we've discussed, our brain skips over most of it), you need a "heavy" area with high visual intensity to up the overall energy in the image so that it's not too boring.

We recommend that you don't worry about the balance aspect of visual weight and look at it more as being about an awareness for where we'll look in the image, which you can then combine with visual intensity. If you have too many heavy spots that pull the viewer's attention, then the image is

probably too visually intense and the viewer will look away. If there are no heavy spots then the intensity is probably too low and the viewer will look away.

The way your eye moves between the heavy spots can affect an image's visual intensity. Movement into and out of space has more energy than if the heavy spots are at the same visual depth. Movement along oblique lines has more energy than if the heavy spots are lined up horizontally or vertically. Even the overall shape between the heavy spots affects visual intensity—does it form a square, circle, or triangle? It is also worth noting that a symmetric arrangement of your heavy spots leads to lower energy than an asymmetric arrangement.

Relationships between Objects

As we've briefly mentioned here and there, what you choose to show (or not show) in your frame creates implied relationships to the viewer. Furthermore, this happens at a higher level, where we mentally create connections (e.g., two people appear to be looking at each other, and that interaction is important in the image), as well as a lower level (e.g., a blue object is much calmer than a red object, and perhaps there's an emotional relationship between the two where one's intense and the other's calm). The relationship between objects can also affect the visual intensity in the shot (e.g., the eye line between two people creates an oblique line, which increases the visual intensity).

You see how framing creates relationships all the time in movies when people are talking to each other. When characters are supposed to feel isolated and disconnected, they're often framed so that they're the only person in frame. But when we, the audience, are supposed to feel a connection, the subject's framed in an over-the-shoulder shot, with part of the person the subject's talking to (usually the shoulder, neck, and head) also in frame, creating an implicit connection.

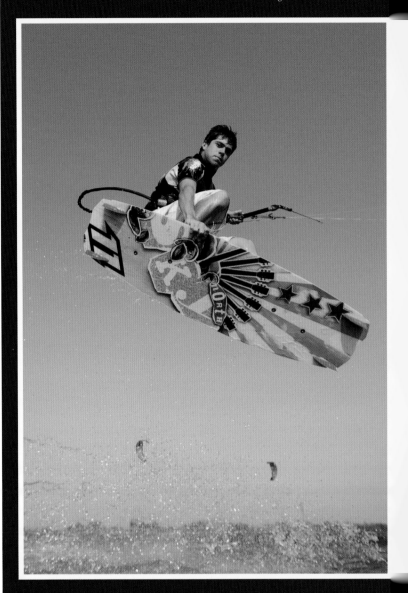

FIGURE 27 The ground gives us a little bit of context as to how high the kiteboarder is, but since it's not relevant otherwise, we only need to show a tiny bit of it in the frame.

FIGURE 28 Even though these people are fairly close together, the strong vertical dividing lines make them appear to be separate and different groups rather than a single large group.

Another simple example is how you split the frame with the horizon. In some basic photo course, you probably heard that you should never put the horizon in the middle of the frame. That's not true. Shifting where the horizon is changes what you're emphasizing in the image. If the horizon's in the middle, you're saying that the ground and the sky are equally important. If the horizon's almost at the very top of the frame, then you're emphasizing the ground but saying the sky matters a little bit. If there's no sky in frame, then you're saying that the sky isn't at all relevant to the photo. The same is true in reverse—if you don't see any ground, then you're saying it's not relevant to the photo. Figure 27 shows a photo where the ground only matters a little bit.

Also, contrary to what some photographers teach, your frame doesn't have to be divided perfectly into thirds

(two-thirds ground/one-third sky or vice versa). Divisions like that are really a function of what you want to emphasize visually and how much intensity each contributes. Just be aware that a fifty-fifty split in the frame contributes a low amount of energy, and the further you get away from that fifty-fifty split, the more energy the frame division creates. This is true for the horizon and sky split, as well as for every division.

Another powerful example is when you're dividing the frame somehow between the points you look at. For example, if one subject is in a bright area and another in a dark area, it creates a boundary between them and implies a difference. Or perhaps there's a big shape, such as a support beam or wall in a building, such as in Figure 28, framed between the two subjects.

You can take this even further by framing the subject within another frame, tightening the space in the image, sometimes even creating a claustrophobic feel (this technique is called frame within a frame). For example, if the subject's in a window or doorway and looking out, he seems small and lonely compared to the rest of the world.

Similarly, if there's a strong line directly behind a subject, it will often appear to be connected to the subject, creating an unusual shape and link. Be careful of these when photographing people, as it'll often end up looking as if there's a lamp pole or tree growing out of someone's head because of the relationship between these two objects in the frame. Chapter Nine gives examples of how moving your body will let you separate out the tree (or other object) from the person's head (and similar).

Many of our students tend to not to like to move around, and they'll often take every photo from their natural standing height. This also creates implicit relationships to objects that usually are not what the students intended! Specifically, when you're shooting down at something, you're often making it feel less important, short, and placing it against the ground plane where it might not stand out clearly. If you're shooting up at an object, you're making it feel tall, important, heroic, and emphasizing its form by (usually) shooting it against the sky, where it stands out more. Sometimes, though, fashion shooters will shoot at a slight down angle since the natural shape of a woman's face responds well to a slight down angle (men look better at a slight up angle), and that pleasant effect is more important than making the subject seem heroic.

Also, shooting up at something tends to create a triangle with the tip at the object's most important point (often where the head is), creating a more energetic shape than the rectangle you'd get from just shooting straight across at the subject.

FIGURE 29 The outer doorway creates a division between the inner door and the rest of the image, which is further enhanced by the different lighting in the two rooms.

FIGURE 31 Shooting down at a crowd helps reveal how many people are in it.

Shooting down can be effective when you want to show a mass of people; when you are above them, you get a vantage point from which you can see the crowd, such as in Figure 31. Since people are all roughly within a similar height range, it's often tough to tell how many people are in a group if you shoot across at a crowd. Keep in mind that the crowd will often read as a lower-energy texture, and you'll need to do something to add intensity to the image.

Don't be afraid to shift your perspective to achieve the shot that you're trying to achieve! Move left or right, get down on your stomach, or stand on a ladder.

Cropping

The boundaries of the frame are as important as the contents, as they imply how the image connects with the rest of the world. For example, is the frame edge completely open to sky, making the image feel like it continues on for a long time? Or is one of the frame edges part of a wall, creating a more closed and contained feel?

Typically images that feel like they continue on have more energy than ones that feel closed, but this is usually not an important contributor to an image's overall intensity. However, since the frame's edges are important to the storytelling aspect of a photo and often ignored in composition, we feel it's worth discussing.

What you want to avoid is the sense that your frame edges are arbitrary; you want the edges to feel intentional. The main way to do that is to make sure you're cropping any objects off intentionally instead of clipping them accidentally.

FIGURE 32 The trees at the left create a boundary (A), implying that the contents of the image (snow and an open area) don't continue in that direction. By including a little more on the left side, we open the frame up (B), because now we see a continuation of the content to the left.

In Chapter Three, we discussed how our brain is really good at completing objects. If you have a shape on the edge of your frame that would complete just outside of the frame (look for strong converging lines), either change your frame so that the object will complete farther outside of the frame or so that you're cutting off the object where its lines are parallel or diverging.

If we perceive that the shape completes just outside of the frame, your frame is clipping the object. That creates unease in the viewer's mind, since they want to see it complete but can't. By moving the frame edge so that either we don't know where the shape completes or it completes far outside of the frame, we accept that the frame is complete. Figure 33 shows an example where the top left area feels clipped and how a crop improves the image.

Similarly, you usually don't want the edge of your subject just brushing the edge of the frame, as the subject appears to merge with the edge. Instead, either provide some negative space around the subject to separate it from the edge or get in tighter so that you're intentionally cropping off part of it.

It's easy to fix these problems via a simple crop. In both cases (converging lines at the edge of frame and the subject merging with the edge), typically just losing a few pixels around one edge of the frame will fix the issue, and in fact that's how we created the "good" versions in Figures 33 and 34.

Cropping is a very powerful tool beyond fixing these problems, though. We often use it to eliminate parts of our image that are fighting for our attention or contributing too much energy to the scene. Or, if we need to shift an object in the frame (e.g., move it off to the side to add more energy), a crop often does the trick. Cropping will also make the subject larger in frame, helping it to become clear, such as in Figure 34.

One of the most convenient reasons to have a high-resolution camera is so that you can crop more, if needed, and still get a very usable, high-resolution image. It is possible to take this too far, though. We've known photographers who crop out 90 percent of the image, giving them a great image with a clear subject, but an image size that's suitable only for emailing to a friend or posting to the web but not printing. If your only intent is to post photos for friends to see, then this is fine, but if you intend to make prints, enter your images in competitions, or just do more with them, then you need to do the work while shooting (get closer, use a longer lens, etc.) to get the framing you want. Some competitions even prohibit you from cropping more than 20 percent of your image.

When you're cropping your shot, consider using a different aspect ratio crop (aspect ratio is the ratio of an image's width to its height). The 3:2 aspect ratio we're all familiar with is popular because it's what 35-mm film has. Other cameras use different aspect ratios, for example some film medium format cameras with a 1:1 square aspect ratio, digital-medium format cameras with a 4:3 aspect ratio, or panorama cameras with 3:1 aspect ratios. A panorama image that you assemble yourself could have an even bigger aspect ratio. Your TV probably has a 16:9 aspect ratio, and many movies are shot at a 2.39:1 ratio.

The point is that no single aspect ratio is correct. Pick an aspect ratio that helps you emphasize the subject (or an aspect of the subject that you find interesting, such as its width) or that helps you achieve the visual intensity you need for a shot. More extreme aspect ratios do tend to have higher visual intensity and a square has the lowest, so do be aware how a crop changes your perception of intensity.

FIGURE 33 In the first image (A), we're just clipping the tip of the whale at the top left corner of the frame, and that clip draws our attention since our brains realize the tip is just out of frame. Cropping in farther feels more natural (B), since the tip of the whale's mouth is now well out of the frame.

FIGURE 34 A simple crop turned this image from an okay shot (A) to an exciting one (B).

Exercises

1. Pick a subject and shoot it using various focal length lenses. Try doing one series where you stand in the same spot so that the subject changes size in frame, and another series where you move so that the subject stays the same size in frame. How do the images change?

2. Find a subject that's near your lens's minimum focusing distance and try shooting the same image at different aperture values. What happens to the background and overall intensity of the image as you change the aperture?

3. Find a subject that's roughly at your chest height. Take various shots where you're above the subject looking down (stand on a chair if needed), squatting down to be level with the object, and on your knees or lying down looking up at the object. How does the image change at each height? Which angles give you more or less intense images?

4. Frame a subject so that it occupies roughly 20 percent of your frame, and take a series of photos where the subject's at the upper left, upper middle, upper right, middle left, and so on until you get to the bottom right. How do the images compare intensity-wise? If your subject has a natural direction of motion, how does its motion affect your perception of the different positions?

5. Try taking a vertical and a horizontal shot of the same subject. How do the images compare? Did you have to adjust your composition between shots to adjust the image's intensity?

Light

- Quality of Light 142
- Direction of Light 147
- Mood and Subject 157
- Exercises 159

Without light, there would be no photography. Light determines the entire look of a photograph and can make or break it. It can reveal or hide detail, emphasize or hide shape, deepen or flatten an object, and more. Some people wait hours or even days for just the right light for an image! Understanding light and how it affects a photograph is a key part in your journey to becoming a better photographer.

Light is one of the hardest parts of photography to understand because we take it for granted. Unless we're out in the middle of nowhere on a moon-less night without a flashlight, there's always a little bit of light to help us see. While you're usually aware of things like a beautiful sunset, how often are you aware of where the sun is in the sky, or whether a scene will look better in the morning or afternoon, or whether you need to get out a flash to get the shot you want? To keep things simple, we'll focus most of the chapter on a single light source, be it a natural light source such as the sun or an easy-to-understand artificial one such as a light bulb or flash. Although we'll mention more complex studio setups here or there, more complex setups with multiple strobes and light modifiers are beyond the scope of this book. Strobist.com is an excellent resource for learning about more complex lighting setups! Before we can begin to discuss shooting with light, though, we need to discuss some attributes of light.

QUALITY OF LIGHT

When photographers discuss light, they often talk about the general quality of light. For instance, you might hear a photographer say the light's great as he runs for his camera bag. He's not talking about what the sun itself looks like. Instead, he's talking about the light the sun (or other light source) is creating in the world at this particular moment. Furthermore, there are a number of specific attributes of the light that make it seem "great."

The first attribute, the brightness of the light source, is called *illuminance*, and it refers to the amount of light from an emitting light source (like the sun) that reaches a physical surface (also called *incident light*). It's often measured in units of lux. There is enormous variation in light in the natural world. Full moonlight provides about 0.1 lux of illumination, and sunlight on a clear day at noon provides over 100,000 lux. Amazingly, our eyes can see in both of those lighting situations and every situation in between!

Typically, we don't take a picture of a light source itself. Instead, we take pictures of things that are being illuminated by a light source (e.g., we take a photo of a friend at the beach being lit by the sun, not of the sun itself). Not all of the light landing on the subject reaches our lens. Luminance is the measure of how much light bounces off a surface and reaches our sensor (or eyes), and it depends on many factors, such as the subject's material and our viewing angle to the subject. For example, imagine that we're taking a photo of a girl in a dress outside on a clear day. If she's wearing a black dress, the luminance will be fairly low, as the dress won't reflect much light. If she's wearing a white dress, the luminance will be fairly high, as the dress will be reflecting a lot of light into the camera.

When light bounces off an object, it can change quite a bit! Over the years, much of the software that manufacturers have added to cameras has actually been designed to calculate how that light changes. Specifically, to help you determine the proper exposure for a scene, your camera has a built-in light meter that measures luminance. These meters were built on the assumption that, when you mix the luminance of all objects in a scene together, they measure out to a neutral, 18% gray value, and they base their calculated exposure around that assumption. Each time a camera manufacturer promotes a more sophisticated auto-exposure system, it's really just an improvement to deal with the cases where not everything averages out to neutral gray. However, reflective meters still don't work all the time, for example if you try to take a photo of a white dog in the snow. Your camera will assume that these white objects are really 18% gray, and they'll be underexposed. Chances are you've learned to use exposure compensation to adjust for these conditions, but there's another way to deal with these situations. If you use an incident light meter, rather than measuring the light bouncing off your subject, you measure the light illuminating the subject and are able to pick the proper exposure value, without compensation and regardless of your subject matter (for the most part—you

will still have to adjust your settings based on how reflective the subject is).

When we combine illuminance and luminance, we get the total amount of light in a scene. As the amount of light in a scene increases, and the scene gets brighter, it causes slight changes in how we perceive an image. Specifically, there are changes in how we perceive luminance contrast and color. First, the Stevens effect occurs when our perception of luminance contrast increases as the light becomes more intense, which lets us perceive fine detail more clearly. This is also the reason we associate seeing the light with an idea becoming clear! Figure 1 shows how contrast appears to change as we increase brightness.

A similar effect is called the Hunt effect. As the luminance in an image increases, our perception of colors in the image also increases. Put simply, colors appear more vibrant and more visually intense in brighter images.

Although brighter light increases our perception of contrast, the truth is that brightness (sometimes called *key*) and contrast are two separate components. It's possible for an image to be very bright (have a high key) but have very low contrast, and it's possible for an image to be very dark but have high contrast, such as in Fugre 2. Understanding and controlling light in an image is often about controlling these two components.

From a visual intensity standpoint, increasing brightness increases visual intensity, as colors and tones appear more energetic. Increasing contrast also increases visual intensity, and in fact luminosity contrast is one of the strongest contributors to the image's overall visual intensity. Also, as we discussed in Chapter Four, if you convert your color image to black and white, a quick way to add back some visual intensity to your image is to increase the luminance contrast. People often prefer high-key black-and-white shots, but high-key color shots often have too much visual intensity.

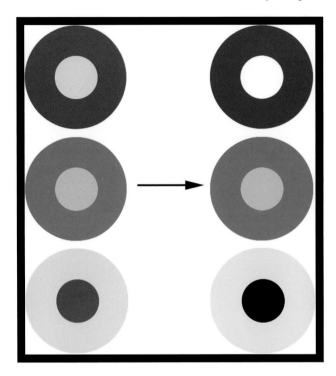

FIGURE 1 This is an example of how the Stevens effect comes into play with different luminance values. The left column contains different scenarios of the contrast between the subject and background, and the right column is an approximation of how we perceive that contrast as the scene gets brighter. Our perception of contrast changes when the subject is significantly lighter or darker than its surround, and the relationship stays about the same when the subject has a lightness similar to the background.

Soft and Hard Light

Describing a light as "soft" or "hard" indicates whether the shadows cast by the light have soft edges or hard edges, not how bright or dim the light is—although hard light is often very bright. Hard light tends to be very directional, often coming from a small, point light. Moving a light source closer to the subject also creates harder light. Hard light creates very dark shadows with sharp edges, and it also creates very bright, specular highlights on shiny surfaces. For example, imagine turning on a bright flashlight in a dark room and pointing it at someone's face. It will look very unnatural, with the nose casting a dark shadow on the upper lip, and the eyes

FIGURE 2 Examples of images with a high key but low contrast (A) and a low key but high contrast (B).

FIGURE 3 Hard light creates depth and a sense of intrigue due to the very bright and very dark areas in this concert photo.

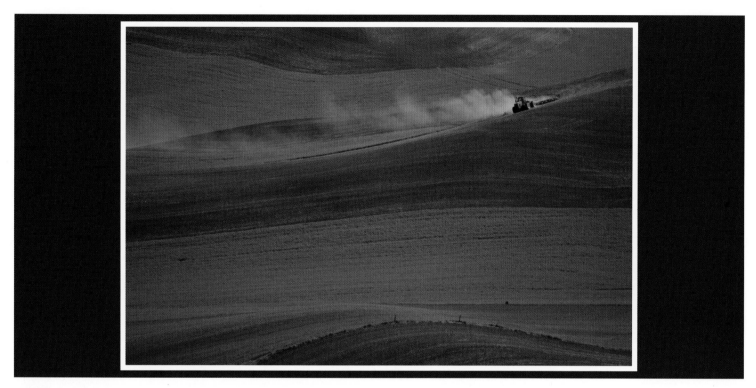

FIGURE 4 Soft light creates a very even illumination across this landscape, emphasizing each part equally.

appearing deeply shadowed and recessed; but sometimes this look is mysterious and alluring, as it was in advertisements for the movie *Black Swan*. Because hard light tends to create a lot of luminance contrast in an image, creating very bright and very dark areas, it leads to a higher visual intensity.

Soft light comes from either very large light sources or from multiple light sources combined together. It can also be created by moving the light source farther away from the subject. The shadows created by soft light sources have very blurry edges, if there's even a visible shadow at all. For example, when you walk outside on an overcast day, the light is very soft because the sun is illuminating the clouds spread across the sky, which in turn illuminate you. You might only see the barest hint of your shadow on a cloudy day. Soft light often has less visual intensity because it has less contrast overall.

Have you ever been in a photographer's studio? If so, chances are you've seen special light modifiers that are designed to make light softer or harder. For example, umbrellas and softboxes, seen in Figure 5, are light modifiers that cause a strobe's light to be spread out over a larger area, creating a softer light. These are often very useful for creating simple portrait images, especially for someone with imperfect skin. On TV and movie sets you'll sometimes see large scrims—panels covered in a diffusing cloth—placed over an area to create softer light on bright, clear days, preventing harsh shadows making the actors look unattractive. Macro photographers also use similar setups, called diffusers, to reduce the luminance contrast in a scene when shooting outside.

Conversely, light modifiers such as beauty dishes are parabolic metal reflectors, which look like semi-shiny dishes placed around a light. They create a light that's harder than a soft light

FIGURE 5 Soft light modifiers include umbrellas and softboxes, such as this Profoto model (A). Their goal is to create a large, illuminating surface from your flash or strobe. They don't create deep shadows on your subject and are helpful when creating a very evenly lit image (B). Figure 5A courtesy Profoto, and Figure 5B provided by Country Setting Portraits, Fairview, PA.

FIGURE 6 Beauty dishes, such as this Profoto Softlight Reflector (A), create a harder light than a softbox, although it's still a soft light since it's a larger light surface than a bare strobe. Although the light in this image (B, provided by Country Setting Portraits, Fairview, PA) is still fairly soft, it's harder and more directional than the lighting in Figure 5.

but still softer than a bare flash (Figure 6A). These can be useful as a primary (or key) light for people with smooth skin, as it creates a more intense, contrasty light, and if you have smooth skin, it doesn't emphasize unattractive features. It's also possible to create harder light with a softbox by using a silver lining instead of white, and a thinner front diffusion panel. Putting the softbox closer to the subject helps create harder light, too.

While a full discussion of these light modifiers and studio lighting is beyond the scope of this book, the take-away point is that both types of light have their uses—you shouldn't look exclusively for one or the other.

Warm and Cool Light

Not all light has the same color, as different light sources have their own unique mixtures of different wavelengths of light. Daylight, for example, has a fairly equal mixture of each wavelength. Tungsten light bulbs give out almost no blue light components, slightly more green light, even more yellow light, and lots of red light. This bias towards the red/yellow end of the spectrum gives tungsten light a yellow/orange appearance. Fluorescent light is slightly odd because it has very strong peaks at certain wavelengths, and different types of

FIGURE 7 Approximate emission spectrums of daylight (green line), tungsten lights (orange line), and fluorescent lights (blue line). The y-axis represents the approximate relative intensities of each wavelength. You can clearly see that daylight contains many frequencies of light, tungsten light is biased toward red/orange/yellow light, and fluorescent light has distinct peaks at each hue but doesn't contain a full spectrum.

fluorescent bulbs have different numbers of peaks. There are even fluorescent bulbs that claim to look like daylight, as they have many peaks at the major colors, but because they don't contain every wavelength of light, some people find that they cause eye strain and headaches.

For photographers, these various light sources have two main impacts. The first one is how we perceive the color of various objects under each type of light. As we discussed in Chapter Two, the white balance setting on our cameras and RAW converters lets us adjust for this. The second impact is how the light's color affects the overall scene.

In Chapter Four, we discussed warm and cool colors, and when light has a certain color, we use those same terms to describe the light. For example, when we take a photo of something in shadow or on a cloudy day, it often takes on cooler hues. If we take a photo right after sunrise on a clear day or inside under a tungsten light, the image will take on a warm hue. Chapter Four also gives a more detailed explanation of the energy levels these various colors contribute.

Something slightly confusing is that you'll occasionally see a temperature listed for light. The science behind this approach, using temperature instead of frequency, is that if you have a perfect black-body radiator (an object that absorbs all light falling onto it completely and radiates energy completely evenly), as you heat that black body up, it starts emitting electromagnetic radiation at different frequencies. Eventually, that emitted electromagnetic radiation will fall into the visible light spectrum, and we can measure what temperature each hue appears at. What's confusing is that the hues we refer to as warm light (reds, oranges, etc.) actually have a lower temperature measurement (2,700 to 3,000 K—color temperature is measured on the Kelvin scale) than cool light (over 5,000 K). It's just like with a fire, where the blue area towards the heart of the fire has a higher temperature than the outer, red flame.

DIRECTION OF LIGHT

The direction of the light can have a tremendous impact on a shot. By moving yourself relative to the light source (or by

FIGURE 8 These fighting eagles are front lit, and you can see details of their feathers.

moving the light source if possible), you can change how the subject's lit, which creates very different images of the same subject.

Front lighting, or pointing your light at the subject like in Figure 8, reveals the most detail about an object because it reduces the amount of shadow. All shadow ends up behind the subject, and if the subject's brighter than the background, it'll really draw attention and help ensure that your subject has more visual intensity than the background. This type of lighting works very well for wildlife shots when you want to see all the detail on an animal. Unfortunately, front lighting can remove depth from an image, lowering its intensity, because the lack of shadows makes it harder to see an object's three-dimensional shape.

However, be careful with the visual intensity in the rest of the frame! Since there are very few shadows, most of the scene will be lighter, creating a lot of areas to pull our attention. Try reducing your depth of field or finding a foreground and background that interact (remember that figure/ground relationship?) to make your front-lit shots work. If you're trying to create a very three-dimensional image, you probably want to avoid front lighting because the lack of shadows reduces the apparent depth in the shot.

To get the most three-dimensional feel from your shot, side lighting, seen in Figure 9, is your best friend. The shadows and highlights created from light entering from the side really create contrast and texture in an image, increasing the overall visual intensity. They do so because the taller points in the image, even very subtle variations in a material, cast shadows.

The side opposite the shadow tends to be brighter, making it stand out more in our brains. Additionally, bigger shadows become lines and shapes in our composition, with all of the implications we discussed

FIGURE 9 This honeybee is side lit. Note how one side of his face is much brighter than the other, but you see the texture and dimensionality in his head and body.

in Chapter Three. If you pay close attention to your favorite movies, you'll see that nearly every shot has at least some side lighting in it to help add depth to the frame and make the subject stand out from the background. Furthermore, cinematographers usually put the camera on the same side of the subject as the shadows to get the most depth and shape.

If you really want to emphasize shape, potentially to the point of hiding detail, then back lighting like in Figure 10 will help you. Light from behind the subject creates a rim around it, a sharp barrier between light and dark that naturally pulls our eye. Furthermore, the light from behind the subject tends to be brighter than the rest of the background, such that it will cause very little detail to be visible in the rest of the background.

If you're metering so that you retain some color in that light, your subject will usually go black, and you'll get a silhouette. By hiding detail in the subject, backlighting can help reduce the overall visual intensity in the shot, but a strong, contrasty rim light will put intensity back in.

There are also a few non-silhouetted subjects that look better with backlighting, such as leaves. In general, objects that transmit light are more appealing with backlighting because they have more saturated colors and it's easier to see some of their hidden details.

Something else to note about when the sun (or any other light source) is shining directly on an object is that direct

FIGURE 10 This bee has a strong back light from the sun, creating a high-lighted rim around his body and the flowers. However, although his body is a bit underexposed and less detailed than the bee in Figure 9, it's not a complete silhouette, and you can still see detail.

illumination emphasizes luminance contrast and has a higher visual intensity. Indirect diffuse light, such as you get on a cloudy day (rather than the sun being a smaller point light, it illuminates the clouds, which become a large light source, sort of like putting a lamp shade over a light bulb), emphasizes luminance similarity.

Indirect light softens and feathers shadows and it lowers a scene's dynamic range, all of which lower an image's visual intensity. Cloudy days might not be the best for landscape shots that include the sky, as the sky will often become solid white, but they're great for macro photography or types of photography with a strong, clear subject, because your subject's details will all be clearly visible and free of harsh shadows. Furthermore, colors like you seen in Figure 11 often appear more saturated in diffuse light. On a cloudy day it's also possible to shoot all day, because the diffuse light doesn't change as much as direct light from the sun does on a clear day.

Time of Day with Natural Light

It's easy to see changes in light just by spending a day observing a subject from the same spot. Before sunrise, with a night sky, there's still light from the stars and sometimes the moon. Since your eyes will be dark-adapted, they'll quickly start to notice as dawn approaches and the sun starts to rise.

At dawn (Figure 12), the air is cleaner than at any other time throughout the day, and since the sun's below the horizon, there is a very diffuse, even light in the sky, casting very few shadows. Light contributes very little visual intensity to a scene at this point since there's very little luminance contrast.

The sometimes spectacular effects of sunrise happen because, even though air is invisible, it still affects light from the sun passing through it. Specifically, the sky

FIGURE 11 A shot from around noon on a stormy day. Because the sky wasn't pure white and had interesting texture, we chose to include it the image's visual intensity.

FIGURE 12 A dawn shot of a flock of birds, just as the sun is about to rise.

FIGURE 13 A shot at sunrise with a vibrant sky.

often ends up having warm colors in it, such as red, oranges, and yellows. This is often a popular time for landscape photography because a colorful sky has a higher intensity than a clear blue one. Because the sun is so low in the sky, it creates very long shadows and so interesting shapes in a scene (affecting the overall intensity, as we discussed in Chapter Three). It's also easiest to create backlit shots during sunrise because you can easily position the sun, at its low angle, behind a subject.

Furthermore, right after sunrise, the light has a very warm color temperature, making objects it illuminates appear golden, like in Figure 14. You'll often hear the hour or so after sunrise called *golden hour* (or magic hour). The visual intensity in a scene tends to be higher because of the color and increased contrast during golden hour.

Morning is a popular time in general for photography. Although the light isn't golden and the sky is blue instead of colorful, the light has a very neutral quality, see in Figure 15, which doesn't significantly affect an image's visual intensity. The light is also still relatively soft, but it becomes progressively harder. This is also a good time for outdoor portrait photography.

Midday, when the sun is at its highest point, is the worst time for photography, as you can see in Figure 16. Here, the sun is directly overhead, and it causes many surfaces to create very harsh and contrasty shadows because there's no light illuminating objects from a lower angle. For example, your eye sockets cast harsh shadows on your eyes, your nose casts a harsh shadow on your mouth, and your chin casts a harsh shadow on your neck. In addition to looking unnatural, images shot at midday often have too much intensity due to all the luminance contrast. If you must shoot at midday on a clear day, use a fill flash to fill in those shadows and reduce the contrast in an image.

FIGURE 14 About half an hour after sunrise, during golden hour, the light had a very warm quality, causing the lavender to glow.

FIGURE 15 A shot in early morning light, after golden hour, when the lower sun angle isn't creating harsh shadows.

FIGURE 16 An unappealing shot from midday, with dark, contrasty shadows.

Afternoon light is fairly similar to morning light, and you get another opportunity for golden hour before sunset. Sunset is similar to sunrise, in terms of light, but it's sometimes more colorful because there's more pollution and dust in the atmosphere at the end of the day.

You might also notice that you can see distant mountains and such more clearly before sunrise and after sunset. This is due to a phenomenon called *airlight*, which is sunlight scattered by air between us and the distant object. When the sun is up, it creates a lot of airlight, which lowers the contrast of distant objects and makes them difficult to see. When the sun goes down, airlight decreases and it's easier to see distant objects. Haze is similar and often confused with airlight; but haze is gray whereas airlight is blue.

As the sun dips below the horizon, it creates a twilight arch, which is a yellow/orange glow in the western sky, shown in Figure 17. At the same time, in the eastern sky, it creates a blue earth shadow fringed with a pink anti-twilight arch. In other words, it's good to look behind you right after shooting a sunset, because the sky does pretty things. A few minutes later, the earth shadow fades and purple light starts to appear above the twilight arch. If you're shooting in the mountains, *alpenglow* will start to appear, which is when mountain peaks appear to glow pink/purple as they reflect the twilight arch. The alpenglow will disappear as the twilight arch takes on a reddish color, and eventually it fades away and the sky goes dark for another night (note the reverse of this process happens at dawn).

FIGURE 17 A shot after sunset of the twilight arch. Also note how the slow exposure used to capture this light caused the water to become silky.

Keep in mind that, while these descriptions of light at different times of day are generally true, they can vary if you're shooting at high altitudes or closer to the poles. If you shoot in Iceland in the summer, you might see midnight sun, where the sky never actually gets dark. In this case, golden hour is a lot longer than an hour!

On partly cloudy or overcast days, these attributes change a lot. For example, it's possible to get decent pictures at noon on a partly cloudy day if the sun is behind a cloud, reducing the luminance contrast. On a cloudy day, you might not see a sunrise or sunset at all, but instead see the large diffuse light source the clouds have become get brighter and darker as the sun rises and sets.

DYNAMIC RANGE

To understand why images with too much luminance contrast look awful, you need to be familiar with a concept called *dynamic range*. Dynamic range refers to the difference between the brightest and darkest parts of an image. For example, if you take a photo of a rose bush at noon, what's the difference in luminosity between the petals on the rose and the shadows inside the bush?

Like exposure, we use stops to measure dynamic range. Our eyes are capable of changing their pupil size quickly so that we can see detail in each part of the scene regardless of brightness, giving them

a very high dynamic range often considered to be over twenty stops, but our cameras aren't that flexible. Most digital cameras can capture five to nine stops of information (another reason to shoot RAW rather than JPEG is that RAW files store more dynamic range). That's fine on a cloudy day where there are about three stops of range in the scene but not helpful on a sunny day at noon with a dynamic range of over fourteen stops. In those cases with extreme luminance contrast, we have to pick which exposure to meter for. If we meter for the brightest part of the image, we are likely to have significant parts of our image that are pure black with no detail. Conversely, if we meter for the dark parts, significant portions of our image may be pure white. The worst outcome is often the most common, where we meter for the mid-tones, such as skin, and end up with both pure white and pure black areas.

These areas with no detail, whether black or white, often look unnatural and disturbing, and if there are both pure white and pure black areas it dramatically increases the visual intensity due to the contrast. There are techniques we'll discuss later, in Chapter Eleven, for combining different exposures to create a high-dynamic range picture. Using light modifiers such as a diffuser or flash or just not shooting when the light is bright and contrasty, as it is at midday, can be effective ways of avoiding having a dynamic range problem in the first place.

Artificial Light

The problem with natural light is that it's out of your control. Once you understand light, you'll find yourself wanting to control it as much as possible to get the shot you want. For landscape photographers, that might mean waiting for the right weather conditions and the right time of day. Sometimes, though, you'll be able to use artificial light. This is often much more convenient because you have full control over it.

Many cameras have built-in flash to help you control the light, but these flashes are problematic. For one, they're not powerful enough to illuminate objects more than a few feet away. They also only create front-lit images, which doesn't let you get depth or shape in the subject—something that separates professional portraits from amateur ones. Because these flashes are aligned with the lens, you also often get red-eye images as a result of light reflecting off the retina. Multi-light setups are a common way to address these problems.

Multi-light setups, like you see in portrait studios, combine lights at different angles and different intensities to blend the benefits of each direction of light. One of the most basic setups, diagrammed in Figure 18, is called a three-light setup. Here, Light 1 is the "key" light, providing most of the light for the image as well as creating the primary shadows. Light 2 is a "fill" light, usually at half the power of the key light, and it's designed to reduce the shadows on the subject's face from the key light, which is off to the side, so that the face has depth but doesn't appear unnatural. Light 3 is the "rim" light, and by backlighting the subject a tiny bit it helps to separate the subject from the darker background and create more depth (and visual intensity) in an image. Sometimes Light 3 is pointed toward the background rather than the subject, as in Figure 19D—that's perfectly fine and also serves to separate the subject.

TIP

Some manual modes on a camera, such as aperture priority on Canon EOS cameras, still meter for ambient light, even when shooting with a flash. You'll often need to switch to full manual mode, choose the settings you want to use, and then adjust your lights' power (if your lights and camera don't do that automatically) to the desired levels.

FIGURE 18 A common three-light setup involves a key light (1) to the side, a fill light (2) at a lower power on the opposite side to the key light, and a rim light (3) to separate the subject from the background.

In Figure 19A, we've taken a portrait shot with ambient light. Because it's a fairly dark room and we don't want a blurry image, we're forced to use a larger aperture that doesn't give enough depth of field, a slower shutter speed that could cause blur, and/or a higher ISO that creates a noisier image. We're also subject to the effects of the ambient light on the subject, which we can't control. Ideally, we'd want to shoot at a faster shutter speed (so that we could hand-hold and move around), a depth of field that means the subject's face is in focus, and a lower ISO for a cleaner image. These settings, in this ambient light, would give us a very dark image, and thus we're going to switch to a three-light setup. Figure 19B shows what happens when we add just a key light, which makes the subject look spooky. In Figure 19C,

we've added a fill light, and in 19D, we've illuminated the background with another light to give it definition but separate it from the subject. Figure 19E shows what happens if we don't pick the correct settings on our camera and it meters for ambient light while also firing the strobes, giving us an overexposed image.

As we mentioned earlier, a full discussion of lighting setups and possibilities is beyond the scope of this book, but the guiding principles we have discussed, about the quality and direction of light, will apply to every lighting setup you encounter. Once you understand light, you can set about controlling it to help achieve your vision!

MOOD AND SUBJECT

All the qualities of light and direction combine with our accumulated knowledge about the world to create mood in an image. We often associate tungsten lights with being indoors and a feeling of coziness. Strong overhead fluorescent light creates an institutional feel. Overhead light can also create deep shadows in people's eye sockets, which can create a depressed or ominous feeling (*The Godfather* is a great example, as every shot in the Marlon Brando character's office is so strongly lit from above that you can barely see people's eyes). Candlelight (or firelight) is very warm, both in color and mood, and it also has a flickering quality rather than being consistent and even, separating it from tungsten light.

Light also inherently conveys information about the image because of our past knowledge. We know if something is indoors or outdoors. We can usually get a rough idea of what time the image was taken, with natural light. Even though this knowledge doesn't directly contribute to the visual intensity in an image, it does affect our interpretation of the image's story, which we discuss in the next chapter.

FIGURE 19 An ambient light-only image (A), and images with only a key light (B), a key and fill light (C), and a key, fill, and rim light (D). If we don't pick the correct mode on the camera when shooting with a flash, it will meter for ambient light and fire all the strobes, giving us an overexposed image that's also slightly blurry due to the model's movement during the slow exposure (E). Images courtesy Jeremy Lasky.

Last, light also helps us focus our attention on the right objects in a scene because we tend to look first at objects that are being illuminated. For example, if we have a front-lit image, revealing details in surfaces, and the background is illuminated more brightly than the subject, our brain is automatically going to go to the background first. In this case, the background has more visual intensity than the foreground. That makes it harder to tell what the subject is and often makes our images less effective. In Chapter Eleven we'll discuss digital relighting techniques that can help fix this problem, but you need to be conscious of the issue while shooting and try to avoid it if possible!

Exercises

1. Go outside and take four photos of the same subject at different times of the day (this could include a shot taken at night). Consider what happens to the light and how it affects your image. Try this on a sunny day and on a cloudy day to see even more variation.

2. At either sunrise or sunset, take different photos of a subject outside, positioning it so that it's front lit, side lit, and back lit. How does the image as a whole change with each lighting condition? Alternatively, use a table light as the lighting source and light a subject, such as a person, from each direction.

3. Take a photo where light is the subject. An example idea would be a shaft of light shining through a window into a dusty room, where your focus ends up being on the shaft of light.

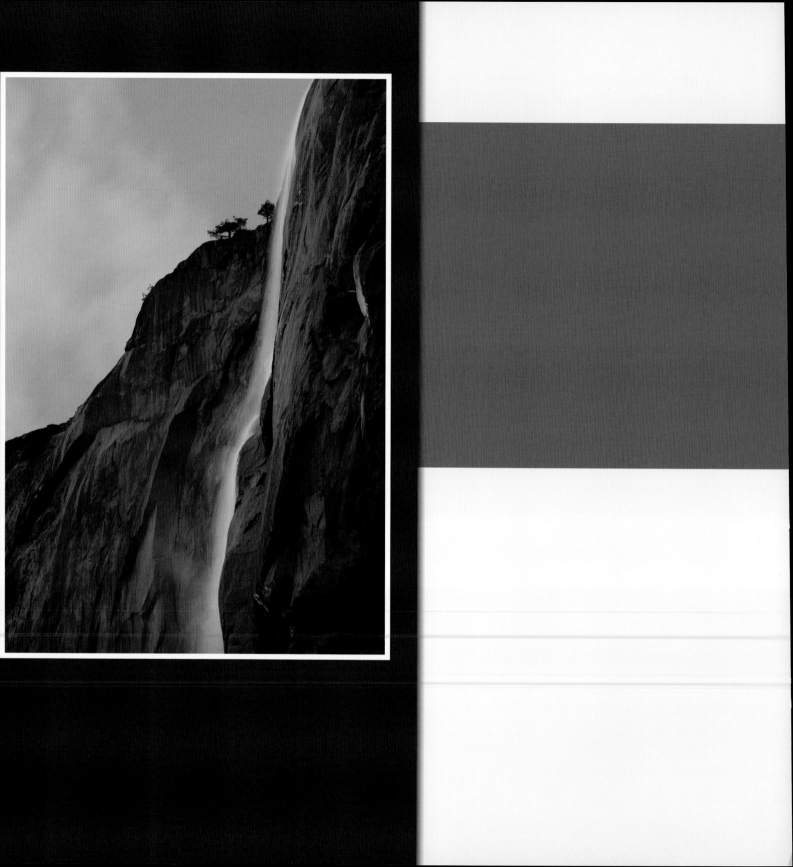

Visual Storytelling

- Perceiving Subjects 162
- Creating Stories 169
- Settings for Storytelling 178
- Multi-Picture Stories 183
- Exercises 187

Images have the power to make us laugh, to make us cry, and to make us stop and think. They can show us something new that we've never seen before or something old that we'd forgotten about. They do so by telling stories, in which characters, plot, and a point of view combine to express an idea. Visual stories are part of our existence, and cameras let anyone tell a story. Ultimately, the story we're trying to tell affects and determines the visual intensity of our image.

FIGURE 1 Sometimes the story isn't the thing that everyone else thinks is the story!

One of the biggest reasons people are unhappy with their photos, even when they're technically correct and have good visual intensity within the components, is because the image doesn't capture our attention or imagination. This is because the subject and story of a photo are what dominates the visual intensity of the image. Visual storytelling is important to every image you take. Even with abstract images, as we discussed in Chapter Three, we will try to find the story.

Identifying the story of a photo and its visual intensity helps us figure out the appropriate visual intensity to aim for with the components of an image. If we have a subject and story with a lot of visual intensity (whether it's because of past knowledge of the story or because of its uniqueness), then the other components of the image should have lower visual intensity. Similarly, if we have a less engaging story, perhaps a shoe on a sidewalk (this is a fairly common sight in cities), then the story contributes less visual intensity and we need to have higher visual intensity in the other components to create a pleasing image. Understanding how we will perceive the subject in an image is the first step in analyzing our visual storytelling skills.

PERCEIVING SUBJECTS

As seen in earlier chapters, science and art are intertwined, and science can help us understand how we find and perceive subjects. Past experiences and our memory of them are key to our perception of a subject.

FIGURE 2 What memories does seeing this airplane trigger in your mind? Do planes make you think of business travel? Your last vacation where the airlines lost your luggage? Maybe a fear of heights?

It used to be that we thought our memory worked a bit like a computer's—we record all of our experiences, and the more we recall something, the stronger that memory becomes. The memories we don't recall, we might forget.

Our understanding of memory has since changed (and is constantly evolving). We now know that memory isn't passive like this; instead it's dynamic and, in some ways, more efficient. But memory can also be surprising. For instance, think about when a particular smell triggered all sorts of associated memories the last time you smelled it.

What's especially interesting is that our visual memory is very fast. We can quickly recognize our parents or an actor, and we can tell if a painting is a Picasso or Da Vinci (assuming we

know who those painters are). When people look at photographs, assuming they know what that subject is they will quickly recall their experiences associated with that subject, and that affects their perceived visual intensity of the image. If you show a photo of a dog to someone who was bitten when she was young, she'll have a very different reaction to the photo than someone who works as a dog walker. How do you react to the airplane in Figure 2?

Obviously, then, learning is important to how we perceive photographs. One theory of learning is called concept (or category) learning. The idea here is that we mentally categorize what we experience. Learning involves judging how similar or dissimilar something is to what we've experienced and figuring out where to classify it.

There is currently debate about how we categorize concepts. One view says that we use more rule-based categorization. For example, we might know that one type of bird is a juvenile because its coloring is different than an adult's, with the rule being that coloration determines age.

Another theory about how we categorize is that we come up with a "prototype," or representative example of a category, and then have more precise definitions beyond the prototype. For example, using the previous example, we might have a "bird" prototype and then have specific "juvenile" and "adult" examples. This theory is interesting to photographers because the similarity between our subject and our prototype affects our perception of how common or uncommon the subject is and therefore how visually intense it is.

For example, draw a house. Chances are that you drew something like Figure 3. You've probably never seen or lived in a house like this, but we all recognize it as a prototypical house.

Do any particular feelings or emotions come to mind when you look at this very common, prototypical house? Chances are that nothing strong does. Now imagine the house you grew up in. What emotions come to mind? For most Americans, it'll be a memory of a comfortable, reasonable-sized house. How do you feel when you look at the houses in Figure 4, from El Alto, Bolivia? If you grew up in the suburbs in America, you might

FIGURE 3 A drawing of a prototypical house.

be shocked at the small size and density of these houses. This subject will have a higher visual intensity for you because it's so different from your prototype and your specific experience with houses. Yet if you grew up in a shantytown in an impoverished country, this image might remind you of home, and your emotions will be different. The image could also have less visual intensity because this sight is more common for you.

Prototypes are also interesting to photographers, and artists in general, because they're similar to a concept called "archetypes." Archetypes are universally common themes, patterns, or symbols that represent fundamental prototypes. Many stories, from plays to movies, have archetypal themes, such as death and rebirth (a central theme in some religions), journey underground, heavenly ascent, search for a parent, sacrifice, loss of innocence, journey home, apocalypse, and hero quest. *Star Wars* has great popularity because it covers many of these themes (hero quest, loss of innocence, etc.).

Those are not the only archetypal themes, however, and there are other kinds of archetypes, such as character archetypes. We often see characters who are damsels in distress, mentors, wise old persons, heroes, and so on. The movies *Avatar* and *Dances with Wolves* are fundamentally the same story, despite big differences in setting and budget, because they have the same archetypal themes and characters—awaiting a messiah figure, a hero who "goes native," and human versus nature.

The psychologist Carl Jung coined the phrase "collective unconscious" to describe these universal archetypes, as he believed they emerged out of how the mind organizes itself, and that the appeal and existence of these prototypes are the result of our genetics rather than our experiences. This theory is appealing to artists, including photographers, because it means that our images can be universally understood and lead to a collective observational experience. If we create an image with a subject and theme that are close to archetypal, then many viewers are likely to perceive it with a similar level of visual intensity, rather than having a huge variation in visual intensity, depending on their experience.

FIGURE 4 The densely packed houses of El Alto, a city adjacent to La Paz, Bolivia.

FIGURE 5 The up angle in this image from Carnival in South America helps emphasize the heavenly ascent themes associated with the Catholic symbolism in the image.

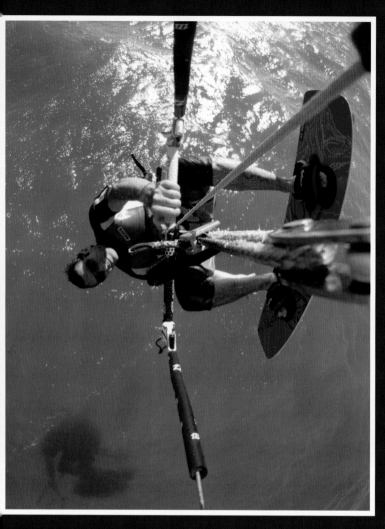

FIGURE 6 By attaching a small GoPro camera to his kite lines, Josh was able to bring the viewer right into the action while kiteboarding. The shadows and angles relative to the water give clues as to where he is and in what position, and this image most likely makes you go "whoa" more than you would when viewing an image of someone sitting on a bench.

Interestingly, some parts of how we perceive a subject also come down to our genes. Pretty much universally, we have a preference for larger pupils in subjects' eyes. There's a correlation between pupil size and emotion: something exciting causes pupils to dilate, and something unpleasant or scary causes them to get smaller. We react to that. There are also specific shoulder-waist-hip ratios for men and women that cause us to say someone has an attractive body—or not.

In 1959, Herman Witkin found, while doing research into how we perceive things to be upright, that our genes can even affect how we perceive tilted images (tilted cameras are referred to as "dutched" cameras in the movie world, and they're often used in horror movies and film noir for the strong oblique lines and uneasy feeling they create). People who use their vision system rather than sense of gravity for balance find tilted images to have more tension. While tilting an image can create diagonal lines and increase the visual intensity, it can also change our perception of a subject.

Mirror neurons, a concept discussed in Chapter Two, also affect how we perceive a subject, like in Figure 6. We can imagine ourselves in the subject's place—especially with human subjects—and doing what the subject's doing. If it's something simple, such as sitting on the bench, the subject's action has low visual intensity. But if the subject is doing something thrilling, such as rock climbing on a high cliff, it will have a higher visual intensity and perhaps even make our palms sweat. Have you ever seen a movie where, even though you were safe in your seat, you were holding your breath watching the action on-screen? That same phenomenon can happen with still images.

Including a person in an image often makes the image more relatable, too, and it becomes a story about interacting with the environment or how people react to things in the environment rather than just about the environment itself, such as in Figure 7.

Compare these two similar images. One is a story of a peaceful scene (A), and the other is about the photographer capturing the scene (B)

FIGURE 8 Do you see the crab in this image? Because the overall visual intensity of this image is lower, if the crab had been completely obvious, it wouldn't have been interesting. Hiding the subject a bit increases the visual intensity, since it takes a second to see him, and makes it into a good image. You might recognize this example from Chapter Two, as hiding the subject makes the "what" system have to work harder.

If a viewer has to work slightly to discover what the subject is (can you see the subject in Figure 8?), she'll usually be more satisfied, and this also increases the visual intensity of the image. But as the subject gets more abstract, you need to provide more context to the image as a whole so that the viewer doesn't get frustrated and give up trying to determine what the subject is, because the image is completely different from anything she's seen before.

While our perception of subjects and the intensity they contribute to an image is quite complex (and varies from person to person), we can sum up how the subject affects the visual intensity choices you'll need to make in the rest of the image

fairly simply. If you have an unusual subject that creates strong emotion, then the rest of the components in the image need to have lower visual intensity. If you have a subject that's close to an archetype or just more common in general, then the rest of the components need to have higher visual intensity (keep in mind that, while you want to boost components in the whole image, you will want to emphasize them more in the subject than in the background so that the subject has more energy than the background).

Keep in mind that these choices might need to change over time, too. Images of lions in Africa used to be uncommon and the lion alone created strong emotion. But photos from safaris

are common enough today that the visual intensity from the subject has decreased and the rest of the image needs higher visual intensity to compensate.

This same advice holds true for the image's overall story.

CREATING STORIES

What we choose to put into the frame automatically becomes connected together, meaning that your subject(s) will become connected with the background. The interaction between the things within the frame creates relationships (and if your subject is looking at or interacting with something out of frame that we can't see, it creates a mysterious ambiguity). These

relationships, along with our past experiences related to the subject matter, create the story of an image.

Every image has a story, whether you realize it or not. Even if you're trying to create the most straightforward, documentary shot possible, there's no such thing as a "pure" documentary shot. The scene and subject we see will always be slightly biased, based on our past experience, mood at the time we're shooting, and desires for the future. We can use this to our benefit! Our technical editor, Lou Lesko, even attributed some of his success as an advertising photographer to always coming up with a story for the shot, no matter how simple it might be. Here's how he developed the story and the scene shown in Figure 9.

FIGURE 9 An image that portrays remoteness because of the landscape and tree, but an American identity because of the cowboy. Image courtesy Lou Lesko.

This image was going to be used for a Qwest Communications ad. At the time they were focusing on the extraordinary reach of their products. I needed to convey a remote location while maintaining an American identity. So I utilized the cowboy archetype. The story is about how an individual in the middle of nowhere can still be connected. So it was important that the path not have an endpoint. The lone tree in the distance adds to the remote feeling by playing on a prototype that we are exposed to as children—the lone tree on the African plain or in the middle of the desert.

Styling and stature were absolutely key here. Even though the story I was building took place in a lonely, remote location, the actor had to be connected to it. And that occurs in the way he stands and the clothes he's wearing. He's not dressed like a traveler, but rather in his everyday clothes. His hands in his pockets and general look of confidence suggesting that he's been there many times before convey that he is on his own land.

It can be tricky to create stories, though! This section contains some helpful tricks. Before determining the story

FIGURE 10 Even though this was taken with an infrared-modified camera, it's from a very common viewpoint for Yosemite Valley, and the weather is similar to the Ansel Adams *Clearing Winter Storm* shot. That similarity makes it a decent stock image of Yosemite, perfect for a postcard, as it's what people expect to see and instantly says, "I was in Yosemite," to the person who receives the card.

you want to tell, think about who your audience is going to be. This can sometimes make your life easier because it creates constraints on the images you're taking, as there's a preset expectation of what people want, such as with the image of tosemite in Figure 10. For instance, if you're taking a photo of a puppy for a calendar, then your audience is probably people who want to see the whole puppy (perhaps in an unusual pose or doing something that most haven't seen a puppy do before so that it's not just another puppy photo) and not just one of the puppy's eyes or a shot of the puppy's fur. In this case, just set out to tell a great story with your shot, one that gives your audience exactly what they want. The ideas discussed previously about the right visual intensity still apply.

The first approach to finding a story is to think about the scene. Try asking an introspective question—what does the scene say to you? Conversely, if you have a story in mind, ask yourself about the type of scene you want to find to convey that story. Sometimes you'll have a clear answer, which helps set you on the path for determining the story (and visual intensity) you want in the image. Other times, we need to dig deeper.

In the previous section, we discussed memory and association a bit. One theory for how our brain organizes concepts involves neural networks and connections between concepts. The more often we experience something with similar connections, the more reinforced those connections become in our mind. For example, Americans often have pumpkin pie around the Thanksgiving holiday, and we see many images on television and in the movies of people having pumpkin pie for Thanksgiving. Because this connection between pie and Thanksgiving is rein-forced over and over, we automatically associate the

FIGURE 11 Early in the morning, this Canadian mountain lake was very calm, almost waiting for people to come enjoy it. To convey a sense of serenity and place, I found these canoes lined up. We know that canoeing is a sport, so there's a sense of anticipation seeing them waiting to be used, and because there are so many canoes, we can infer that a lot of people will be active in this lake. The reflection on the still water and blue colors add a sense of serenity, and the red in the canoes adds visual intensity. The overall intensity is lower, though, as this image has a calm story.

two, even if only one of them is present. We can use these associations to help determine the stories we want to tell. Here's how to do this yourself:

1. Look at a scene and write down a few keywords that come to mind. It's fine if some of them are literal words for the subject and others are more abstract ideas.

2. Each word from step one is now going to be a primary word. Look at each primary word and think about what words you associate with it.

3. Try taking the secondary words from step two and go into even more detail, finding more associated words for each one.

This approach mixes two techniques, called word association and word clustering, to help inspire you. Chances are that, as you were coming up with words in step three, you were thinking about various shots you could take to tell the right story. Some will need images with higher visual intensity, especially if you had more active words like "exciting," and others will need images with lower visual intensity, if you had words like "serene," for example.

You can use this approach in two ways. The first is when you're struggling to think of what to shoot before going to a location. Use this to help pre-visualize the type of shots you want to take to create the stories you want to tell. For example, if you knew you were taking a photography trip to Hawaii, what images might you want to take (this can also help you pack for a trip if you have a lot of gear)?

Second, when you're on location and have framed up a shot, you can also use this technique to make sure the shot is telling the story you want to tell. Use this technique while focusing on the framed image, such as with the word cluster and image in Figure 12, rather than looking at a scene in general or thinking about an abstract concept. If the words you end up with on your word cluster match the story you're trying to tell, then you have the right shot. If not, think about how they vary and how you can change your frame to adjust the concept.

Another aspect of your shot to think about is its semiotics. Semiotics is the study of signs and communication. Signs are a way of referencing something, whether an actual object or a general concept, that may or may not be in the photo, like the llama in Figure 13. They're a common way of quickly adding concepts to a story (e.g., a sign in a foreign language can help give a sense of place). Since these concepts can affect the visual intensity of your story, you need to be aware of what signs might be in your shot.

Charles Peirce was a philosopher, logician, and mathematician who studied signs extensively. He came up with the idea that there are three primary types of signs, which we can apply to photography. The first is that a sign can be an icon, such as an icon of a deer on a "deer crossing" sign. These icons are as close as possible to the prototype we have for the object and provide a very simple visual reference to it.

The second way a sign can reference an object is with an actual connection. For example, if we see smoke coming from a structure, we know there's fire inside the building, even if we can't see the fire in the image. The sign of smoke literally adds fire to our story for this image.

Finally, a sign can be a symbol for an image. For example, if we see a Ferrari logo in the image, we automatically think about fast, stylish cars with loud engines, even if there isn't a car in the shot.

An object in a frame can be both a literal object and a sign (or metaphor) for a different object. A snake in an image can be both a snake and a reference to the story of Adam, Eve, and original sin. This type of dual meaning is common in advertising photography, when advertisers want you to associate complex ideas with their product through a single image.

While signs are great because they can be simple ways to express very complex ideas in an image, they also create problems because people can read something as a sign that wasn't intended that way. As such, do be aware of everything in your frame and the meanings it can create!

(A)

(B)

Vastness

Iceland Icebergs

Serenity

Midnight sun
Endless horizons
Constant flow
Unbounded frame

Repetition of waves
Silky and smooth
Warmth
Calm action

Change

Melting ice
Caving glacier
Cold physical conditions/
 warm tones
Endings
Fleeting image
Rocks covered by smooth
 water

FIGURE 12 An image of icebergs on a beach in Iceland (A) and sample word cluster (B).

FIGURE 13 Many people find this image funny because it contains a reference to an object, a llama, as well as the llama itself in a similar pose to the icon on the street sign.

FIGURE 14 Cars are such a part of American culture that, even if we don't recognize the specific symbol, we probably recognize that this is a hood ornament; and from the style, which we're exposed to in many movies and television shows, we can infer that it is a classic 1950s or 1960s car (it's from a

VINTAGE FILTERS

Recently, there has been a trend in digital photography for adding vintage filters to images. This is especially popular with smartphone images. We believe there are two reasons for the popularity of these filters. The first is that we as a society find images with a picturesque quality, defined during the Romantic era as being sublime and beautiful, appealing. In fact, in the late eighteenth century tourists and artists carried around a Claude glass, a small, dark-tinted, convex mirror. Rather than look at a scene directly, they would look at its reflection in the Claude glass since it made the image more picturesque.

Vintage filters help create a picturesque quality as well, simplifying the color and tonal range of the scene (which can help the subject stand out) and giving it a more painterly feel. This can also enhance an image's visual intensity (images with too much visual intensity get simplified by having their components simplified and images with too little become more interesting due to the color tint and texture).

The second reason is that digital images are very ephemeral. There's no physical cost to creating them, and they're easy to delete. Relying on our past experience we know that as film fades, it achieves a certain look. By applying that look to a new image, it makes the image seem older and more substantial, as if it were actually a film image taken years ago that we've digitized. Vintage filters help add weight and a sense of history to an image's story. Since many of the images we take with our smartphones are of more common subjects that automatically have less visual intensity, adding this weight helps boost the image's visual intensity.

We don't recommend using vintage filters for every photo, but sometimes that look does help achieve the visual intensity you need for the image and story you're creating!

Fortunately, especially with the digital darkroom, it's easy to add, remove, and replace the signs in an image, as we will discuss in Chapters Ten and Eleven.

Pre-Visualizing and Finding Images

Photographs tend to fall into two categories: ones we pre-visualize and ones we find while shooting. Finding images while shooting can be quite challenging, especially if the subject is moving quickly, and it takes lots of practice to be able to quickly frame a compelling thought with the right visual intensity. Some of the exercises from previous chapters, such as learning what your lenses do (Chapter Five) and the effects that different types of light create in an image (Chapter Six) help you become a faster photographer. Practicing pre-visualizing shots will also help you become faster at finding shots, as it'll give you a mental arsenal of what you like and don't like in an image.

The amount of pre-visualization photographers do can vary significantly. When we travel to a location, we often have one or two images in mind that we want to try and achieve. Those goals can come from something concrete, such as having been to the location before and having not quite gotten the shot we wanted, or from something abstract, such as an expectation for the location. Looking at images online will help you pre-visualize in a concrete way. Be careful that it doesn't bias you into thinking that these images are the only types of images you can shoot of a scene—find your own shots and don't just copy someone else's! Techniques like word clustering will help you pre-visualize in an abstract way.

When you get to your shooting location, a technique that works quite well is to imagine that the scene is a big stage, waiting for actors and lighting. Find a spot that you like a lot for the set design (and you might need to do your own set design, moving objects around). Then, determine who your actors are going to be. Are they the bride and groom at a wedding? A flock of birds flying through the stage? Last, determine the lighting you want for your stage. Sometimes you'll need to wait for the right time of day to get the shot you

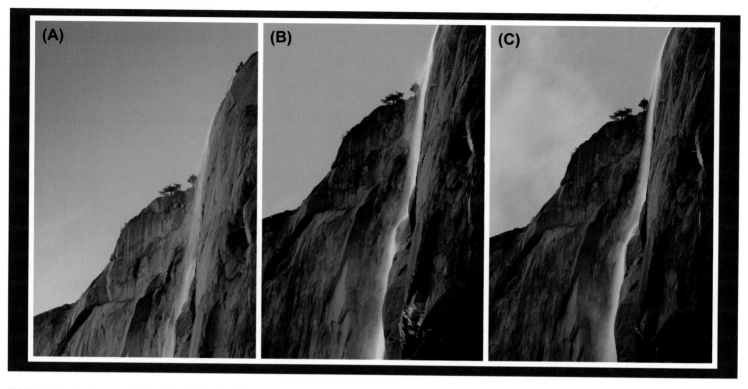

FIGURE 15 This is a shot of the "firefall," a backlit, seasonal waterfall called Horsetail Fall in Yosemite Valley, that happens in February some years, when there's enough snow. We set up a frame we liked (A) upon imagining what the light was going to do, waited for the right light and adjusted our frame a tiny bit once we saw the actual light (B), and then waited for a cloud to come into the frame to add some texture and visual intensity to the sky (C).

want, or if you're in a controlled situation you can set up your strobes to get the look you want. When all the pieces come together, press the button. Figure 15 is an example of this style of pre-visualization with a landscape image.

It's very easy to practice pre-visualization with street photography, as Figure 16 demonstrates. Go wander around, find a setting that you like, and wait for the right light and actors to show up. You could even ask someone to move or stand a particular way if you really want to direct your actor, although sometimes candid shots are more compelling because people automatically pose if they're aware of the camera and look stiff. If you find this freedom to shoot anything too

overwhelming, try creating a plan of a specific thing you're going to try and find before you go out shooting, such as we have you do in this chapter's exercises.

Of course, as you pre-visualize, think about how much visual intensity your image will need and how to create it. If you're creating a depressing, sad scene, you'll want less visual intensity than in a happy image. Think about the pre-existing knowledge of the subject that your viewer will have, and also think about the secondary emotional aspects of each component that we've talked about previously in this book. A sad image will read more clearly as "sad" if it has a lot of blue rather than yellow, for example. However, not all sad images

FIGURE 16 While walking around Chinatown, we found this garage door with graffiti and saw the bags on the ground. We knew that someone would come by to grab the bags at some point, and the pink bag made us decide to stop and see what type of person would show up. A young Asian woman with distinctive white iPod headphones and an "I love San Francisco" sweatshirt came to watch her bags (A). The juxtaposition of the graffiti, headphones, sweatshirt, and girl created a scene that really expresses San Francisco's unique culture. With our "actress" in place, we took a variety of shots, not knowing how long she would stay there and how long cars would stay clear of the shot (B, C, D, E). Because we were shooting in between a car on the street and a trash can, we were limited in how much we could move. Furthermore, there was a man standing to screen right, and adding him in (F) changed the shot from a story about the girl, which we wanted to tell, to a story about the relationship between the girl and the man (also interesting as a young-and-old story, but not what we were shooting). A minute later, she picked up her bags and left.

will have low visual intensity. For example, images of the Post-It notes left on Apple store windows after Steve Jobs's death are sad for many people, but these images have higher visual intensity because of how powerful the subject was.

Over time, try delaying your pre-visualization for a shot until you see the setting, lighting, and acting that appeal to you, so that you have to focus more on shooting than planning. Then start visualizing shots and figure out where you need to move and what you need to do to achieve them. This will force you

both to be faster as a photographer and to work the subject, taking multiple different shots of the same subject to find the story you're trying to tell, as we discuss in Chapter Nine.

The Decisive Moment

Henri Cartier-Bresson was a famous French photographer who helped define the street photography style and is considered to be a master of the candid. The English title for one of his books of images, *Images à la Sauvette*, was *The Decisive Moment*, a title created by his publisher.

"The decisive moment" has taken on its own life as a concept, based on what Cartier-Bresson told a *Washington Post* reporter in 1957:

> Photography is not like painting. . . . There is a creative fraction of a second where you are taking a picture. Your eye must see a composition or an expression that life itself offers you, and you must know with intuition when to click the camera. That is the moment that the photographer is creative. . . . Oop! The moment! Once you miss it, it is gone forever.

The decisive moment represents the point when everything in an image comes together to show the story you're trying to tell. It might be when the child playing with a toy looks right at the camera or when the baseball player hits the ball. As you frame a shot, you need to be aware of what the decisive moment will be for the story you're creating.

With slower film cameras, it could be challenging to wait for the decisive moment to press your shutter button, as sometimes they happened so fast they were easily missable. Fortunately with digital cameras and the ever-increasing frame rates these cameras let you shoot at, it's much easier (and less expensive) to capture the decisive moment. Find out how many pictures you can take in a row if you hold your finger on the shutter button and how long it takes your camera to capture those shots (e.g., maybe your camera can capture six frames per second for five seconds before it pauses to write to the card). Then, when you feel the subject's close to the decisive moment, if you're worried about missing it, press the shutter and keep holding it down until after the moment has passed. Figure 17 shows why there's nothing wrong with taking more than one shot and using your motor drive, since it will help you get the shot you want!

SETTINGS FOR STORYTELLING

In Chapter Nine we discuss in greater depth using all aspects of visual intensity in the field to create compelling images, but this section will cover some specific settings as they relate to visual storytelling.

One of the easiest elements to think about is where you focus. We automatically assume that the sharpest part of the image is the subject. If you focus on something that's not the subject, and your subject's out of focus, then it will be harder if not impossible for the viewer to understand what you're trying to convey.

Related to focus is your depth of field, demonstrated in Figure 18. If you shoot with a small aperture (f/16, f/22) and have a lot of the image in focus, then there will be more potential subjects and parts of the frame that contribute to the story. If you have a large aperture, then the soft background will only contribute to the image based on its components (e.g., how the colors influence the emotion of the image). If you have a mid-range aperture (f/8, f/11), then while some of the background will blur out and only contribute via its colors, pay close attention to the part that's just slightly blurry. If the viewer is still able to identify objects there (and faces are easy to identify), these items will contribute to the story—though since they're blurred the viewer will perceive them as less important.

A specific focus point and limited depth of field might not be a storytelling tool for too much longer, though. A company named Lytro has developed what's called a lightfield camera which captures the rays of light themselves rather than red, green, and blue values at different pixels. This new type of camera lets a viewer focus a picture after it has been shot. This enables you to capture a decisive moment faster, since you don't have to focus, but it makes it so that a viewer can re-focus on anything he chooses in the photo. You really have to be aware of what's in your frame with these cameras!

Shutter speed also has an effect. A slow shutter speed like in Figure 19 can imply motion in a frame because moving objects become streaks (motion blurred). In addition to the visual intensity component this creates, as discussed in Chapter Three, the length of these streaks can convey how quickly objects are moving, and fast motion can create a more intense

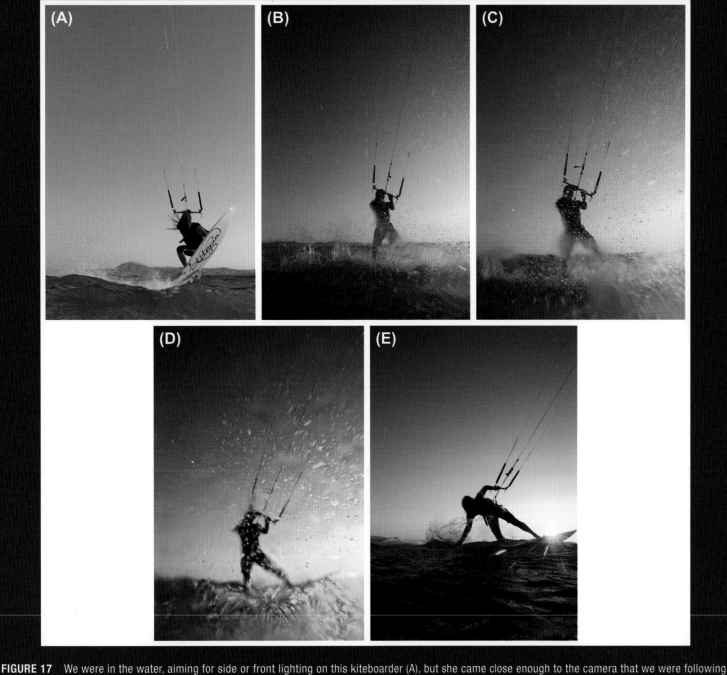

FIGURE 17 We were in the water, aiming for side or front lighting on this kiteboarder (A), but she came close enough to the camera that we were following her just to see what happened. The sunset lighting was actually fairly pretty, and it created an interesting silhouette (B). The spray from the surfboard's wake created a very neat image and sprinkled the lens (C), and we kept pressing the shutter button, waiting for the decisive moment (D). Trying to recreate this shot later (E) didn't lead to such good results as this singular, unintended moment.

FIGURE 18 In the first image (A), we used a very wide aperture to completely blur the background out. The second image (B) has a slightly narrower aperture and different focal point, which lets enough of the background come into focus that it draws our attention and becomes part of the image. Perhaps the yellow area is another dandelion, in full bloom.

FIGURE 19 A slower shutter speed, while panning with the birds, lets us see motion in their wings and the sky.

story. However with some subjects, such as running water, the streaks might be smoother and less detailed than if you'd used a fast shutter speed, creating a more peaceful image. Our prior knowledge also comes into play, as we perceive running water as peaceful and a fast-moving car as exciting.

Conversely, a fast shutter speed such as in Figure 20 can freeze action and capture something unusual that our eyes typically don't detect, such as how a dog's face distorts when he shakes water off his body. This can create a more visually intense story because it shows something we don't normally see.

Other components, as discussed in previous chapters, also affect our perception of the relationship between parts of the story. For example, if we have a shot of two people, and

person A is much closer to the camera than person B, person A will be much larger in frame than the second person. We automatically assume that person A is more important, such as the monkey in Figure 21. Or if one person is in the light and the other is in shadow, we perceive the person in the light as more important and the person in shadow as less important, perhaps even mysterious and creepy.

The colors and lighting in the image can also affect the overall mood. If you're trying to create a happy image, then a black-and-white, high-key image is less effective than a saturated image taken at golden hour.

Finally, don't forget to look at the basic shapes and lines in the image and use what you learned in Chapter Three to think

FIGURE 20 A faster shutter speed lets us capture the water droplets falling from this whale as it disappears under the water.

FIGURE 21 We perceive the monkey closer to the camera as being more important than the other, smaller monkeys in the distance.

FIGURE 22 This photo of a baby gentoo penguin could be an interesting opening shot. Babies are always cute, there's a lot of depth, and it establishes that this is a story about penguins while giving a different context (a colony instead of the ocean) from the one that appears in the next few shots.

about their relationships and what emotions they create. If it's not what you want, try shifting your position to change your perspective and the perceived shapes and lines!

MULTI-PICTURE STORIES

We've been focusing thus far on single-image visual stories, as that's the most common form of presentation. You see a single printed image in a frame, you look at a single image full-screen on your computer, and so on. However, multi-picture stories, where you have space for more than one image and perhaps even some text, can help you create a more compelling and complete picture. Since it's so easy to create your own blog with multiple images or to show multiple

images with slideshows and digital photo frames, multi-image stories are becoming more common. Multi-picture stories are also how images are typically laid out in newspapers and magazines, whether it's *National Geographic* or *Life*.

Rather than trying to show everything happening in an environment in a multi-picture story, there are a few key image types—images that tell specific stories—that you'll want to look for.

Typically, you'll want an opening shot like Figure 22 that captures the viewer's attention. This will be an image with more visual intensity and a clear, strong emotion. This shot might not explain the broader context and is really more about engaging the viewer. It's the hook to your story, somewhat like the first five minutes of a movie or first five pages of a book.

FIGURE 23 By using a low camera angle, the waves appear much bigger than the penguins, creating a visual story about the danger from the water that these penguins face each day. You wonder how the fuzzy, cute baby from Figure 22 will fare in this environment!

Next, find a shot that explains the context of the story. How does it relate to the wider world? For example, if your opening shot is a dramatic shot of a penguin, is the penguin by itself or part of a group of penguins? Is there a particular theme you want to portray in the story? This context shot can be a good place to show that theme. Ask yourself how Figures 23 and 22 interact when you look at them next to each other.

Shots that show relationships between images can help connect pieces of the story, such as with Figure 24.

Continuing our penguin story, adding in a shot of a penguin's predator, especially if there's a supporting caption or paragraph, creates a hero/villain relationship in the story.

Showing the experience of your story's protagonist (Figure 25) is also useful, as these will be the shots you pick from to create the body of your story. What does the penguin go through as he faces the predator? These shots might be wider, of the penguin and its predator, or more focused on the penguin's reaction. One way of approaching these shots is to ask a question visually and then answer it.

Is there something unusual about what you're capturing? Perhaps our penguin has gotten lost and ended up in Rio de Janeiro rather than South Georgia. Showing that context will help keep the viewer interested.

If your story involves an important moment for the subject, especially if it involves change, make sure to show what happened before, during, and after that moment! For instance, imagine a photo essay about a politician. You might pick an image from the campaign, an image of the election victory, and then images that define key points in the politician's career. You would also pick a few images of just the politician, in private, to help make him more sympathetic for the audience. The change from before the election to after it is much more visually interesting than simply pre-election or post-election images.

Lastly, what type of image and impression do you want to leave the viewer with? That feeling should define what you look for in a closing shot such as Figure 26. This shot doesn't always have to be a wide context shot. For example, the last shot in a wedding album might be just the clasped hands of the newly-wed couple featuring their rings, leaving the viewer with a sense of togetherness.

On a final note, if you have the option of using text when you present your images, go for it! Simple captions can help make clear the story you're trying to tell and prevent misinterpretation based on people's past experiences.

FIGURE 24 While we were hoping to get a photo of a predator and penguin together, to show the scale difference, this shot of a sleeping seal was the closest we found (we guarantee that he was breathing and alive, despite how still he looks!).

FIGURE 25 Penguins are awkward on land but graceful in the water. Here's a penguin in its favorite place.

FIGURE 26 This last shot of a penguin in beautiful grass, looking at the viewer, seems peaceful, and the eye line creates an interaction between the penguin and the viewer which would be especially powerful if the last paragraph or caption discussed how the penguin's habitat or food is at risk, for example.

Exercises

1. Pick a color and spend a day photographing things of that color, whether it's around your house, a park, or a city.

2. Pick an emotion and spend a day taking only photographs that convey that emotion. Take advantage of the emotional aspects of each component, as well as past knowledge of a subject.

3. Pick a few images from your photo library or from the authors' websites and try creating word clusters for them. Next, try thinking of a place you might visit and create a word cluster of potential subjects and themes for that place.

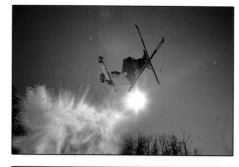

Putting It All Together: Classic Good Images and Visual Intensity

- Art Wolfe — 191
- John Paul Caponigro — 193
- Steve Simon — 195
- Mallory Morrison — 197
- Arthur Morris — 199
- John Ricard — 201
- Lindsay Adler — 203
- Freeman Patterson — 205
- Nevada Wier — 207
- Kirk Paulsen — 209
- Charlotte Lowrie — 211
- Peter Burian — 213
- Clay Blackmore — 215
- Art Becker — 217
- Exercises — 218

Some of the best lessons you can learn are from comparing your work to that of known masters. We'll look at some extraordinary works in this chapter, from fine art to photojournalism and lots in between. All of these images have been generously contributed by photographers who are among the best at their specialties. We'll highlight the visual intensity and energy of each image as it pertains to the elements of composition that we've discussed so far. As we delve into the story that each image conveys, we'll see how the visual principles discussed in the earlier chapters are exploited to help tell the story in each photograph. It's our hope that by spending some time looking at these images and understanding what makes them work so well, you'll be more able to view your own images similarly, noting what works and what doesn't.

ART WOLFE
www.artwolfe.com

Art Wolfe's gorgeous image of salt piles in Bolivia is unique in its dramatic use of triangles, a high energy shape. Not only are the salt piles triangular, the overall pattern of the piles is a triangle. The repetition of the triangular shape creates a sense of depth in the image that adds energy. With so many triangles in the image, it would have been easy for the visual intensity to have become overwhelming but in fact we'd rate the overall energy level of this image as moderate. By locating the salt piles close to the center of the image, the shape energy is tempered slightly by the low level of energy contributed by their placement. Splitting the frame with the horizon so that nearly half the image is taken up by a triangle-free sky also lowers the overall intensity.

Our eyes are attracted to the texture of the salt piles rather than the textureless background and foreground. The remainder of the image lacks any extremes of tonal contrast that might have competed with the salt piles. The overall darker sky helps it to recede even though the colors are more dramatic than those in the foreground. The fact that the salt piles are pale, consisting of very little color, separates them from the background. Their high luminosity makes it clear that the piles, rather than the more colorful water, are the subjects. Since the overall color palette is limited and the colors in the sunset are almost complementary, the energy from the color component is moderately low. This careful balance of the high energy of the salt piles with the low energy of the surrounding elements results in an outstanding image.

JOHN PAUL CAPONIGRO
www.johnpaulcaponigro.com

Abstract images force you to rely on shapes, colors, lines, and textures, as well as your imagination, in order to tell their story. While it's not clear what the subject actually is as an object, it's clear where the subject in the image is in this captivating image by John Paul Caponigro. Even though the texture in the water, created by dramatic luminosity contrast, is somewhat energetic, all of the lines in the image converge to a circular point near the top of the frame, creating a clear figure/ground separation. The background beyond that point has far less texture, luminosity contrast, and energy, even though that part of the image is a bright orange. The decrease in texture adds a sense of depth and dimensionality to the image. The elliptical subject area is so elongated that it's almost a triangle, creating a shape that has the contained feeling of a circle but the energy of a triangle. A strong oblique line leading into the image guides you to that

point, also adding energy. By placing the focal point near the color transition and where our attention naturally goes, John Paul further emphasizes the subject. In addition, by placing the subject closer to the edge of frame, rather than at a rule of thirds point or the center, he has increased the subject's intensity. The amount of orange in the image is perfectly balanced by the amount of its color opponent, blue, in the frame (see Chapter Four), which helps contain the energy from the color components. Limiting the color palette to two colors also prevents the saturated colors from becoming overwhelming. If a full spectrum of intense saturated colors had been used, it's likely that the visual intensity of the image would have been too high—and rather than being a dramatic, striking image, it could have become chaotic. Instead, by carefully controlling which elements have the most energy, a strong, visually compelling abstract image has been created, with a fairly high, but still pleasing level of visual intensity.

STEVE SIMON
www.stevesimonphoto.com

In most images the person largest in the frame and closest to the foreground is the primary subject and must be in focus. However, in this image Steve Simon masterfully creates a dynamic situation in which we first gaze at the out-of-focus child in front, who is the largest figure in the frame, and then at the in-focus older woman farther back. The eye line of the child in front meets and holds the viewer's eye, which adds energy and commands attention, whereas otherwise we would most likely quickly skip over an out-of-focus person even if they are in front. Our eye travels back and forth between the two, which adds a sense of depth and dimension to the image, and then to the third figure, another child, at the back. By carrying our eye between the three figures, we know that the story is about the relationship of the older woman and these two children. The lighter window area behind the front child further serves to direct our attention there, while the woman's lighter-colored clothes also direct our attention to her. The light falling on the corner between them creates the greatest luminosity contrast within the image and is fairly harsh. Its placement adds to the sense that there is tension between them. The oblique lines and brightness of the gold curtains adds both color and luminosity energy to direct attention to the rear child, as does the light falling on his face. The expressions on all their faces tell us that the situation is serious. The overall visual intensity of this image is moderate and the image is quite compelling. However, if the front child had been looking elsewhere, the overall intensity of the image might well have been too low and the image would not have been nearly as successful.

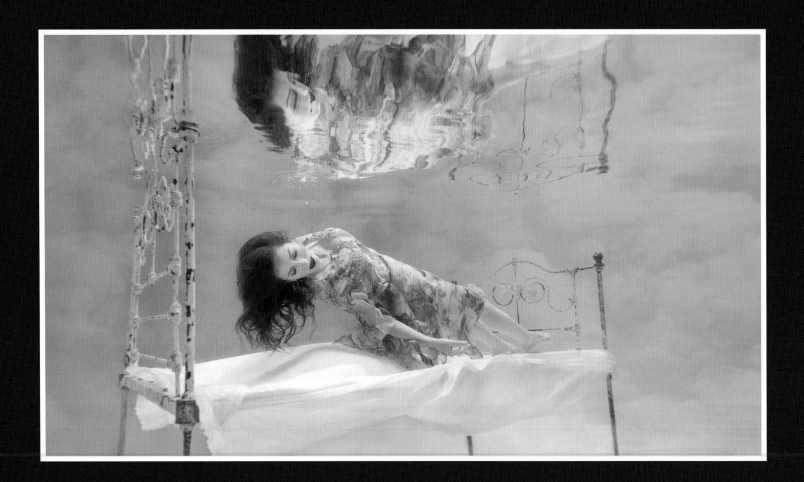

MALLORY MORRISON
www.mallorymorrison.net

Mallory Morrison's image of a woman hovering above a bed presents us with an unexpected subject, one who appears to be floating in mid-air, and as such there is extra energy in the image from the element of surprise and cognitive dissonance. To see a woman suspended horizontally above a bed in apparent defiance of gravity grabs our attention and this is further enhanced by the reflection that draws our attention to the top of the image. We then reconcile her position and the reflection with the fact that she must be underwater, but are faced with more cognitive dissonance because she's wearing a dress. Thus the irony of the subject component contributes considerable energy to this image. Mallory wisely limits some of the other potential components of visual intensity in order to maintain an overall pleasing level of energy. Indeed, most of the lines associated with the bed are horizontal or vertical so they add only limited energy. Further, the subject of the image is contained within the bed and its reflection, creating a smaller, more confined and less energetic subspace. The color palette is also limited and contributes only a small amount of energy. If any of these components contributed more energy to the image, it would have been easy for the visual intensity to have become too high. The woman's position in the lower part of the frame along with her reflection in the top half provides energy from placement as well as from detail and textural contrast. If you imagine the image without the reflection, the visual intensity would be too low. The additional energy from detail and texture in her dress and hair emphasize that she is the main subject by increasing the energy associated with her. Lastly, it's important to the success of this image that the lighting and water movement were carefully controlled so that there were no unintended hot spots from above-water light sources to create distractions and no ripples creating extra lines and shapes that might similarly have resulted in distractions.

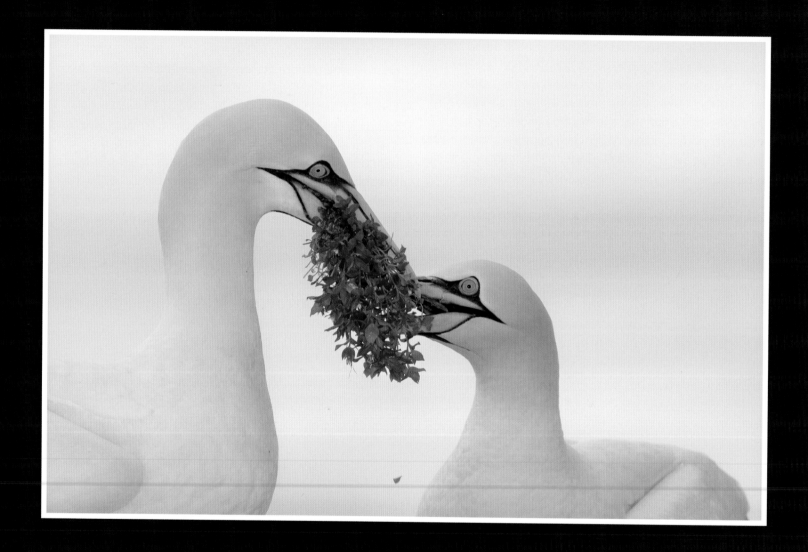

ARTHUR MORRIS
www.birdsasart.com

Arthur Morris's romantic portrayal of a gannet presenting a branch to his mate is an inviting image that evokes a variety of positive feelings in the viewer. In terms of visual intensity, it's in the low–moderate range. When capturing nearly white birds (or any subject) on an almost-white background, there is danger that the image could be too low in intensity to hold the viewer's interest, but clearly that is not the case here. In fact, there are numerous elements that add carefully placed energy, making the image a winner. For example, the gannets' eyes are circular shapes with a smaller contrasting circle in their center, which tend to attract attention (as discussed in Chapter Three) and contribute moderate energy. More importantly, the two birds are positioned so that there is a strong imaginary oblique line between their eyes. In fact, the head angles are slightly tilted so that we can see the gannets gazing at each other. This oblique eye line brings considerable energy to the image. It's further accentuated by the contrasting black areas surrounding the gannet's eyes and on their beaks. This is the only area of the image with strong luminosity contrast and so it adds energy exactly where we need to be looking. Had these been birds with strong designs lower down on their bodies and plainer heads, our eyes may have been slightly less focused on the eye contact. The greenery, which connects the two birds, is the area of strongest color energy, and helps direct us back to the interaction between them. In addition it has the finest detail, which increases the energy in that part of the image. There is a hint of warmth due to the golden tones on the backs of the gannets' heads and this adds to the warm feeling of the image. What many viewers may be less conscious of initially is the importance of the negative space between the two birds, which nearly forms a heart shape. As we mentioned in Chapter Three, our tendency is to complete familiar shapes and so we perceive that area as a heart. The shape completes the image so that we perceive a loving interaction between the two birds. The energy from these components balances the very limited color energy and depth cues, and results in a very successful image.

JOHN RICARD
www.johnricard.com

When John Ricard sets out to create a portrait of a person, he first spends time deciding how to photograph them in a way that captures what he perceives to be their essence. His portraits are highly individualized images, often in unique settings. For example, in this image he wanted to convey that the subject is a writer. John views writers as fairly lonely individuals and wanted to convey that. When we first look at the image, it seems to be moderately high in visual intensity. There's a lot of luminosity contrast, and the foreground is separate from the background, where there seems to be a lot of people. As we look more carefully, we notice that the subject is placed off center in a place with a moderate amount of energy. The light is illuminating his face and neck, helping separate him from the black wall and giving him some energy. However, he's looking through the windows, apparently at the other people, who seem to be in groups, and he's visually separated from them by the various walls and shapes in the image. He's on the outside of the activity. We follow his eye line and are aware that he's alone, whereas others are together. John cleverly set up this situation to evoke the feeling of loneliness. We feel the energy in the background and that it is different from the energy of the subject. But we return to the subject because we can see more details and texture in his face and clothing. The red and white oblique lines in the lower left have a moderate amount of energy and point us to the subject. Above we see letters and can identify some of the words. They are at the same spatial depth as the subject, creating a connection to him, but they make no sense to us by themselves. This adds some dissonance, which also adds energy. However, the purpose of placing the subject in the same spatial plane with the words that we don't understand is to subtly communicate that words are a major part of his life and that they may at times separate him from others. By carefully controlling so many details in this image, John Ricard has created a compelling portrait of a writer that communicates far more than the stereotypical head shot.

LINDSAY ADLER
www.lindsayadlerphotography.com

At first glance, analytically it might seem like Lindsay Adler's image has very low visual intensity. She's created a very flat space in which there's almost no depth. By using a frame within a frame, she's restricted the actual image frame to a very narrow, vertical band. And by converting it to black and white, she's eliminated all energy from color. Yet when you look more closely you appreciate the subtle details that she's cleverly included, which add intensity and make the image interesting. For example, the subject is very close to the bottom left edge of frame, giving him an energetic position. The extreme luminosity contrast also adds energy as the image is either very bright or very dark, with few tones in between. However, she has captured these highlight and shadow areas with texture, which again adds energy. Furthermore, the narrow rectangle isn't precisely a rectangle. One of its edges, the one the man's walking toward, is at an oblique angle, creating a strong, unstable line through the image. It feels like the space could expand as the man walks toward it, or perhaps that it will move along with him.

Since his position is active with one foot in the air, we mentally think about walking, which adds intensity to the shot, as opposed to if he were standing on two feet, in a very static pose, appearing to be going nowhere. Here he seems to be in motion and in the spotlight, with a subtle message that he's on the move. Often portrait photographers use a variety of lighting techniques to avoid harsh shadows, but here Lindsay has deliberately created a harsh shadow. This in effect duplicates the man, giving him far more impact. By having him place his hand in his pocket while wearing a shirt sleeve that is massively bunched up above his hand and peeking out of the jacket, we have a sense that, although he might be moving with purpose, he's also fairly casual and relaxed. However, his expression conveys tension and almost defiance as he appears to be looking almost but not quite at the viewer. Because he's looking out of the frame, his eye line creates depth, adding to the overall intensity of the image. By adding energy subtly, Lindsay created a very successful image.

FREEMAN PATTERSON
www.freemanpatterson.com

Sometimes simplicity leads to a sense of elegance, as it does in Freeman Patterson's landscape extraction. At first glance we're not completely sure what we're looking at. We see that it's a series of rather sensuous curves, but is it sand, snow, folds of fabric, or what? When we look closer we see evidence that it's sand. There's very little to give us an indication of the size of these dunes except for evidence of some sand texture in certain places. The sand texture that is visible in scattered areas throughout the image serves to move our eye around, as do the bright white areas where the sun appears to be triking the sand. Primarily the image gets its energy from a series of oblique lines. The fact that these lines are not quite parallel and that they are not evenly spaced increases that energy. Further, on closer observation, these oblique lines create a repeating series of shapes that are nearly triangular, which also contributes energy to the image. Since the lines get closer together as they go higher in the frame, we get a sense of depth, even though there are very few clues to indicate how deep the space actually is. The sand texture that is visible in scattered areas throughout the image serves to

move our eye around, as do the bright white areas where the sun appears to be striking the sand.

Most monochromatic images use the full range of tonal values to take advantage of as much energy as possible from luminosity contrast. But this image uses barely more than half the tonal range, which obviously limits the amount of energy from this contrast. In fact, though, the purity of the white tones in the image is important and adds to the sense of simple elegance while also providing some energy. There is little color energy except for the bluish tone of the shadows, which emotionally creates a sense of peace and perhaps a sense of cold. Given the minimal amount of energy contributed by the color component and the fact that the full range of tonal contrast is not used, it would seem likely that the overall visual intensity of the image would be too low to be interesting. But by leveraging the energy from other sources, Freeman has instead created a very peaceful image, with low–moderate overall visual intensity, which seems like a visual counterpart of the soothing sounds of waves on a beach.

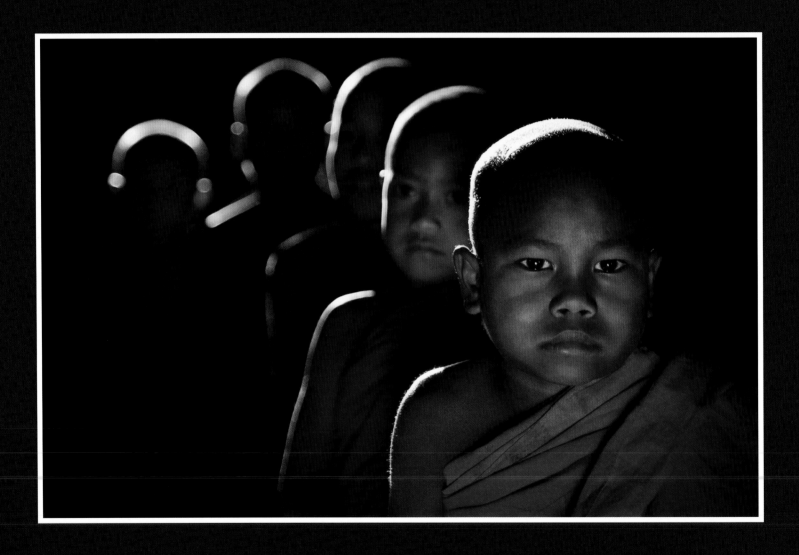

NEVADA WIER
www.nevadawier.com

There is no doubt where your eyes will land when you look at this compelling image. Nevada Wier has masterfully crafted this photograph using limited depth of field and superb lighting techniques. The fact that we can see the first child clearly, and the next one almost clearly, leads our brains to automatically continue the pattern and to interpret the shapes defined by the harsh back/top lighting in the rear of the image as more children. The second-closest child is still a bit dark, not quite in focus and is looking out of the image, away from the viewer. His eye line might lead our eyes briefly out of the image, but because more detail is clearly visible in the front child we continue on to him. There is beautiful warm glowing light on his face, as opposed to the harsh back/top light defining the shape of his head and shoulder. Thus, although the luminosity contrast changes from the rear of the image to the foreground, it's one of the major sources of energy in this image.

The eyes of the front child are inescapably intense. His eyes do not connect to the viewer but instead seem to be locked onto something in the distance or even at another time and place. This eye line extending beyond the image, in addition to the limited depth of field, expands the sense of depth, adding to the visual intensity.

Although the color palette is limited, the warm color cast and reddish robe of the front child also energize the image, as do the details of his face and the texture in the robe. His placement in the right third of the image, rather than a central location, also adds energy. An imaginary line connecting the tops of the children's heads and then their shoulders creates a nearly triangular shape that is resting on a corner, making it unstable and adding energy to the overall image design. Thus, despite the fact that much of the image has little detail and is quite dark, the overall visual intensity of this captivating image is moderate.

KIRK PAULSEN
http://kirkpaulsen.smugmug.com

Images of athletes somersaulting in the air have significant impact and energy simply due to the subject matter. We're not used to seeing people upside down in midair! Therefore, you have to be careful to control the overall visual intensity of these images and not let them get overwhelming. Kirk Paulsen did just that in this well executed image that's far more dramatic than images that are simply the inverted athlete and sky, but nonetheless it stays within a pleasing range of visual intensity. The backlit explosion of snow is visually impressive and leads up to the athlete. Its textured, irregular shape, with distinct bits of snow visible, as well as the overall angle suggest a powerful burst of action that adds significant energy to the image and complements the story told by the skier's position. The extreme luminosity contrast provided by the bright sun leads us right to the skier who is above the sun. Because Kirk stopped down, the sun is rendered as more of a starburst than a circle. This starburst shape is more energetic and points to the skier. Seeing her

above the sun, as well as the tops of distant trees, gives us clues as to how high she is in the air and increases the sense of action.

Fortunately, other components are less energetic, limiting the overall intensity of the image to keep it within a pleasing range. For example, the image has limited depth cues—we can't be sure how far away the trees are and they're the primary source of depth information. The overall color palette in the image is limited to primarily shades of blue, with the only variation being the skier's pants, which are a bluish-red and put slightly more energy on the skier. The vignetting around the edges of the image helps guide the viewer's eyes toward the subject. The skier is nearly centered in the image, a location that inherently has less dynamic energy. In this case it's effective because it helps to balance the other sources of energy, including her position in the air and her crossed skis. Had there been more details—perhaps more ground, more background, and more colors—it's likely that the visual intensity could have become too high. But as-is, it's an image that's as attention getting as the freestyle action!

CHARLOTTE LOWRIE
www.wordsandphotos.com

Images of food are designed to make us salivate and hunger for the food, but many tend to be fairly static. Charlotte Lowrie took a very different approach when creating this tempting photograph. Although strawberries and cream are commonly served together, Charlotte opted to capture the strawberry dropping into the cream. This is something we don't often see. Capturing the action of the berry impacting the cream immediately adds significant energy to the image. Further, she's used a round bowl. This shape, as we discussed in Chapter Three, adds a moderate degree of energy. However, the triangular shape of the strawberry, echoed by the nearly triangular shape of the displaced cream, add even more energy. The strawberry itself is a vivid, saturated red that contrasts dramatically with the white cream, bowl, and background, and adds color energy.

Charlotte has skillfully minimized the energy from other sources to maintain a visually pleasing image. For example, much of the image is white or nearly white and the background itself is pure white. She's controlled the lighting so that there are minimal shadows—just enough to create some depth to establish the shape of the bowl and the height of the splash of the cream. The color palette is extremely limited—in fact less than 10 percent of the image has any color. Similarly, texture and details are visible in less than 25 percent of the image. By limiting these sources of energy, she has maintained the overall visual intensity of the image at a very comfortable level. Because the color, texture, and details are limited to the subject itself, all our attention goes right to the seemingly perfect, tasty berry, as she intended. But by placing that berry almost in the center of the image—a spot which contributes the least energy—she has created a very successful image.

PETER BURIAN
www.peterkburian.com

Photographing events where action happens seemingly everywhere, nearly simultaneously, can be challenging.
To create an image that conveys the story of multiple competitors but which is not chaotic or overly visually intense can be a tall order. Peter Burian successfully does just that in this impressive image of snowmobilers. First, he has positioned himself so that he was able to concentrate on capturing a single rider in the foreground, with other riders farther back and at various positions on both sides of the frame. This helps tell the story of the ride and creates a sense of depth. By slightly limiting the depth of field, the front rider is separated from the others and emphasized, and so is identified as the subject of the image; at the same time, we can clearly see the other competitors as well as gain a sense of the environmental conditions. We can see all the details on the front rider's snowmobile and the tire tread pops out since it contains the most texture contrast in the image. If all the riders and the trees were captured in perfect detail, they would visually compete with each other and we wouldn't know where to look. Partially limiting the depth of field causes the trees in the background to read as a softer texture that our brain glides over, rather than as a detailed forest that competes for attention.

By placing the riders fairly high in the frame, Peter has emphasized the feeling of action and has also captured more snow in the foreground. In fact nearly one-quarter of the image is almost pure white, with little texture and no color, and that helps control the overall visual intensity of the image. It also helps the action to stand out. Interestingly, the rider and his snowmobile together form a triangular shape that is tipped to one side, and there's a larger triangle formed if you draw an imaginary line connecting all the snowmobiles, adding to the energy of the action. This balance of action and simplicity helped Peter create a great shot during a chaotic event.

CLAY BLACKMORE
www.clayblackmore.com

Wedding photographers are faced with the task of repeatedly photographing groups of people in similar situations in ways that don't just result in another stereotypical shot. Creating dramatic, unique images is what separates top wedding photographers such as Clay Blackmore from the masses. In this image which has moderate visual intensity, Clay breaks with convention and has us looking down on the groomsmen. The unique perspective immediately adds interest but runs the risk of making them look small and unimportant. However, spirals are inherently energetic shapes that add a sense of motion, and in the case of stairs spirals can add considerable depth. In this case that depth is emphasized by the converging lines of the pole at the center of the steps carefully placed so that it begins at the bottom of the image and continues on toward the center, pointing to the groomsmen. Additional lines formed by the chains radiate up from the steps and help point to the groomsmen. By their position on a spiral staircase, the groomsmen are contained within a smaller area limiting how much of the image we focus on. Further, the groomsmen are all looking directly at the viewer, which adds even more depth and draws attention to them. By using these various components, Clay has taken advantage of the unusual perspective and ensured that we focus on the groomsmen as the subjects of the image.

Given all this shape energy, it was a smart move for Clay to limit other sources of visual intensity. By using a wide-angle lens from a distance, the groomsmen are rather small. In addition, since much of the photograph is quite light, most of the luminosity contrast is limited to roughly 20 percent of the image taken up by the groomsmen and is used to draw attention to them. In addition, there is very little color in the image. The only clear color is in the small turquoise Tiffany gift boxes scattered on the steps. Because they contain the only color our eye goes to them and they contribute to the story: we know that this is an elegant wedding. In addition, one box has been unwrapped and is closest to the youngest groomsmen, whose expression conveys that he's not so sure about what's going on. That adds a subtle touch of humor to the image. The only other hint of color is that much of the white is actually a warm off-white, which conveys a subtle emotional message of calm warmth, very appropriate for a wedding, without adding too much energy!

ART BECKER
www.artbeckerphoto.com

Sometimes the most effective way to tell a story is to capture only a piece of it and let the viewer deduce the details. Art Becker has cleverly shown us just a small piece of a scene, creating an image with moderately high but still pleasing level of visual intensity. He has honed in on the ends of three trumpets capturing two complete circles and one partial circle. These are shapes with a moderate amount of visual energy. We have the sense that these instruments are part of a performance but the background is sufficiently blurred to provide few cues about depth or location. However, the reflections on the trumpets, particularly the closest one, reveal enough detail to let us know this is a sporting event with a fairly large crowd in attendance. The details are not clear enough to overwhelm the image; instead they supply just enough information to help tell the story. If the photographer had shot the image from the other direction, with the trumpets against the stands, the people in the background would have added too much energy to the image because we would be looking at all the detail and even if he used a limited depth of field, the color and shape contrasts would still draw our attention.

The trumpets form an oblique line that implies movement and brings energy to the image. In addition, Art has framed the scene so that the portion of the performers we see forms a triangle at the left side of the image. This is an energetic shape consistent with the feeling of being part of a performance. Indeed, the trumpets seem to be tipped up as if they are being played and the position of the hand on the front trumpet reinforces that. Although the background is blurred, the luminosity contrast in it forms a series of lines at a contrasting oblique angle that serves to reinforce the impression that the trumpets are tipped upward in motion. The negative background space also forms a triangle. Given the amount of shape energy in this image, Art has wisely limited the energy from texture and detail. Color energy plays a role, given the warm orange color of the background, but limiting the color palette and color details also helps keep the overall intensity of this image with in an effective range.

Exercises

1. Find five images from photographers whose work you admire and analyze them in terms of their overall visual intensity. Then identify as many components as you can that add energy to each image as well as potential sources of energy that may have been minimized in order to moderate the visual intensity.

2. Identify three of your own images that you like and go through the same steps to understand why those images work.

3. Choose three of your own images that you're not happy with, and analyze them the same way. Pay attention to sources that contribute too much or too little energy and be as explicit as you can in identifying why the image doesn't work as well as you'd like. That's the key step in improving your photography! That way, you can improve the shots you take while shooting as well as the way you work with them on the computer.

Creating Images in the Field

- Initial Approach and Choices 222
- First Steps 222
- Choices 227
- More Than One Shot? 248
- Special Tools and Techniques 250
- Exercises 263

So far we've considered many of the individual components of visual intensity that go into making a successful shot, and we've looked at some successful shots, pointing out how they employ the various concepts that were covered. Now it's time to get practical and take all the pieces and focus on putting them together to help you find the best shots in the field. That's what really counts! We're going to suggest a series of steps to take, and questions to ask yourself, to help you make images that have impact.

INITIAL APPROACH AND CHOICES

Sometimes it's difficult to take a bad picture because the environment you're in is so stunning. It seems like no matter where you point your camera you're going to get a great image. That was the case at Fy Geyser, where we created the opening image for this chapter.

In reality, those situations are few and very far between! What we want to focus on are those times when it seems likely there's a shot—indeed, if you walked up with an iPhone, there's a shot you would take—but we want to help you go beyond the handshake of that first impulse shot.

One thing that will help, no matter whether you're a nature photographer, a travel photographer, a pet photographer, a photojournalist, or whatever other type of specialist, is to be as familiar as possible with your subject. The more you know about your subject, the better prepared you will be, so that when the right moment happens, you'll be in position and ready. It's so easy to do a search on the Internet and get at least basic information about places, species behavior, and events, that this should become a routine part of your preparation before you go out shooting. Sometimes there's more in-depth information about locations and events in some of the photography forums. A bonus is that they're interactive, so you can ask specific questions. That way you'll know where to go, what lenses to take and what time of day might be best. Sometimes you'll have a chance to scout out a situation in person ahead of time so that you can plan where to stand, at least initially. Other times you'll want to be shooting as soon as you arrive. But knowing at least some basics about what you're shooting gives you a head start.

FIRST STEPS

Photographic experts are divided as to the first thing to do when you get to a promising location or situation. We know some who insist that you put your camera down, walk around, get familiar with the setting, and take some time before you ever pick up your camera. That usually doesn't work for us. (The one exception would be when arriving at a location to photograph people. Then it's often helpful to remember your manners. Be gracious enough to first talk with the people and help them understand why you're pointing your camera at them. This will give you time to get a sense for who is willing to be photographed and who is not, as well as to understand a little about their culture and activities. You may miss some initial candid shots, but people are likely to be more cooperative and may create opportunities that never would have existed otherwise.)

Our usual approach is to have a camera ready when we first get to a location and follow our instinct to photograph whatever it is that we first saw, particularly if the light is good. All too often a moment is fleeting and doesn't exist for long, whether because the light changes or because the subject changes in some way. We take that first shot to capture what caught our eye and make sure that we don't miss it. Sometimes it's a winner. Other times it winds up looking like a snapshot. But for us, we have to take that shot. Otherwise, it keeps intruding in our thought process like a refrain from a piece of music that you can't get out of your mind. The mistake is to think that you're done after taking that shot. In fact, you've only just begun!

We took the close-up shot in Figure 1 when we first arrived in Tuscany, excited at the prospect of spending several days photographing this beautiful field of poppies. We were so excited that we hardly knew where to begin, and so we took the close-up shot we'd been thinking about. The next morning, to our horror, we watched as a tractor plowed them under. You can imagine how much we wished that we had taken more shots of the whole field!

After you take that first shot, the next step is to connect with the situation. Take a breath and look around. What sounds do you hear? Are there sounds of traffic and sirens, or birds, or leaves or crickets, or children playing, or is there silence? Rarely are we in silent places even though often we may not be aware of "background sounds." What do you feel on your skin? Is it cold, hot, windy, dry, or damp? What do you smell? Are there scents of woods or flowers or pollution or what?

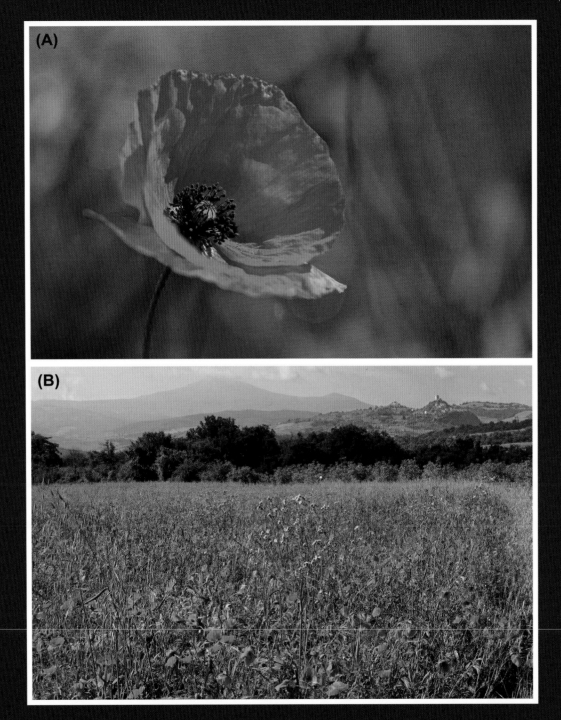

FIGURE 1 When you see a shot, don't assume it will be there another day. You never know what may happen. (A) Close-up shot. (B) Field of poppies in Tuscany.

FIGURE 2 We went down to the beach hoping for a spectacular sunset that didn't materialize, but because we tuned in to what else was going on, we captured a fun shot of a mother playing with her young child.

Did you notice that we didn't yet mention what you see? That was deliberate! Because the point is to slow down and immerse yourself in the situation. Sometimes this takes a minute or two, sometimes it takes much longer. But letting yourself clear out other thoughts and tune into your various senses will enable you to more fully be aware of what's around you and help open up the world of photographic possibilities. Too often we take a shot that's similar to one we've seen and/or expect to see and miss other magical shots because we're in such a hurry to move along with our busy lives. Slowing down will enable you to discover things you might not see at first. That's how we happened to capture the whimsical shot of the mother and child at the beach in Figure 2 even though we had initially hoped for a dramatic sunset.

Now it's time to look and *think* about what it was that caught your eye. What are you trying to photograph? The more specifically you can identify what it is that captured your attention, the better the image you're likely to make! You may think that the subject is obvious. And sometimes it is. For example, you might say that you're trying to photograph a bird catching a fish such as in Figure 3. The bird is obviously the main subject. But some element of the fish must be there too, whether it's diving for the fish, the fish in its beak, or the fish in the process of being swallowed. If you continue thinking about what you reacted to in the situation, you might realize that you are intrigued by the size of the fish relative to the bird, or the light playing on the bird, or other birds trying to steal the fish, and so forth.

FIGURE 3 We were captivated by the size of the fish this heron caught and hoped he would try to swallow it in front of us. Unfortunately, he turned and walked off with his prize!

Similarly, you might be tempted to photograph a scenic location. Your first thought might be that it's pretty. You need to force yourself to dig a little deeper to determine what grabbed your attention. Is it the colors, the play of the light, the shapes, the detail that makes it seem like you can see forever, the mood, the serenity, or something else? When you figure that out, you know what it is that you need to emphasize and can then make choices accordingly.

Walk around the subject (when appropriate) to determine where to stand. Consider getting higher or lower, as we did for Figure 4. Some people find it helpful to look through the camera without using a tripod to see the view they want. We rarely do that because it can be difficult to recreate the exact position after you attach the camera to the tripod. We walk around the subject first to get a preliminary sense of potential shots, and then we get set up with our gear. Sometimes we do this looking through the camera with a particular lens, but in that case the camera is loosely mounted on a ballhead on our tripods. That way it's very easy to fluidly move the camera. When we find a shot, it's easy to tighten the controls on the ballhead and we're ready to go. For example, in Figure 4 the first shot captures the triangular pattern of the orange poppies and the openness of the area. The cloud formation seems to mirror the poppy formation. By getting lower with the wide-angle lens, we increased the energy associated with the poppies but lost a little of the sense of the overall location. Both shots work but convey different aspects of the scene.

FIGURE 4 We used a wide-angle lens to capture (A) and (B), but by getting down to ground level for (B), we created images that convey different aspects of the scene.

Once you clearly identify what caught your attention and where to stand, you still have a lot of choices to make in order to create an image that captures what you're seeing and feeling. If it were simply a matter of capturing just what you were seeing, it might be a lot easier, because you could just leave your camera on some version of a P (program) setting that would make a best guess of settings and shoot for you. Once you add the goal of capturing what you're experiencing in that moment, in addition to what you're seeing, it becomes imperative that you make at least some of those choices yourself. You can't simply rely on a best-guess pre-programmed setting included in the camera that was developed using nice snapshots with some characteristics similar to the scene in front of you. You have a lot of decisions to make, and those choices will come together to determine the impact and message of your image.

CHOICES

1. Choose a Lens/Focal Length

In Chapter Five we considered how the different lenses portray the same subject differently due to differences in the field of view and apparent depth in the image. Now is the time to put that knowledge into action. If you want to replicate a scene similarly to the way you see it with your eyes, you'll want to use a lens with a focal length that's close to 55 mm, for a full-frame 35-mm sensor. (With sensors that have a multiplication factor, you'll need to be wider, and for medium format cameras you'll need to be a little longer.) But often we turn our heads quickly and take in more of a scene, mentally merging the views, so that our mental concept of the scene before us is more of a wide angle. Similarly, you may be visually honing in on a particular part of the scene and ignoring the remainder of what's in your field of view. In that case, mentally you're using a telephoto lens! Ask yourself whether you want to show the context of the subject, in which case you'll lean toward a wide angle, or whether you want to isolate a particular detail, in which case you might at least start with a longer telephoto lens. Your lens choice will also be affected by how close you can physically get to your subject. Keep in mind that in many situations, a wider lens creates more visual intensity right off

the bat. In Figure 5, we convey the beauty of the overall surroundings with a wide-angle lens, but use a telephoto lens to capture the drama of a single crane in flight.

With practice you'll recognize what focal length will translate to the view you're mentally capturing, but initially you may have to make a guess and look through the viewfinder. That's one reason that zoom lenses are so popular—you zoom until the image in the viewfinder is in sync with the one in your mind! Sometimes you may realize you've selected the wrong lens. Although you may be able to work with that "wrong" lens, if your initial vision for the shot is different, we recommend changing the lens to match the image in your mind. Later you may try that "wrong" lens again and come up with an image you like even better, but initially, if you have something in mind, follow it through.

Having said that, we admit that there are times when serendipity strikes, and when we look through the viewfinder with the "wrong" lens, it becomes the "right" lens as we are struck by a slightly different rendition of the image. If you go "Wow!" when you look through the viewfinder, by all means stick with it! But if your reaction is "Oops, that's not what I had in mind," then change the lens.

2. Think Carefully About the Composition

You need to consider how large you want the subject to be in the frame. It's not a given that everything will be small with a wide-angle lens or large with a telephoto. Your distance from the subject is also a key factor. The subject may be quite large and dominant if you're quite close to it with a wide angle and much smaller if you're farther away. The same thing holds no matter what focal length you use. Part of this decision has to do with the role you want the background to play. Sometimes the background plays a more important role than at others. Sometimes it's important to include the subject in the context of its surroundings in order to tell the story, while other times the background needs to just provide support for the subject without calling any attention to itself. Thinking about the role of the background will help you determine how much of the frame to fill with the subject.

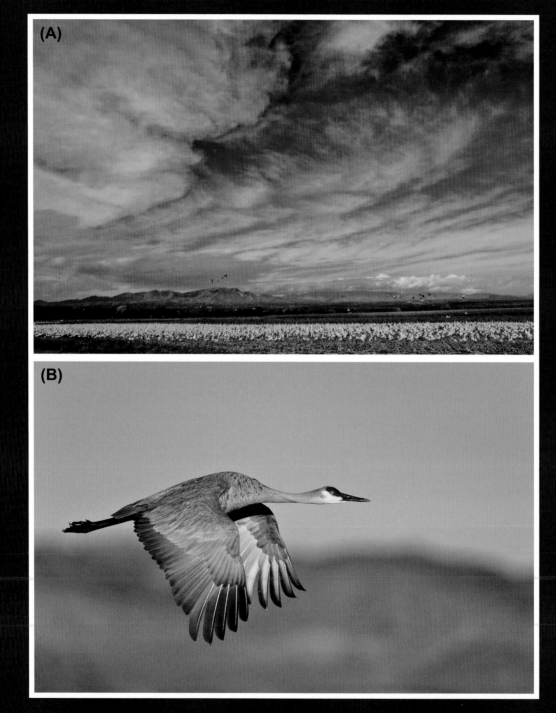

FIGURE 5 (A) The wide-angle lens conveys the environment and has a high degree of visual intensity due to the amount of detail and subject matter included, whereas (B) the telephoto shot gets its energy from the detail within the specific subject and the lighting on it, while the background consists of only vague shapes and colors.

FIGURE 6 (A) The egret needs no additional energy from placement so it can be centered, whereas (B) the trees benefit from the additional energy due to being placed off center to draw attention to them.

Next, you'll need to make an active choice about where to place the main subject in your image. Recall from Chapter Five that certain positions are more energetic than others. If the subject is large in the frame and the background unimportant, you may want to center it, or put it close to center. Doing so will limit the visual intensity from the position, but if there is a lot of detail, texture, or other sources of energy in your subject, that may be exactly what the image needs. With a small subject, chances are you'll need to place it closer to an edge.

Figure 6 shows two different subject placements. The egret is large in the frame and centered because the visual intensity comes primarily from the feather detail, shapes, and luminosity contrast. We placed the trees in the other image far off center to add importance and energy to them, since they are small.

In addition, the oblique lines of the snow-covered hill lead to the trees and they are framed by the end of the shadow area—all of which adds energy to the trees.

Similarly, if there is a horizon in your image, you need to think about where to place it. If the image is primarily foreground with just a thin band of sky, you're communicating that the sky plays only a small supporting role and what's important is the foreground. That will feel different than if you include no sky at all, which focuses attention on particular elements in the foreground as the subject, and other elements become background.

If you place the horizon near the bottom of the image, you're drawing attention to the sky. If you place the horizon in the middle, you're saying that the sky and foreground are equally

(A)

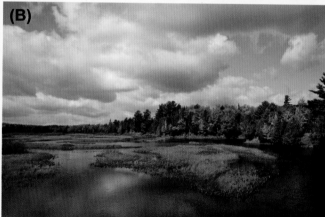

(B)

(C)

FIGURE 7 Placing the horizon at different levels causes us to look at different aspects of the image.

important. That works in the case of some reflections, although sometimes even with reflections an off-center horizon may work well.

In the series of images in Figure 7, we changed the horizon placement to enable you to compare the results. Although we think the version with the high horizon works, we also like the centered horizon. In the first version, the viewer's eyes goes go to the land, which has more visual intensity by virtue of its placement near an edge. The final version, also off center but with the horizon near the bottom, emphasizes the sky and the land no longer looks nearly as interesting. When the horizon is in the middle we look at both the sky and the land. Since the shape of the clouds seems to almost mirror the shape of the land, and there is interest within the clouds, this composition is also successful.

Horizon placement is important whether you're shooting a shot of a landscape or you're shooting a particular subject outdoors. You can control the placement of the horizon by your position and/or the camera angle at which you're shooting. Even if you opt to shoot wide open so that the background becomes a blur, changing your position may make the difference between the background being an out-of-focus texture that's semi-identifiable and its being a blue sky. And that can alter the energy level of the background significantly, perhaps changing it from distracting to complementary.

Tilting the camera up or down, as opposed to just raising or lowering it, can change not only the horizon placement but may also add a sense of depth. Depth added by tilting the camera increases the visual intensity of the image. In Figure 8, we tilted the camera toward the ground to exaggerate the sand patterns. This dramatically increased the visual intensity and sense of depth in the image.

FIGURE 8 The illusion of depth in this image is a major component of its visual intensity.

3. Decide on the Depth of Field

Do you want everything seemingly in focus or do you want to direct the viewer to a specific subject or area of the image? Images with selective focus—those with very limited depth of field—create something that looks very different from what we see with our eyes. We see most things, from moderately near to moderately far, in reasonably sharp detail, with items that are either very near or very far blurring somewhat. So when we see an image that is mostly blurred with a very defined area that's in focus, we tend to concentrate on the area that's in focus. That area becomes the figure. The out-of-focus areas (the ground) then contribute to a mood, such as mysterious, soft, peaceful, isolating, and so forth. While selective focus may decrease the visual intensity of the image due to less texture/detail contrast, often this is balanced by the fact that what we see is different

from what we initially expect. We have to use our imaginations to determine what those blurred shapes and colors might be, and that engages us with the image. That engagement means that the visual intensity has been maintained at a pleasing level. Of course there are also instances where the visual intensity would be far too high if everything were in focus, so using selective focus to reduce overall visual intensity is important. Use depth of field to control both where the viewer looks as well as the energy contributed by the background.

In Figure 9, the very limited depth of field in the flower forces us to notice the details that are in sharp focus and similarly enables the owl to separate from the background. With more depth of field, the owl would blend in with the background and the entire image would be too visually intense. We shot those wide open. With the swan, we wanted to retain some sense of

9 Shooting wide open can help separate the subject from the background (A) or help direct you where to look (B). In (C), we stooped down some serve of background but deliberately left it out of focus so as not to compete with the main subject—the swan.

FIGURE 10 Using a very small aperture for maximum depth of field increased the energy and impact of this image.

the background to provide a sense of place, but also wanted it to be out of focus enough to avoid competing with the subject, so we stopped down slightly to f/8.

On the other hand, you might be struck by all the details of the scene before you and want to capture as much as you can. In fact, we are often quite captivated by images that show us everything in minute detail from foreground to background. That was some of the appeal of using large format cameras for landscape photography—the resulting images actually had more detail than we were aware of when in the same location. If you have a chance to view an Ansel Adams image such as *Tenaya Creek, Spring Rain*, the longer you look at it, the more you see individual leaves and other such details.

Today's high-resolution, digital-medium format images come close to that amount of detail, and 35-mm DSLRs can capture

truly impressive amounts of detail. The image shown in Figure 10 has minute detail visible throughout the image, which increases its visual intensity. Had we used a shallower depth of field so that the distant buildings gradually blurred away, there would be less visual intensity.

As discussed in Chapter Five, if you want to render nearly everything sharp in an image you'll need to choose a small aperture for maximum depth of field, and then set your focus at the hyperfocal distance.

The risk when using maximum depth of field and hyperfocal distance is that the image may feel chaotic and overly busy. In other words, it may become too visually intense. In some cases, it may be difficult to distinguish the subject from the background. In fact, typically you'll want to use this approach only when your subject is the entire scene in front of you. You

won't normally want to use maximum depth of field with a portrait, for example.

There was an old adage that basically said to take good images, use f/8 and be there. We certainly agree with the being there part! But use the moderate aperture settings carefully and with deliberate thought. How much depth of field do you need to render the subject sharp, but the background softer to help the subject stand out? The answer will depend both on how far away you are from the subject and on the focal length of the lens you've selected.

Rather than try to memorize a set of rules, many cameras have a depth-of-field preview button. Use this button to see the effect of the aperture setting you've selected. When you initially look through the viewfinder of an SLR camera or at the liquid crystal display (LCD) on most cameras, the image you see is with the aperture wide open. That's to let as much light in as possible to make it easier for you to compose and focus the image. But it can be misleading when you're shooting using smaller apertures. When you use the depth-of-field preview button, the image in the viewfinder on an SLR will get noticeably darker unless you're shooting wide open. That's because the amount of light getting to the viewfinder is now reduced due to the smaller aperture. After your eyes get used to the decrease in light in the viewfinder, you'll be able to see how much of the image will be in focus using that particular aperture. You'll be able to get a feel for the overall energy level of the image. That way you will know if you need to increase or decrease the aperture. If you have a live view option with your camera as well as a depth-of-field preview button, you'll have the advantage of being able to preview the effect on the image without it getting darker as the aperture decreases. Not all cameras have a depth-of-field preview button, but since it's such a helpful feature, double check your camera manual to be sure. Then, if your camera does have it, take advantage of it!

Alternatively, after you've taken a shot, you can use the LCD to review it, zoom in, and see whether your entire subject area is in focus and whether the background separates and softens as desired.

Sometimes it's difficult to determine the best f-stop based on a small preview, so at times we bracket our apertures, shooting at several apertures. Once on the computer, it's often easy to see which approach is best, but even there the difference between two settings, such as f/2.8 and f/4, may be subtle.

4. Choose the Shutter Speed

Even if you opt to shoot in aperture priority mode most of the time and let the camera choose the shutter speed automatically, you still need to be aware of the shutter speed. And in some cases, notably those involving motion of any kind, you may want to exercise more control over the shutter speed by using shutter priority or manual mode.

With any subject matter you're intending to render sharp (without a motion blur), you need to determine how fast a shutter speed to use. In some cases, such as birds in flight or sports or with aerials such as in Figure 11, you may need to use 1/500 or 1/1000 a second to freeze the action. If your subject isn't moving, then you need to use a shutter speed fast enough that there isn't camera movement, or you need to use a tripod. Some people can handhold a short lens, particularly one that has image stabilizing (IS) technology at 1/15 to 1/30 per second. The slowest shutter speed that you can successfully use while handholding the camera depends on the weight of the lens, the focal length of the lens, and your steadiness. A general rule of thumb is 1/focal length (35-mm equivalent) is the slowest that you can handhold. IS gives you extra room, and some people are steadier than others (especially if you've just stopped at Starbucks!). When in doubt, use a tripod, or alternatively choose a higher ISO that will enable you to use the same aperture and a faster shutter speed. Whenever possible we use a tripod so that we don't accidentally introduce camera movement, but of course there are situations where using a tripod is not feasible.

FIGURE 11 With aerial shots (A) and rapidly moving critters such as great white sharks (B), shutter speeds of 1/500 or faster are helpful.

FIGURE 12 Holding the camera steady with moving subjects such as birds (A) and water can sometimes create images that capture the feeling of motion better than simply freezing the action. The little girl (B) is also moving slightly, and the slight blur adds to the impression of her pushing against the undertow.

It's certainly possible that you may not always want to freeze the action. You may want to add a sense of motion to the image by using a slower shutter speed. That way the subject will move during the exposure, creating a blur if you hold still. Sometimes these blurs are artistic and exciting, and sometimes they're just plain misses! With this approach, often the background is sharper than the subject, and that can be tricky, particularly if people are the moving subject matter. Waterfalls often work well this way. As you can see in Figure 12A, birds blasting off can create interesting designs. For this approach to work you have to be careful to maintain the visual energy of the subject and not let the background have most of the energy. Often that may mean making sure there is a lot of shape energy on the subject, with the possibility of energy from color, luminosity, and so forth.

Another approach with subjects that are in motion is to pan with the subject, meaning that you frame it in the viewfinder and then smoothly move the camera with it, depressing the shutter after you've already begun moving the camera. This takes some practice, but ideally you can render the subject sharp or at least identifiable, while the background becomes blurred in a way that we clearly interpret as motion, as shown in Figure 13. Often lines appear in the background in place of details due to the movement, and these lines add their own energy.

This creates an image with some similarities to those with selective focus discussed earlier, in that the viewer's eyes will be guided to the subject matter where there is more detail and texture energy, as well as possibly luminosity and color energy. The viewer is engaged because he or she has to imagine what those blurred colors and shapes might be in the background. This approach is particularly useful for separating the figure and ground when there is a distracting background, and concentrates the image's energy on the

FIGURE 13 Panning with a moving object blurs distracting backgrounds and can capture impressionistic but recognizable renditions of the subject; or if you pan at the same speed as the subject is moving, the subject may be sharp.

subject and the motion. With many subjects, panning and using a shutter speed of 1/10 to 1/30 per second creates some pleasing images. (Don't be frustrated if you think most of your images done this way are terrible. It takes time to get good with this technique. And finding a gem this way can be very exciting because you know that your image will be different from that of anyone else who was there at the same moment.)

If you want to venture into completely creative, more abstract imagery, you may opt to add camera movement with static subjects such as trees, as shown in Figure 14. To do this you choose a longer shutter speed—we use from 1/15 to 2 seconds or more—and then either move the camera, zoom the lens, or both. Again, many images will be destined for the delete bin, but occasionally some are magical. The beauty of these images is that you are no longer relying on details to convey your subject matter. Color, shape, and tone become the important sources of energy to convey what you're feeling. The lack of detail forces viewers to engage their imagination to fill in the missing information.

Keep in mind that although blurs (be they pan, zoom, or just motion) lose some energy from the lack of detail and texture, the blur itself creates shapes and lines that have their own visual energy, which that may help render a pleasing overall level of visual intensity.

FIGURE 14 Moving the camera vertically retained the sense of trees, but reduced the other vegetation to colors and vague shapes.

5. Choose the ISO

This is normally pretty straightforward. Usually we keep the camera set to an ISO of 400 to enable fairly fast shutter speeds with a variety of apertures. With older digital cameras that were more prone to noise, we used ISO 200 as our default setting, or even 100. Keep in mind that if you want to create a blur during daylight, you'll likely need to use a slow ISO like ISO 50 or 100. (You can also add a neutral density filter that reduces the amount of light getting to the sensor so that you can use longer shutter speeds.) If you want to create tack-sharp images in low light and don't have a tripod, you're going to need a high ISO. The specific ISO depends on your camera model. Some of the latest cameras give excellent results at amazingly high ISOs, whereas cameras made just a few years ago show bothersome amounts of noise at ISO 800.

Selecting where to stand, the lens, ISO aperture, shutter speed, and depth of field are the fundamental choices. Next come choices that will further improve the artistic aspects of the image.

6. Check Your Framing

Carefully look through the viewfinder and be sure that there are no unintended distracting objects creeping into the frame. You may need to modify your position or focal length slightly. In Figure 15, our first shot was too visually intense, as the viewer's eye goes to the bright sky at the top and the detail work near the top of the bridge. What we had intended to

FIGURE 15 The initial shot (A) is too visually intense, so we chose a longer focal length to remove the distracting elements. Shot (B) has a more visually pleasing level of energy and guides the viewer's eye along the canal.

FIGURE 16 We were so thrilled to be photographing these penguins at such close range that we didn't notice the triangle form in the background. The result is that the eye is pulled toward the background, because of the energy from the triangular shape as well as the intensity of the blue sky. The image could have been far stronger had we taken a couple of steps to the side.

show was the pathway down the canal under the bridge and the reflections, so we then chose a longer focal length and eliminated the distracting details in the top third of the image. This focuses the eye on the parts of the scene we wanted to portray and creates an image with a more pleasing level of visual intensity.

Similarly, make certain that the background is not interacting with your subject in unintended ways as happened with the image in Figure 16. The classic example of this is that you want to be certain not to have telephone poles or trees growing out of someone's head. In addition to concerns about telephone poles and trees, you want to be sure the subject

aligns with the background in a flattering way. Moving a step or two to the right or left or moving the camera up or down can make a huge difference. You also need to be certain that the background doesn't have too much energy. Keep in mind that actually moving changes the perspective slightly, which is what you need. Just tilting the camera up/down/left/right will not change the alignment of objects in the image.

As you look through the viewfinder, double check that the subject matter is clear. Initially you may be concentrating so hard on the subject that you mentally remove distracting objects. In addition, many viewfinders don't show you 100 percent of what will be captured—most range from

93 to 100 percent. This means that although you've done your best to carefully frame the subject, when you see the image later there may be some unfortunate surprises along the edges. For that reason it can be helpful to check the LCD after you've taken a shot. Often it's easier to see the image more objectively that way, plus you can see the entire image including the edges. Then you can take whatever steps are necessary to capture what you intended without having to crop the image later or spend a lot of time cloning something out. You might need to move a step or two or use a different focal length. It might even be that you need to wait until a cloud moves into a better position and complements your subject rather than competes with it.

As you look carefully at the edges of the frame, check to see whether they're open or closed, as discussed in Chapter Five. Think about how the image would look with more space around the subject or with less. How would it look if you deliberately cut off part of the subject? One trick with doing this is to be sure to cut off enough that it's obvious this was a deliberate choice rather than an accident. A subject that just touches the frame edge or is just barely cut off is often distracting and makes it feel crowded into the frame. As shown in Figure 17, you either need enough space so that the subject feels comfortable or you need to make it clear that you're choosing to show only part of the subject.

A trap that many people fall into when they first get a long lens is that they're so excited to capture a small subject large in the frame that they literally stuff the frame. You need to give subjects some breathing room. The classic advice is to leave more space in front of the subject (if it's heading across the frame) than behind it, so that it has somewhere to go. However, you can break this rule at times to convey a different message. Doing so will be unexpected and will add to the visual energy of the image.

7. Check the Lighting

As discussed in Chapter Six and shown in Figure 18, it's not just the quantity of light that matters, but also the quality and direction of the light. If you're outdoors, pay attention to the patterns of light and shadow. Sometimes you need to wait

until a cloud rolls by to diffuse the sunlight. Sometimes you need to augment the light with a reflector or fill-in flash, or change your position slightly. Sometimes you realize that you need to come back later. If the lighting isn't ideal, the first shot you take might be just for reference, and the shot you take later when the lighting is right will be the magical one.

8. Consider a Filter

If you're shooting outdoors, consider whether using a filter would help. The two types of filters we use frequently are polarizers and split neutral density. Polarizers filter scattered light so that it appears to be coming primarily from one direction. They not only deepen colors such as a blue sky and emphasize cloud detail, they can also reduce distracting reflections as shown in Figure 19. The increased depth in the sky, in cloud detail, and colors will increase visual intensity, but any decrease in reflections may reduce intensity. So the final effect on visual intensity—an increase or decrease—will vary according to the specifics of the image.

In some outdoor scenes, the sky is considerably brighter than the ground, as seen in Figure 20. This is true of shots that include water and reflections as well as shots at sunrise or sunset, and sometimes at midday as well. In such cases you have two choices. The first is that to use a split neutral density (ND) filter—a rectangular filter containing clear and darker parts. The transition between the light and dark areas can be gradual or abrupt. The dark area is commonly one, two, or three stops darker. Most people choose to carry one or two of these combinations, for example a two-stop graduated neutral density rather than an entire set.

Some finesse is required to accurately place a split ND filter with a hard-edge transition, but when the luminosity transition in the scene has an abrupt boundary, these filters can come in handy. Most of the time we prefer the forgivingness of graduated edge filters. Using a split ND in the field will even out the exposure so that the visual intensity remains similar throughout the image, rather than having a faded portion or a part that's too dark.

FIGURE 17 (A) There is no doubt that we deliberately excluded most of the mother and part of the baby snow monkey. (B) However, when a subject just barely fits in the frame, it can be overly energized and overwhelm the composition, as it does here with the crane silhouettes. (C) When more space is included

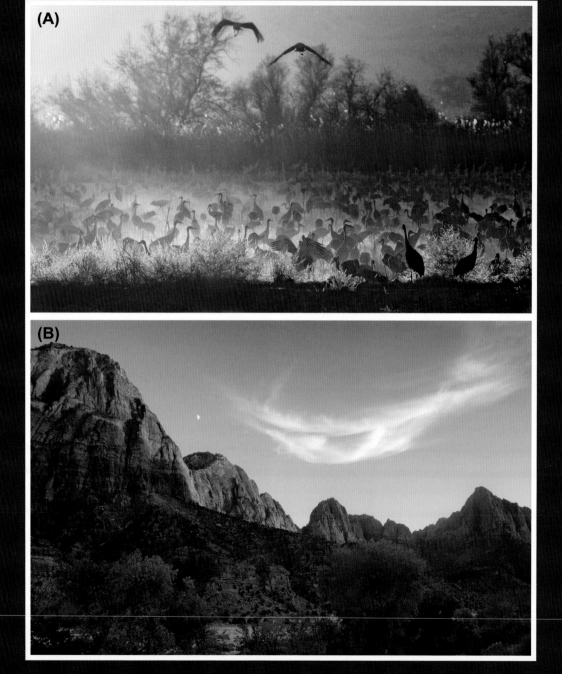

FIGURE 18 (A) Just as the sun fell to the horizon, it backlit the dust in the cornfield where the cranes were gathering. The result was striking, whereas a few minutes earlier it had been a totally boring scene. Waiting until the lighting was right increased the luminosity contrast and overall visual intensity. (B) Similarly, waiting until the cloud was just right in this landscape scene increased the visual intensity to give a dramatic image. Without the cloud, the visual intensity would be too low to be interesting.

FIGURE 19 (A) Image before using polarizer. (B) Using a polarizer not only deepens the blue of the sky, it emphasizes the clouds and reduces reflections on the buildings. Image courtesy Art Becker.

FIGURE 20 Initially in this scene the reflection was noticeably darker than the sky and mountain (A). By using a split ND filter we corrected the exposure in shot (B).

FIGURE 21 Including a meandering path is an excellent way to add a three dimensional feel to an image.

If the areas in the scene that are bright do not follow a roughly linear division, then a split ND filter won't be helpful. In that case you're better off using the second option, which is taking multiple shots to create a high dynamic range (HDR) image. You expose one for the bright area and one for the darker area and combine them later. Of course, you can also use that approach if you don't have a split ND filter. We'll talk more about that in the last chapter of the book.

9. Depth Cues

While you're composing an image, take note of whether you're incorporating any depth cues. The image in Figure 21 includes strong depth cues including the meandering path and the decreasing site of the flowers. On the other hand, if you're shooting a bird against an out-of-focus background (such as in Figure 6A), you'll have very few depth cues.

If you're shooting with a medium to wide lens, consider adding elements to create the sense of depth. The best landscape images have elements in the foreground, mid-ground, and background to create a sense of depth. Sometimes, but by no means all the time, the subject may be in the foreground, as in the racing rocks picture (Figure 22A). Other times you may have an out-of-focus or inconsequential element in the foreground that exists to create depth, while the story is about what's in the mid-ground. For example, you can

FIGURE 22 Including depth cues in your image will increase its visual intensity. (A) Racing rocks has the subject in the foreground whereas the mountain reflections scene in shot (B) has the subject in the mid-ground and uses the branches as a depth cue in the foreground.

FIGURE 23 The head on tractor shot in (A) has less sense of depth than the partial side angle shot (B) which includes depth cues such as converging lines as well as changes in the relative size of the wheels.

add leaves or branches from an overhanging tree that is clearly much closer than most of the scene (Figure 22B). The branches or leaves act as a doorway that you visually enter through to see your subject. Depth cues such as this add to the intensity of the image. You have to be careful that they don't have too much energy and overpower your subject, though. They exist to complement, not compete with the subject.

Another way to add depth to an image is to shoot near a wall, fence, or relatively tall structure so that there are converging lines. In some cases, as in Chapter Five, Figure 4 (page 118) with the example of buildings on a street, the converging lines may be quite obvious; in others they may be more subtle, but equally important to the image. Consider the images of a tractor in Figure 23. Because we used a moderately wide-angle lens and the camera-to-tractor distance was greater than the depth of the subject, there's not much sense of depth in the head-on view. By moving around to the side and getting low with a wide-angle lens, we've created a sense of depth, as the front tractor wheels are so much larger than the rear ones. If you imagine lines extending from the top and bottom of the front wheel to the rear wheel you'll see that they converge. That sense of depth adds to the visual intensity of the image. (Note, however, that the word "Versatile" on the tractor in the more static view adds considerable subject energy and it also has more energy from the background clouds, so that version also has a pleasing level of visual intensity.)

MORE THAN ONE SHOT?

Now that you've captured the shot that first caught your eye and any that are obvious to you, it's time to pause for a minute and look around. Chances are that there may be more good shots to be had, though initially they may not be as apparent. As Dewitt Jones

FIGURE 24 We had been photographing sunset at low tide with beautiful colors and wonderful reflections, when all of a sudden someone walked into the frame with a metal detector. Suddenly we had a very different image. It would have been easy to be annoyed with him, but instead we got a little closer and made him an element of the image.

says, it's time to find the "next right answer" as you consider the possibilities. Even if you love the first shot you took, don't assume that it's the only one, or even the best one. You need to look for what else is there.

Sometimes you just need to wait and watch for a little while. Maybe the lighting changes a little, maybe the subject changes in some way, or maybe something new appears as shown in Figure 24.

As you look around wondering what image to create next, consider what would happen if you used a very different lens. Sometimes we get in the habit of always using a particular focal length for a certain type of shot. For example, perhaps

you often photograph a garden with your 24–105 lens. What could you do if you got out a macro lens, or used close-up filters and/or diopters to let you get much closer? Similarly, if you often use a macro lens in a certain situation, what would it look like if you shot it with a wide-angle lens and put the lens right up to the subject?

One of the best ways to get a shot that breaks out of a rut is to change your position—move yourself higher, lower, more to the side, closer, farther away. And the one tip that you should *never* forget is to *always* turn around and check what's going on behind you. You may think you're aiming at the best subject, only to discover that there's something even better behind you. That often happens at sunrise and sunset, when

it's tempting to point the camera toward the sun. But in reality the color behind you may be even more dramatic! Or if you're photographing wildlife in front of you, be alert to what might have gathered behind you. We were once photographing penguins in the Falklands, and Ellen was concentrating on photographing some penguins at close range with a wide angle. When she turned around she discovered she was inadvertently standing in what the penguins used as a primary travel path and they had queued up, patiently waiting for her to finish!

If it's obvious to shoot the scene at sunset, consider staying and shooting with stars in the sky and long exposures. If it's obvious that you need to get everything in focus, try using selective focus and highlighting a particular detail. If it's obvious the horizon should be straight, tilt it. If it's obvious that you need a fast shutter speed to freeze the action and get everything sharp, try a long shutter speed where subjects may become blurred and abstract suggestions rather than documentations. If it's obvious you need to shoot using a wide angle, consider using a longer focal length and isolating part of the scene, and so forth. The point is that you need to question all the automatic choices you make and the assumption that there is one right way to photograph the subject before you. Chances are there are several "right" ways that may have very different impacts, styles, and looks.

As you try each new approach, consider how it alters the overall visual intensity of the image and what else you may need to do to maintain a pleasing level of energy.

Sometimes the key is to wonder "what would happen if I..." and then find out! In Figure 25 we were photographing a sunset on the beach that was nice, but not spectacular. We wondered what would happen if we used a slow shutter speed and moved the camera horizontally, rather than keeping the camera as still as possible, so we tried it. Suddenly the sunset took on the appearance of a watercolor. It captured the

feeling of the beach and sunset with few of the details visible. We placed the horizon slightly above the center line so that the yellow we decide is the sun is in a more energetic place. The variety of colors contributes some energy, as do the lines that result from the horizontal motion. Most of the energy in the image comes from the abstract shapes and bands of color that require the observer to participate and imagine the details. By doing something unusual with the camera, the rather ordinary sunset became special.

Next we aimed the camera down and played with what was happening at the water's edge, with the various patterns and colors (Figure 25B). We looked up to see an older couple walking by, enjoying the moment even though the woman needed a cane (Figure 25C). It felt like we shared in an unexpected special moment. If our only thought had been to capture a wide-angle view of a spectacular sunset, we would never have seen any of these shots.

SPECIAL TOOLS AND TECHNIQUES

In addition to all the choices we've covered so far, there are some other options to consider. If you're in a situation with a lot of luminosity contrast and you can't return at a time when the lighting is better (or perhaps no matter what it will always be too contrasty for a camera to capture full detail), then consider creating an HDR image. We'll talk more about that in Chapter Eleven. In addition there are some specialty lenses that you may want to consider using, such as macro, tilt-shift, fish-eye, and Lensbaby.

Macro

Definitions of macro vary slightly but we're referring to lenses that let you capture your subject at life size or larger. When we view something at life size, most of the time we start to see details that we'd never noticed before. When we increase the magnification beyond life size, we not only see details that may not have been obvious to our eyes, but eventually the

FIGURE 25 By moving the camera during a long exposure we created a painterly rendition of a sunset (A). We looked down and played with the water's edge (B), and looked up to see an older couple passing by (C), all of which added interest to what was a rather ordinary sunset.

FIGURE 26 Macro images often give us new ways of seeing familiar objects.

subject ceases to be readily identifiable and becomes instead a series of shapes, textures, details, and colors marked by the lighting that defines highlight and shadow areas. We lose the quick and convenient label attached to the subject and instead examine the components of what is an abstract design rather than a documentary photo.

Initially at life size, when the subject is still identifiable, seeing more detail may increase the visual intensity of the image. However, by making the subject larger in the frame (often completely filling the frame with only a portion of the subject, as happens when it's viewed at life size), there may be no background at all and that may keep the overall image energy within a pleasing range. As the image becomes more abstract,

its energy will be determined by the elements that are visible and their organization within the frame. For example, rather than thinking that the image in Figure 26 is a picture of a flower, it's a picture of parts of the flower that are now a design. The visual intensity of the image then depends on colors, shapes, luminosity contrast, and the need to make sense of something that you almost, but don't quite, recognize.

You can opt to buy true macro lenses that let you focus from life size to infinity, and if you love macro this is a great solution. But there are less expensive options you can try. You can add magnifying filters (called close-up diopters) to the front of a lens, or extension tubes between the lens and the camera

FIGURE 27 By adding a 2 × tele-extender to our macro lens, we captured this water droplet at twice life size.

body that will let you capture life-size images. You can also add tele-extenders that will effectively magnify the focal length of the lens you're using. In Figure 27 we combined a tele-extender and a macro lens to get a twice life size view of a droplet of rain on a flower. It's also possible to use an adapter to reverse mount a lens so that it becomes a macro lens.

If you are an abstract lover and a Canon user, you can buy a special macro lens that lets you capture an image at up to five times life size! It's even possible to use a microscope with a camera and capture images at a level of magnification you couldn't even imagine existed without a microscope. These images at unusually high magnification are not what we're accustomed to seeing, and as such engage our curiosity. That adds energy to them. Beyond that, their visual intensity depends on the design elements and the energy of the components. Chances are that this type of composition is beyond your control and involves an element of chance.

Another issue with extreme macro is that depth of field is quite limited. This can be distracting when looking at something like a fly's eye, where you hope to see the entire thing in focus, and can cause the image to lack visual intensity. To increase it to a pleasing level, you may need to combine multiple shots of a subject after focusing at different distances. You can then combine them into a single image using Photoshop, or a program such as Helicon focus. The final image may then have dramatic impact, since it will show exquisite detail we can't often see.

Tilt-Shift

Tilt-shift lenses were originally the territory of large-format cameras, and later a few versions became available for medium and 35-mm formats. These lenses move in ways other lenses can't. Shifting is moving the lens parallel to the image plane and is used to alter the position of a subject, such as a building, in the image without needing to angle the camera back. Tilting involves changing the angle of the lens's focal plane relative to the sensor's imaging plane, which alters the plane of focus.

Tilt-shift lenses are often used by architectural photographers to avoid the illusion that a building is falling away. That occurs when people angle their cameras upward to get the entire building in the shot and as they do so the building's sides appear to converge at the roof. The bottom of the building appears to be closer than the top because in fact, it is closer to the camera due to the position of the camera. If you hold your camera parallel to the building, you won't see that type of distortion.

The image your lens creates is circular, but our sensors use a rectangular region within that circle (see Chapter 5, Figure 13). The shift function in these lenses changes what part of that circular image the sensor is capturing. This lets you adjust

your framing of a building, for example, without angling your camera up at the building.

Shifting can also help you capture shots to stitch into a panorama. It can be preferable to panning the camera because you maintain the same focal plane and avoid distortions, as shown in Figure 28.

When you tilt the lens, what is in focus may change, as shown in Figure 29. You're not actually changing how much is in focus—you can only change that by setting your aperture. However, because you're changing the plane of focus (it's not parallel to your lens anymore), you might mistakenly think that tilting your lens changes how much is in focus.

For example, imagine you're standing up high, looking down on a field of flowers. If you want to take a picture of the field of flowers where everything is crisply sharp with a normal lens, you could set the camera to a small aperture such as f/22, but you'd need a relatively long exposure. Chances are that there may be some wind that will create movement within the flowers. Using the tilt part of the lens to angle the optics so that you're counteracting the angle from looking down at the flowers will correct the distortion, putting most of the flowers into the same focal plane, and letting you use a larger aperture (and faster shutter speed). Conversely, you could use the tilt feature to blur most of the field of flowers to direct your eye to a specific spot, by making it so that all the other flowers are in a different focal plane. Tilting this way is sometimes done in portrait photography for a trendy look.

Architectural photographers sometimes combine both functions, tilting and shifting, to reduce unwanted distortions when photographing buildings. Note that rendering the building rectangular instead of somewhat triangular and distorted does decrease the visual intensity of the image, which may or may not be what you want creatively. However, for those who regularly photograph architecture and don't want that distortion, tilt-shift lenses can be lifesavers.

Tilt-shift lenses tend to be fairly expensive and some of their effects can be replicated with other techniques, such as combining several shots of a subject in order to expand focus. In addition, some tilt-shift lenses can be a bit more demanding to use since many do not enable full auto-exposure, when the tilt or shift portions are engaged, and may not offer autofocus.

A creative and far more affordable alternative for selective focus is the Lensbaby series of lenses. These are small aftermarket lenses and optics that allow for selective focus with the ability to move the lens so that you can choose any point to be in focus and progressively blur the rest of the image, not just according to distance to the camera, but also distance to the lens (given that it may be angled away). This allows for some quite creative effects that significantly reduce energy from detail or texture, but emphasize lighting, color, and shape energy, as seen in Figure 30. In addition, because the effect is visually unexpected it adds energy. The lens can also be used to increase what's in focus by matching the lens angle to the subject angle.

Fish-Eye Lenses

A fish-eye is another type of specialty lens. Lenses that are quite wide, 15 mm or wider for 35-mm cameras and even shorter for some of the smaller formats, are often (but not always) fish-eye lenses. Fish-eye lenses deliberately produce a convex effect and are not rectilinear. There are some ultra-wide lenses, such as the Canon 14-mm lens, that are ultra wide and rectilinear, which limits the amount of distortion they create. Such lenses tend to be more difficult to design and manufacture, which in turn makes them more expensive. Most of the more affordable ultra-wide lenses are fish-eyes.

Fish-eye lenses may be full frame, or they can create a circular image with the remainder of the rectangular image appearing black. Their distortion significantly increases the visual intensity of images due to the unexpected shapes and

FIGURE 28 (A) Shifting the lens enabled us to capture this building as a panorama without distortion. (B) Same building photographed as a panorama without shift.

FIGURE 29 In this image we used the tilt function to help straighten the side of the building (A). Without the tilt (B) you can see the distortion

FIGURE 30 A Lensbaby enables you to adjust the focus point such that other parts of the image have an exaggerated blur.

angles, in addition to a 180-degree field of view (measured horizontally for a rectilinear fish-eye and vertically for a circular one). When held quite close to the subject, the subject will become distorted, as in Figure 31 showing the interior of a dilapidated house. Using a lens like this to take a portrait of a friend is not a very friendly thing to do! However, the same distortion can be beneficial as seen earlier in this chapter in Figure 22A, when we placed the camera and ultra wide angle lens down low near the rocks to make them more imposing.

Some of the impact in fish-eye images comes from the surprise element of the distortion and as such, if you see an entire portfolio of fish-eye shots, you may find that you lose

interest. What's happened is that the energy from the surprise component has decreased, and you are left searching for other components that make it worth continuing to look. If the images are well composed or funny or varied in other ways, the visual intensity will remain pleasing, but if they are too similar conceptually, the visual intensity will dip too low to hold the viewer's interest. Of course, the same is true of any specialty technique or tool.

Multiple Exposures

A fun technique for creating an abstract, artsy image in a variety of situations is to create a multiple exposure, as seen in Figure 32. A few cameras have this feature built-in, so you

FIGURE 31 Wide-angle distortion adds visual energy as familiar objects take on unfamiliar shapes.

can set the number of exposures to take, often up to nine, and then the camera will determine the exposure if you're using a programmed mode with aperture or shutter priority. You simply hold the camera and take a series of shots, moving the camera slightly between shots. It only takes a tiny movement to work. Most people suggest moving the camera in the direction that the subject grows and/or moves, but you can experiment to see what works in a particular situation. You can even rotate the camera in a slight circular motion and zoom the lens slightly between exposures, or move back and forth. There is no right or wrong technique. Some people do this handholding the camera, while others prefer to have the camera on a tripod with a somewhat loose

setting so they can easily move it. The results are impressionistic, simultaneously having more texture but less recognizable detail. Colors and edges often become softer. Overall the visual intensity is often decreased. Many times it helps if the subject matter is still identifiable. This approach is somewhat similar to a single long exposure where you move the camera, but this technique creates more detail and edge contrast.

Infrared Filter

Infrared (IR) cameras have become quite popular in recent years, partly because it's possible to convert a digital camera you're no longer using to IR by using a company such as Life

FIGURE 32 Multiple exposures simultaneously create slightly more texture but less detail to create an unusual rendition of familiar objects.

CREATING MULTIPLE EXPOSURE EFFECTS IN THE DIGITAL DARKROOM

If your camera lacks a multiple exposure function, you can emulate the effect by taking series of shots and combining them later in Photoshop. We recommend creating an action for this. Follow these steps for creating a 9 layer multiple exposure image:

1. Open all the images to be combined.
2. Go to File > Scripts > Load Files into Stack, and then choose Add Open Files from the dialog that appears.
3. In the Layers panel, set the second layer from the bottom to 50% opacity, the third to 33% opacity, the fourth to 25% opacity, the fifth to 20% opacity, the sixth to 17% opacity, the seventh to 14% opacity, the eighth to 12% opacity, and the top layer to 11% opacity. In addition, you may want to change the blending mode of the top one or two layers to Overlay. To create a multiple exposure image from a different number of images, create the action as described but change the number of layers included in Step 3. The opacity of each image is always 1/layer number i.e. the second layer is 1/2 of 50% opacity, the third 1/3 of 33% opacity, and so forth.

FIGURE 33 Infrared images, both traditional (A) and false color (B), often have significant visual intensity from the high levels of luminosity contrast as well as unexpected tonalities such as light to white leaves.

Pixel (www.lifepixel.com) or Max Max (www.maxmax.com). It's also possible to use a filter with some cameras to allow the camera to capture the IR portion of light. Digital IR is far easier than film IR because with film you needed to use a filter that blocked all visible light. That made it impossible to compose or focus when the filter was on. With a converted digital camera, you compose as you normally would. The focusing distance may be slightly different, but many companies that convert digital cameras also modify the focusing so that you focus as you normally would.

Infrared images can be monochromatic or color. When monochromatic, blue skies often become nearly black, and green grass or leaves become nearly white. Color IR is considered false color because much of it is distorted, but by swapping the red and blue channels you can create a blue sky. That way you have an image with something that appears the way you expect, though other components, such as leaves, clearly do not. Often, there is a tremendous amount of luminosity contrast in IR images. The unexpected intensity of skies, leaves, and grasses adds to the visual energy of the images. The result is that IR images have tremendous impact and people tend to look at them longer.

We've covered a lot of ways to approach a situation and tools that you can use to create an image. All of them are designed

to help you go beyond a quick snapshot and create an image that's more than a mere documentation of the objects or people in front of you. The goal is to create an image that clearly expresses what caught your attention and hopefully the feeling it evoked in you. By no means is this an exhaustive list of all the possibilities! It's up to you to look and truly see what's possible. Take the time to… SEE IT!!!!

USING VISUAL INTENSITY IN THE FIELD

Figure 34 is an example of how we put the principles of visual intensity into action in the field. We were hired to photograph this particular lighthouse, so we first went to scout out the location. Immediately we were struck by the fact that the visual intensity was too low and started considering what we could do to increase it. We experimented with using the pier as an oblique line to increase the energy, and then we waited until another element appeared (a boat) but that really didn't help much (A). We walked around and tried several angles as well as including some of the surrounding vegetation to add some energy from color and texture (B). We realized we needed to return when the lighting would add to the visual intensity, so we returned before sunrise the next morning (C). The color in the sky was good but we realized we needed to change positions so that the sun would act like a spotlight on the lighthouse. As the sun rose, a cloud appeared and the sky provided the previously missing energy (D). We created several versions that we liked. Ultimately, the buyer chose the one that had the greatest visual intensity, the one we shot as an HDR to render detail in the lighthouse rather than portraying it as a silhouette. Note that it has a strong sense of depth, the greatest color contrast, and the most shape variations in addition to the greatest luminosity contrast.

Exercises

1. Go outside with your camera gear and bring several lens choices if you have them. Choose a spot, *any* spot! (You can throw a hula hoop and stand where it lands, walk fifteen steps from your front door, or use another random strategy.) Spend the next thirty to sixty minutes making at least ten different images from that one spot. Make the images as strong as possible, keeping all the visual intensity principles in mind.

 When we do this with our students, often the first few images are easy, and then they think they've selected the worst possible location and there's nothing there. Then suddenly a light goes off and all sorts of possibilities emerge and they think they lucked out with the location.

2. Go outside with a single camera lens. While you can use a zoom lens we suggest you select a single focal length to use. It doesn't matter if you choose 24, 42, 142, or whatever. Just pick one. Then spend the next thirty to sixty minutes creating at least ten different good images with just that one focal length. Hint: This time you're probably going to have to move around a lot. As always, think through the energy in each image and what you need to do to keep it at a good level.

3. Choose a room in your home. Bring your gear in and make as many photographs as you can during the next thirty to sixty minutes. Photograph everything you see even though the elements may be common, ordinary objects. Take advantage of lighting to help you capture the ordinary in as extraordinary a way as possible.

4. Review your images on your computer. Rate the overall visual intensity in each and identify the sources of energy. Are there things in the image that you hadn't noticed initially? Do they add to the image or detract from it? Why didn't you see them? Pay attention to everything we've discussed, from subject placement to lighting to depth and distortion. If you are happy with an image, note what you did that made it work. If you want to delete an image as soon as possible, don't! Instead identify the problems and what you could have done differently to improve the situation. We learn as much from the images that don't work as we do from the winners!

Improving Visual Intensity with Digital Manipulation

- Selecting Images — 266
- Developing a Game Plan — 266
- Determine What Specific Adjustments to Make — 271
- Other Issues — 283
- Summary: Putting It Together — 290
- Exercises — 293

In this chapter we focus on how you decide what an image needs. Often people have an immediate reaction to a picture that they like or don't like it, but they're not sure why. Further, they may be at a total loss to figure out what to do to improve the image to make it pop. In this chapter we show you that, by applying the basic principles of our visual intensity approach, you'll know exactly what your image needs. That means you won't waste time with countless trial-and-error adjustments. You'll work more efficiently and create stronger images at the same time!

SELECTING IMAGES

After you download files onto your computer, the first decision is whether to keep or delete each image. It's far too easy to keep way too many images and then be overwhelmed when you look through trying to find one to share, use in a competition, print, and so forth. It will be much easier if you delete the images that aren't good. In Chapter One we recommended that you don't aggressively delete images while shooting or immediately upon down-loading because it's likely that on your initial pass-through you're still emotionally caught up in what you were hoping to capture. That makes it more difficult to be objective about what you did capture. But on your second pass-through, whether a few days later, or ideally a couple of weeks later, you're more likely to be able to evaluate them objectively. The images you were hoping to capture might not be as strong as you'd like, but an image of something else might be outstanding. We can't tell you how many times we change our ratings on our images on our second or third pass-through. We suggest aggressively deleting images that just aren't that good on the second pass-through. Nonetheless, sometimes it's hard to know which images have the potential to be good, and which are unsalvageable or not worth the time it would take to improve them.

We recommend that you begin by checking the basics of the images and use the following guidelines to help determine which to keep and which to delete.

1. Is the exposure correct, or at least close enough that you can correct it using software without revealing excess noise?

2. Are the areas that you want to be in focus tack sharp? Although you can sharpen an image digitally, that doesn't fix an image that's not sharp to begin with. (We're aware that there are some software programs that claim to sharpen soft images, but we've not seen one yet that creates the same results as an image taken correctly with tack-sharp focus on the areas that are intended to be sharp.)

3. If your image involves a person or animal, is their head position, facial expression, and body position good? These things can't be readily changed in most images, although Photoshop's Puppet Warp tool does enable you to reposition some subjects. Head positions, and particularly eye lines, discussed in Chapter Three, add to the visual intensity of the image. Facial expressions and body positioning may trigger emotional reactions and thus higher-level components that may also contribute to the energy in an image.

4. Is the image free of excessive digital noise? If you're not sure, try running the image through your favorite noise-reduction software to see how it looks.

5. Are you attracted to the image, whether for sentimental reasons or just because you find yourself drawn to it? It's okay to keep images that are less than ideal if they mean something to you, but keep in mind that you may want to keep them private.

6. Is the image unique for some reason? If so, you may opt to keep it even if it has other flaws.

If an image doesn't make the cut, delete it. It's tempting to save a lot of "almosts" since digital storage space is relatively inexpensive. However, doing so will ultimately create more work for you as you search for your best images, and useless images will force you to buy more storage space prematurely.

DEVELOPING A GAME PLAN

We'll assume that you've edited your images and are looking at images that have potential but need to be opti-mized. We can't stress enough how vital it is to *make a game plan before you start to adjust an image.* Otherwise you're likely to spend far too much time making adjustments and then undoing them, as you try all sorts of things in a somewhat random fashion to improve the image. If you take the time to create a game plan, you'll save yourself time and frustration.

First Impressions Count

To create a game plan, we recommend that you follow this approach. Begin by evaluating the image using the VI (visual intensity) concepts. *The first step is to gauge your immediate reaction to the amount of energy in the image.*

Figure 1 It doesn't make sense to save countless versions of the same image. Instead carefully evaluate them and keep the best two or three.

Does the image seem a little boring or dull (too little total energy) or is it too busy (too much energy)? This should be a gut-level reaction you have to the image, *not* a carefully thought-out intellectual response! At this stage you don't need to articulate *why* you're reacting that way to the image. Instead, what you're after is a reaction to the visual intensity of the image. Is the image pleasing, dull, or overly stimulating? This gives you the overall mindset for the direction in which you need to take the image, that is, whether to increase or decrease its energy level. For example, look at the images in Figure 2. In one the energy level is too low and the image is boring. In another the energy is too high. There's so much going on that you don't know where to look. The energy in the

last image is more moderate and chances are that you think it's a better image.

The second step is to take note of how your eye travels through the image and where it lands. As we look at any image, we are initially drawn into it by some component, as discussed in Chapter One. Often our eye then travels around the image, finally concentrating on one area. When you look at your image, is your eye going where you want it to? Even more importantly, is it landing where you want it to so that you, as the viewer, are focusing easily on the subject? You'd be surprised how often you might be forcing yourself to look at the subject but your eyes want to go

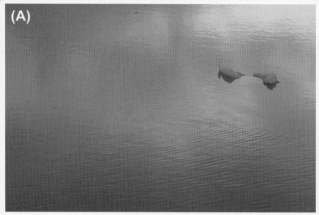

elsewhere. Now is the time to let your eyes go where they want, because that's where other viewers' eyes are likely to go when they look at the image. Knowing where your eye wants to go will help you make adjustments to the image that will guide any other viewer's eye to look where you want them to look. In Figure 3 the petal on the right leads your eye out of the frame, and some of the dark areas along the bottom and left side compete for attention rather than letting you easily focus on the center of the flower, with its sharp stamen.

As discussed in the early chapters of this book, our eyes are drawn to areas of contrast, whether this is luminance (light/dark) contrast, contrasting colors, varying textures, different shapes, or areas with differing degrees of detail. Sometimes these elements naturally guide the eye to the subject and sometimes they accidentally work against us to steer the eye away from the main subject.

Third, note what types of contrast are at work in your image and whether there are any types of contrast that are driving your eyes away from the main subject. As you optimize the image, you may need to increase one or more types of contrast on your subject and/or decrease visible contrast in what should be background supportive elements of the image. For example, in Figure 4A our eyes have trouble staying on the subject because there's too much detail in the background, with contrasting shapes, lines, and tones, even though it was shot with a shallow depth of field. If we want to improve this image, we'll need to tone down the background and then add some light to the subject to help separate it from the background. We'll also sharpen the subject to increase the contrast between the detail of the subject and the out-of-focus background.

FIGURE 3 Unfortunately, one petal leads the eye out of the frame in this image.

FIGURE 4 By toning down the background of the original image (A) by blurring it, and increasing the detail and luminance contrast in the subject, we made a far stronger image (B) with slightly less overall energy.

DRAWING ATTENTION TO THE SUBJECT AND MINIMIZING A DISTRACTING BACKGROUND

To create the after-version in Figure 4B, the exact steps you take may differ from what we did, depending on your image editing software. However, we'll describe our procedures for this in detail; you can achieve similar results using other tools if you prefer. What's most important is that you understand the concept of what needs to be done to improve the image, including use of a layer mask to affect just part of the image. We used Photoshop and Nik Software's Color Efex Pro 4.0 (CEP) and Sharpener Pro with the image as follows:

1. Begin by duplicating the background layer of the image in photoshop: Layer > Duplicate Layer, then press OK in the pop-up dialog.

2. Turn off the visibility of the new layer by clicking the eyeball icon next to it in the Layers Panel.

3. Click the Background layer to make it the active layer and then choose Filter > Blur > Gaussian Blur. You'll need enough blur to smooth out the background to the degree you want. We used a blur setting of about 40 pixels but you might need a very different setting. You might also prefer a different type of blur. Don't worry about losing the flowers; we'll get them back in a minute. (Note: If you have Photoshop CS6, it's more efficient to use the Iris Blur filter because it will auto-mask your subject. That way you won't have to make a layer mask by hand and you can adjust the amount of blur in real time. We show you that in Chapter Eleven.)

4. Click the space for the eyeball icon by the top layer to restore its visibility. This layer will hide the blurred layer.

5. Click the third icon from the left at the bottom of the Layers Panel to add a layer mask to the layer.

6. Select a large soft brush and then press the D key to set your foreground and background colors to black and white. Then press X to make black the foreground color.

7. Be sure that the mask is selected in the Layers Panel (it will have a white outline around it). Then paint over the background on the mask to reveal the blurred layer beneath it. Zoom in to work carefully near the edges of the petals and change your brush size as needed.

FIGURE 5 This is how the Photoshop interface looks when you add the layers and layer mask.

8. If you are going to use a Nik Plugin such as CEP, create a merge visible layer by selecting the top layer, holding down the Option/Alt key, and choosing Merge Visible from the flyout menu at the top right of the Layers Panel. Alternatively, you could achieve similar results with a series of Curves adjustments in Photoshop. If you're using adjustment layers in Photoshop, you won't need to do the merge-visible step. Instead, proceed using Curve adjustment layers.

9. Next, we used CEP's Tonal Contrast filter to help separate the foreground and background. You might prefer one of the other filters such as Detail Extractor or Pro Contrast > Dynamic Range or Tonal Contrast. We'll talk more about those options in Chapter Eleven.

10. If you're using CEP, use control points as needed to selectively apply the additional contrast to the flowers.

11. As a final touch, we selectively sharpen the flowers using Nik Software's Sharpener Pro, although you can use Unsharp Mask or Smart Sharpening in Photoshop, or another sharpener.

At this point you should have a rough idea of the direction you need to take to optimize the image. For example, you might decide the image lacks energy but your eye does go to the subject, in which case you might need to increase the overall visual intensity of the image, while being careful to make sure the background doesn't suddenly attract too much attention. Or perhaps the image lacks enough energy and, to make matters worse, your eye doesn't land on your subject. In that case, you're going to need to take steps to increase the visual intensity of the entire image and particularly the main subject, while making certain that the background doesn't start to overpower the main subject. Or perhaps the image has enough energy but your attention doesn't stay on the subject. Then you may need to slightly increase the visual intensity of the main subject while decreasing the energy associated with the background. (That's what we did with the flower.) It's also possible that there's just too much energy in the image as a whole and you don't know where to look. In that case, you'll need to decrease the overall visual intensity and make adjustments to help the viewer find where to look. As vague as that might sound, it actually provides you with a good framework to begin working on your image.

We suggest that you reread the previous paragraph. The step it describes is essential. It needs to become automatic when you look at an image before you work on it. It's the foundation for all your digital adjustments.

DETERMINE WHAT SPECIFIC ADJUSTMENTS TO MAKE

The next step is to look more carefully at the image and decide what elements are contributing to the overall energy level. That will help you determine not only why the energy might be too low or too high, but will offer clues as to what you can do to change the energy level to make the image more pleasing.

Tonal Adjustments

If the image feels a bit flat or dull, check the histogram to see how much of the tonal range (tonal contrast) you're using.

Setting White and Black Points

Many images look best when they use the full tonal range of contrast. In most image editing software, this involves setting the white and black points of the histogram to correspond to the lightest and darkest pixels in the image. (The white point determines how light the lightest pixel in your image is and similarly the black point determines how dark the darkest pixel in your image is.)

FIGURE 6 Holding down the Command key in Aperture shows a clipping preview that makes it easy to accurately set the white point.

You can do this in Camera Raw, Lightroom, or Aperture, as well as in any program that has a levels or curves type of adjustment.

To set a white point in Camera Raw CS6 and Lightroom 4, use the White slider to set the white point, and the Black slider to set the black point. (Use the Exposure slider to control the overall exposure of the image.)

In versions of Camera Raw prior to CS6 and Lightroom prior to LR4, use the Exposure slider to set the white point and the Black slider to set the black point.

In most programs, holding the Alt/Option key (Command key in Aperture) while setting the white and black points will turn the display temporarily black (or white) to make it easier to see

when you begin to clip pixels (turn pixels pure white or pure black), as shown in Figure 6. Normally, you want very few if any pixels to be pure white, and similarly very few to be pure black, so you'll back off the setting just slightly.

In Aperture, we first use the Exposure slider to set the overall exposure of the image, and then set the white and black points. We use either the Black Point slider to set the black point or the black point control in Levels. Then we use the Levels white point control to set the white point.

Setting the Black (Point) slider in Aperture affects primarily the darkest pixels. If you want to darken the image slightly, setting the black point by using a Levels or Curves adjustment will do more than using the Black (Point) slider,

because Levels and Curves adjustments affect a wider range of pixels.

In Photoshop, Aperture, and most other programs, you can also set the white and black points in Levels or Curves by moving the small white or black triangle in the tool's dialog underneath the histogram at the ends, so that it corresponds with where the data in the histogram begin and end.

There are some slight differences in the results depending on the tool you use. When you make a Levels adjustment, the change in tonal values is spread evenly across all the pixels in the image. That may or may not be the effect you're after. If you use Curves and make adjustments other than at the ends, the pixels that are closest in value to the point you adjusted are affected more than pixels that are more distant in value. So if you add a point on a Curve adjustment that's perhaps one-eighth of the way up from pure black, the really dark pixels are affected more than a pixel that's halfway to white. In other words, Curves adjustments affect some pixels more than others, which ultimately gives you more control over the results, but is a little harder for some to use. However, with a bit of practice we find that most of our students are comfortable using Curves adjustments.

One tool is not universally better than another. Instead, it depends on the image and what you're trying to accomplish. The difference between the various alternatives is the extent to which other pixels within the image are lightened or darkened. We normally set our white and black points in the RAW converter and then may use curves to make finer adjustments to part of the image.

No matter which approach you choose, expanding the tonal range in the image to use most of the histogram will increase the image's energy by increasing its luminance contrast.

Although not all images need to use the entire range of tonal values, most will benefit from having some very light to white and some very dark to black areas. Some images that are moody may have very few pixels in the darkest or lightest portions of the histogram. Others that are foggy or moody, such as Figure 8, may need no tonal values that are black or nearly black, but may benefit from having some areas that are extremely light. Many cameras expose foggy pictures so that there are no extremely light or dark values and the result tends to be a gloomy, heavy feeling. To lighten the feeling, you'll need to modify the exposure to add light tones. You can do this in your RAW converter by setting the white point as described earlier, or with a Levels or Curves adjustment in any software that lets you modify the tonal values.

Moody images can also be quite somber, and in those cases will have many dark tones but few, if any, very light tones. Usually a moody image will have lower energy because it uses less of the tonal range.

Mid-Tone Contrast

Most images will nonetheless look best when the full tonal range is used and there is adequate *mid-tone contrast*. Mid-tone contrast is an often overlooked but essential element in successful images. Many times people tend to consider the overall contrast in the image and they're satisfied when there are some black or nearly black values and some white or nearly white values. But adequate contrast among the mid-tones is also vital. Properly adjusting your mid-tone values will go a long way toward making your image pop, as shown in Figure 9.

By making a Curves adjustment in Photoshop, or any adjustment in other software that lets you increase the mid-tone contrast, you can increase the amount of energy in the image without blocking up shadows or blowing out highlights, which might happen if you were to increase overall contrast. (Note that the Clarity slider in Camera Raw and Lightroom as well as the Definition slider in Aperture slightly increasing mid-tone contrast as well as slightly increasing saturation.) Our current favorite tools to increase mid-tone contrast are CEP's Dynamic Contrast slider in Pro Contrast as well as the Tonal Contrast filter.

FIGURE 7 (A) Initial histogram and levels control (in Aperture) and (B) initial image. By setting the white and black points (C), we significantly increased the luminosity contrast, which in turn added tremendously to the visual intensity of the final image (D).

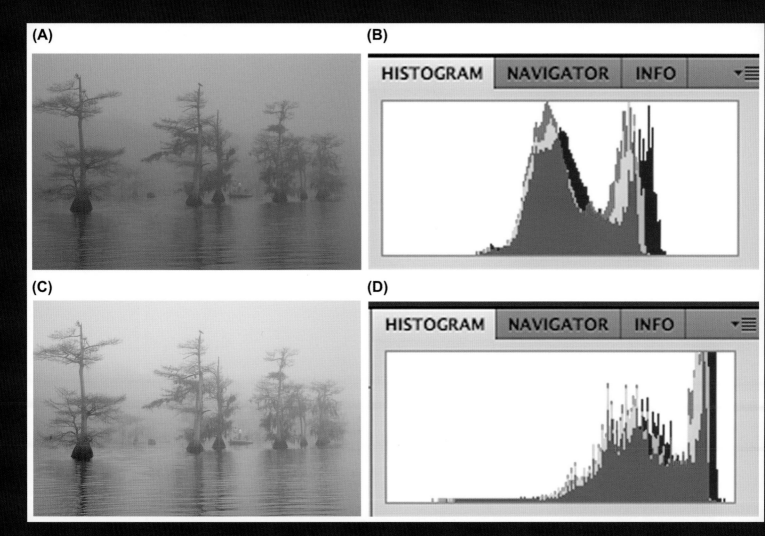

FIGURE 8 Initially this image (A) uses only part of the tonal range (B). Although we don't need to use the full tonal range for it, use do need to lighten it so that it's moody, not gloomy (C) and (D).

FIGURE 9 (A) Initial image. (B) Note the apparent increase in detail and thus visual intensity in this image, achieved by increasing only the mid-tone contrast. We used the Dynamic Slider in CEP's Pro Contrast filter.

Lighting on the Subject

Check the *lighting on the subject* itself. By slightly brightening it and/or slightly darkening the background, and possibly decreasing the contrast of the background, you can draw attention to the subject just like we did earlier in Figure 4.

There are numerous ways to go about modifying the lighting in an image. Most require making selective adjustments so that each adjustment only affects part of the image. In Camera Raw, Lightroom, and Aperture you do this by brushing on (or off) an adjustment, while in Photoshop and Elements you do this via layer masks. The brushes are "smart," in that they can often detect edges and are applied to the image where you want. Nik software, such as Viveza and CEP, also makes it easy to do this using Control Points. (You add a Control Point to the image and the software creates the mask for you with minimal effort on your part. Then you adjust that area differently from the rest of the image.) In Chapter Eleven, we cover some additional techniques for relighting an image, such as the Render Lighting Filter. Here we'll focus on more basic ways to increase or decrease the lighting in selected areas of an image.

Dodging and burning is a time-honored way of darkening some areas and/or lightening others. As you do so, you're emphasizing details in some areas and subduing others, which rebalances the energy both from luminosity contrast and from detail and texture contrast. When done with a light touch, this is a highly effective technique for drawing attention to your subject. You can also use it to create a custom vignette.

NONDESTRUCTIVE DODGING AND BURNING IN PHOTOSHOP

There are several popular techniques for digital dodging and burning, but we'll show you our favorite method in Photoshop, as seen in Figure 10. We're partial to it because it's very forgiving—meaning that if you discover you've dodged or burned where you shouldn't have (perhaps over the edge of the subject into the background), it's easy to correct. To save time, you can create an action to set up the dodge-and-burn layers.

1. Create an adjustment layer—you can use any adjustment but we suggest using one that you don't often use—such as Exposure. *Don't make any changes in the sliders.* You're making what we call an "empty" adjustment layer.

2. Rename the layer *Dodge*.

3. Change the blending mode to Screen. The entire image will become too light. Don't panic.

4. Go to Edit > Fill > Use Black and click OK. The layer mask will turn black and the image will return to normal.

5. Create a second empty adjustment layer, but this time name it *Burn*.

6. Change the blending mode for this layer to Multiply. The image will get too dark. Go to Edit Fill > Use Black to fill the layer mask with black and restore the original appearance of the image.

7. Choose the brush tool. Make it soft.

8. Change the opacity of the brush in the tool options bar (as shown in the screenshot in Figure 10) to between 10% and 15%. You want to burn and dodge gradually so you can create natural-looking results.

9. Make sure that the color picker is set to white as the foreground color and black as the background color.

10. Select the *Burn* layer and begin painting over the image to darken areas and/or select the *Dodge* layer to paint to lighten areas. Every time you release the cursor and begin again the effect will be additive.

11. Zoom in to check your results. If you've gone too far or accidentally affected a particular area, change the color picker to black as the foreground color and the opacity of the brush to 100%. Now as you paint over the problematic area, you'll be restoring that area to its original appearance because you're actually painting the layer mask black.

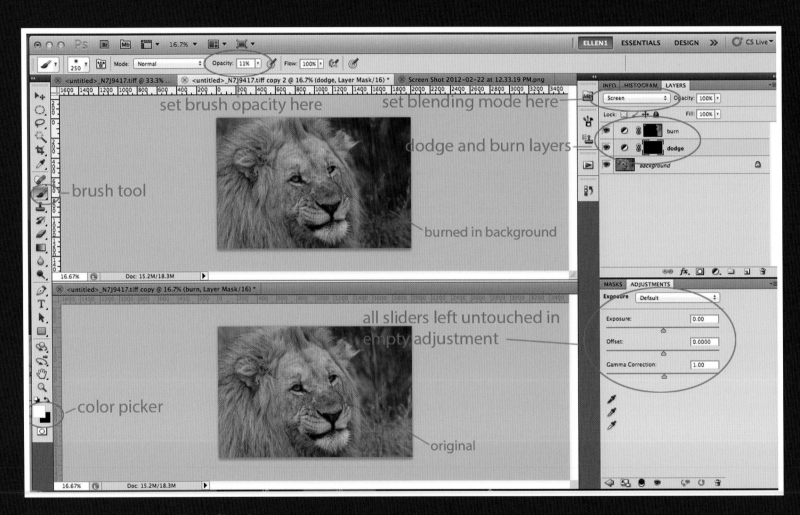

FIGURE 10 Dodge-and-burn method in Photoshop.

In Figure 11 we used Nik Software's Viveza to draw attention to the leopard. We placed Control Points on the leopard and increased its brightness, as well as making slight increases in saturation and warmth. By increasing the warmth slightly as well as saturation and brightness in Viveza, we can create a feeling of sunlight. In other programs you can make similar adjustments affecting brightness, saturation, and warmth one at a time. Doing so increases the energy of the image on the subject, thereby drawing more attention to the subject and helping to separate it from the background. Note that the adjustments don't have to be huge changes. Often small, subtle adjustments get the job done with a more natural and realistic result.

Color Adjustments

Color, as discussed in Chapter Four, plays a huge role in the overall energy of an image. Color can be warm or cool, saturated, muted, pastel, accurate, or creative. Some colors are more energetic than others. As you optimize an image, you are faced with numerous decisions about color. For example, you can correct color casts, alter the white balance to make the image warmer or cooler, saturate or desaturate colors (or remove them altogether and create a black and white image), and/or modify hues. Your choices will impact the overall visual intensity of the image as well as possibly guiding the viewer's eye toward (or away) from your subject.

One of the first color steps to improve the color in an image is to determine whether there is a *color cast* that's creating negative energy within the image—meaning that it increases the visual intensity in a bad way. The image shown in Figure 12A has such a strong color cast that it's difficult to get beyond it and look at the image itself. Removing the

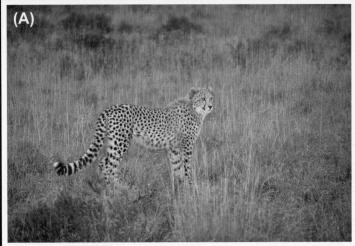
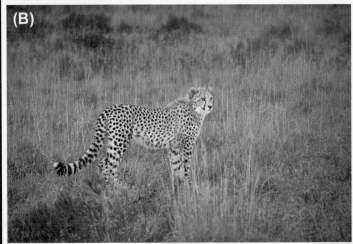

FIGURE 11 (A) Initial image. (B) By placing control points on the leopard and increasing the brightness, saturation, and warmth slightly, we were able to increase the visual intensity of the subject and draw attention to the leopard in a subtle, natural way.

FIGURE 12 (A) Initial image. (B) We used the White Balance eye dropper tool in Aperture on a flamingo's beak to correct the unpleasant color cast.

color cast will enable you to adjust the color saturation so that the visual intensity is pleasing rather than unpleasant. One of our favorite ways to remove a color cast is to use the White Balance eye dropper tool available in Camera Raw, Lightroom's Develop Module, and Aperture, as well as the gray eye dropper in Levels and Curves in Photoshop. By selecting the eye dropper and clicking on something that should be a neutral gray within the image (that is to say, it should be pure gray, whether light gray, dark gray, or in between, without a hint of another color) the software remaps all the colors in the image accordingly. With subtle color casts, this approach tends to work well. We also like the Correct Color Cast slider in CEP's Pre Contrast filter. For fixing an extremely strong color cast, Photoshop's Selective Color adjustment can be helpful.

When removing a color cast, in some cases you're after truly accurate color, but in other you may prefer to leave or even to create a small color cast to warm or cool the overall image. As long as you're using a color-calibrated monitor you can make subjective decisions based on visual preferences. Restoring a pleasing color cast to the image may increase the overall visual intensity, as it did in Figure 12B, but because it removes the unpleasant energy of the color cast, you are willing to look at the image longer.

Color also affects the overall mood of the image. Keep in mind that blues and purples tend to be cooler while oranges, yellows, and reds tend to be warm. On the whole, warmer tones tend to be perceived as having more energy, so if your image uses warm tones, you may need to slightly reduce the energy elsewhere in the image. It's possible to shift the hue of the entire image to make it warmer or cooler and to change the overall energy. Similarly, you can simply modify the hue or

saturation of a specific color to change the energy within the image. You can do this in most programs by taking advantage of any sliders that enable you to modify the hue of specific colors in the total image. For example, in Photoshop you can use Hue/Saturation and adjust the hue overall or in specific colors, or you could use Selective Color or Color Balance. The Hue/Saturation tools enable you to modify specific colors throughout the image. Selective Color is similar but gives you more precise control over the modifications to each color. Color Balance helps limit the color modifications to the highlights, mid-tones, or shadows.

Figure 13 shows an image with the warm colors of sunset and the same shot without the warm colors. (The warm colors were added using the Graduated Filters in CEP.) We think both images are sucessful but there is a noticeable difference in their energy levels. The all-blue version (which has less color contrast energy) is definitely moodier but works even though it has less overall energy and visual intensity. The "blue" hour of sunset captures a particular quiet mood, and if that's what you're after you want to keep the visual intensity a bit lower. It's certainly possible that in some situations you may prefer the cooler tones, but keep in mind that you may want to take other steps to adjust the mid-tone contrast within the image or overall contrast or brightness and so forth to add some energy, if you don't want quite as moody an image.

Working with the colors in an image can modify both its overall energy and draw attention to a particular part of the image. Fortunately or unfortunately, there are no hard and fast rules, only guidelines to help you express your vision as effectively as possible.

When you look at the image, does the overall color appear pleasing or does it need some help to pop? Do all the colors need help or do just some specific colors need to be more or less saturated? Remember that increasing the color saturation will increase the overall energy of the image, whereas more pastel tones have less energy. Removing color and creating a monochromatic black and white (or sepia) image removes one type of energy (color) but may make the image contrast (or lack thereof) even more apparent. This means that you may have to make tonal adjustments in order to create the visual intensity that you're after.

In Figure 14 we slightly increased the saturation of the entire image along with strengthening the color contrast within it. The image went from a bit dull and lifeless to strong, while retaining its time-weathered appearance. We used CEP's Color Contrast to accomplish this, but again, you can use any tools that enable you to adjust the properties of the colors and the contrast in your image.

Facing an image with too much energy in Figure 15, we opted to remove the color, and changed the image into a black-and-white monochrome by using Nik Software's Silver Efex Pro 2. We also used it to vignette the edges. These changes decreased the visual intensity and created a moodier image reminiscent of a bygone era, which is well suited to the subject matter. Entirely removing a single source of energy—in this case, the color component (which is the one most likely to be removed entirely)—means that the visual intensity of the image is dependent on fewer components. When there is too much energy to begin with, this can solve the problem. But for images with more moderate levels of energy, removing the color component may mean that you need to increase the energy from other sources, most commonly the luminosity contrast. One reason we particularly like SEP 2 for monochrome conversions is that the sliders enable us to amplify whites and blacks and increase soft contrast. Thus we can increase the mid-tone contrast without losing highlight and shadow detail. This is often a very pleasing way to augment visual intensity, perceived details, and gradations of light without the luminosity contrast becoming so obvious that it's like getting hit with a two-by-four.

FIGURE 13 The same image (A) without and (B) with the warm colors of sunset.

FIGURE 14 (A) Initial image. (B) A slight boost in the saturation retains the mood of the image but adds enough energy to make it more appealing.

OTHER ISSUES

Cropping

As mentioned in Chapter Five, where you place your subject in the frame is vitally important, since certain areas of the frame contribute more energy than others. Placement can increase or decrease the impact of the subject. But sometimes while photographing, other issues come into play. For example, perhaps your camera doesn't have focusing points toward the sides, and so to use autofocus you find yourself composing with the subject more centered. Or perhaps you did use one of the peripheral focusing points but you'd like the subject even farther to the side. Or maybe you composed the image slightly off center but realize that it needs to be more symmetrical to feel balanced. If you need to add energy to the image, you can change the framing by cropping, or conversely by adding canvas on one or two sides. Doing so changes the relative placement of the subject within the frame.

All the major image-editing software programs have tools for croping an image. Some have overlays for the rule of thirds, golden spiral, golden ratio, and so on that can be helpful as you plan the crop. Even though we often use positions slightly more extreme than the rule of thirds would indicate, because doing so adds to the visual intensity of the image, we still find the rule of thirds overlay helpful.

FIGURE 15 (A) Initial image. (B) Creating a sepia monotone reduced the overall energy to a more pleasing level.

Sometimes people get caught up in believing that they must crop to a certain size, whether to maintain the aspect ratio of the shot or to fit a certain frame size. We believe that, when possible, it's best to crop so that the image has the most impact.

In Figure 16, the crop makes it far easier to focus on details in the cat's face and fur. Without the crop, the background area with all its colors has too much energy and takes away from the visual intensity of the cat. Of course, ideally you'd do this in-camera, but sometimes you have to do it in the software.

We prefer to crop in non-destructive ways, meaning that we like to have the flexibility to return to the file at a later date and modify the crop. Cropping is non-destructive by default in Aperture, Camera Raw, and Lightroom, and is even possible in Photoshop! Photoshop CS6 is set up for non-destructive cropping by default, but you can force it to be destructive if you check the option to delete pixels in the tool options bar at the top of the interface. (We recommend you leave it unchecked.) In Photoshop, to access the entire pre-cropped image at a later time, choose Image > Reveal All or choose the crop tool and then click and drag one of the corner handles on the image if you've not yet closed the file. To preserve the ability to access the uncropped image, you must save the image in a format that preserves layers, such as a TIFF or PSD file. If you save it as a JPEG, the crop will become permanent.

Rotating

Consider rotating your image to increase or decrease visual intensity. Recall Chapter Three and how oblique lines have far more energy than horizontal lines. By rotating an image slightly or dramatically, you can increase or decrease the energy in the image. One of the things we particularly like about Apple's Aperture software is the ability to quickly and easily rotate and crop an

FIGURE 16 (A) Initial image. (B) Cropping this image took a so-what image and made it far more captivating, giving it much greater visual impact.

NON-DESTRUCTIVE CROPPING IN PHOTOSHOP

In earlier versions of Photoshop, non-destructive cropping is also possible. To crop non-destructively in older versions of Photoshop, take these steps:

1. You must begin on an unlocked pixel layer. This means that if you're on the background layer, you need to double-click on the layer in the Layers Panel. In the dialog that appears, click OK. You'll see the name of the layer change to Layer 0.

2. Select the crop tool and draw out the desired crop.

3. In the tool options bar at the top, select "hide" rather than delete.

4. Click Return/Enter to apply the crop.

5. To reveal the entire pre-crop image, choose Image > Reveal All. To be able to do this after you've closed the image, you must save it as a TIFF or PSD with the layers intact. Saving it as a JPEG without layers makes the crop destructive.

image. Often this leads to new and effective compositions. Photoshop CS6 also lets you rotate the image using the crop tool to easily see how much of the image will be preserved. Other programs such as Elements, Lightroom, and older versions of Photoshop enable you to rotate an image, but you must decide ahead of time how much rotation to apply. The beauty of Aperture's and Photoshop CS6's approach is that you can see the results as you're rotating the image and determine the rotation visually by what looks good.

FIGURE 17 —(A) Initial image. (B) Slightly rotating the image so that the major lines of the leaf became vertical, which reduced the number of oblique lines, decreased the overall visual intensity to a more pleasing level. In addition, the rotation placed the ant in a more energetic position in the frame, which attracts more attention to it.

Distracting Elements

Check to see if there are distracting elements in the image. Strong compositions need clear, easily identifiable subjects with supporting elements in the background. No element in an image is neutral. Either it's contributing to the image in a positive way or it's detracting from it.

If there are elements that are distracting—or not actively contributing to the image—consider removing them. Common approaches to removing them include using the cloning or healing tools, or in some cases applying a vignette. Keep in mind that a vignette can be an area near the edges that gets darker than the rest of the image, or it can get lighter, more transparent, or more blurred. Basically, a vignette means that the areas closest to the edges have less visual intensity and energy, and thus guide your eyes inward toward the areas that have more energy.

Taking the time to remove distracting elements can significantly improve your image. We've often said that careful clean-up work with cloning and/or healing is imperative, but sloppy work results in an image that's quickly and scornfully identified as having been "Photoshopped." Telltale signs of careless clean-ups are repeating patterns and sudden areas that don't fit in within the surroundings. Photoshop's Content Aware Healing has gone a long way to making this task easier, but it still involves time and zooming in to 100% magnification to be certain that your changes blend in and appear natural.

Some background elements cannot practically be removed, but may need to be *toned down* so that they can play a supportive role rather than competing with the main subject for attention. You can tone down the background or a background element in a variety of ways, including by slightly darkening it, selectively decreasing the contrast in the background, blurring it, and/or selectively decreasing the color saturation in the background. These actions will reduce the overall visual intensity of the image while helping the viewer see your subject.

In Figure 19A, a shot of the peloton at the Tour de France, the distracting background makes it difficult to focus on the riders. We used Nik Software's Color Efex Pro 4 Vignette Blur filter to blur the edges and decrease the energy in the background. We could have opted to use a vignette to darken the background, but doing so enough to reduce the energy of the background made it feel too heavy. Since in this case we needed to significantly reduce the energy in the background, we opted to go with a blur vignette to create a selective focus effect. On the other hand, most of the time when we use a vignette we do it subtly, barely darkening the edges—just enough to make the viewer's eyes naturally seek out a subject that is slightly brighter. In most cases, we prefer subtle vignettes rather than something that looks like a cut-out from a craft store. You want the attention and energy to be associated with the subject, not the effect that you apply!

When it's your own image, there is a tendency for you to see what you expect to see and what you're looking for, so a distracting background may not seem that awful to you. But another viewer, who is not emotionally invested in your particular image, may find that it's hard to focus on the subject because she keeps being drawn to the background. So if you even begin to wonder if a background is distracting, chances are that it is!

FIGURE 18 (A) Initial image. (B) Removing the blurry tail feathers of another penguin along the left edge and the bit of rock in the bottom left corner make this a far stronger image. The original image has too much visual intensity due to these distracting elements.

FIGURE 19 (A) The original image has a lot of distracting detail in the background. (B) A vignette blur reduces the visual intensity of the image to a more pleasant level by decreasing the background detail, texture, and luminosity contrast.

SUMMARY: PUTTING IT TOGETHER

Before optimizing your image, we suggest you look at it and develop a game plan to create the optimal amount of energy within your image. Chances are that you're going to need to do several things to help draw as much attention as needed to your subject and to give the overall image the amount of visual intensity and impact that you envision. We recommend the following steps:

1. Look at the image and decide whether your first impression is that it has too much energy, too little energy, or that the overall energy level is good.

2. Check to see where your eye travels through the image and where it lands.

3. Check the exposure and histogram to evaluate how much of the tonal range is being used. For most images, you'll need to adjust the exposure so that the complete tonal range is used. Keep in mind that moody images may require less tonal range.

4. Evaluate the mid-tone contrast in the image. If the image needs more energy, consider making a Curves type of adjustment in Photoshop, or another adjustment that increases mid-tone contrast. To draw attention to the subject, consider selectively applying the adjustment to the subject alone.

5. Evaluate the color in the image. Consider increasing (or decreasing) saturation or vibrance or adjusting the overall hue or white balance, when appropriate, to increase (or decrease) the visual intensity of an image.

If there is an objectionable color cast, remove it. This may slightly decrease the visual intensity of the image, but doing so will enable you to work with the saturation or vibrance adjustments to adjust the energy contributed by color.

6. If the image initially has too much energy, consider removing the color and creating a black-and-white or sepia image. This will increase the importance of the tonal contrast in the image but remove the energy contributed by color.

7. Consider the subject placement within the frame. Objects closer to the sides tend to have more energy. To increase the visual intensity of an image with a smaller subject, you may want to crop the image, or conversely add canvas to place the subject off center. With a larger subject, you may want to follow the same approach to place a key element of the subject, such as their eyes, at a power point in the image. Subjects that are centered often appear more static and calm, contributing less energy to the image.

8. Experiment with rotating the image to increase or decrease the visual intensity. Doing so may impact the visual story of the image.

9. Remove or reduce all distracting elements by cloning, vignetting, or selectively adjusting the background to reduce contrast within it.

10. Increase detail, particularly in your subject, using Clarity (Photoshop, Lightroom, Elements), Definition (Aperture), Color Efex Pro 4 > Detail Extractor (Nik Software plug-ins), or Topaz Adjust 5 to increase the visual energy in the image, or decrease detail to reduce visual intensity. There are numerous software plug-ins that allow you to reduce detail in various ways, and we'll cover those in more detail in Chapter Eleven, since they tend to involve more creative interpretations of your images.

FIGURE 20 (A) Initial image One. (B) Revised and improved image One.

Let's look at a couple of images and create a game plan for them.

Image One

Game plan: Initially the visual intensity seems a bit too high because of the distracting piece of the plane wing, but the intensity in the rest of the image seems a bit low. There is a distracting color cast from the window tint that we need to fix, and then we need to increase the mid-tone contrast slightly.

We cropped out part of the plane wing because there was more sky than we felt we needed, and then used the clone and healing tools to remove its remnant. Although there are many tools you could use to address the mid-tone contrast as well as the color cast, we used CEP > Pro Contrast > Remove Colorcast and Dynamic Contrast to do both. As a final touch we applied a small amount of CEP > Polarizer filter.

Image Two

Game plan: The initial overall visual intensity seems moderate, but when we look more closely the image itself seems to lack mid-tone contrast and impact. In fact, the luminosity contrast is too low. The additional intensity that we initially note is from the seagull, which adds too much energy to the composition.

FIGURE 21 Initial image Two. (B) Revised and improved image Two.

It's distracting. The game plan is to remove the seagull using the Patch tool in Photoshop. Then we'll add mid-tone contrast, address the hint of a color cast, and slightly boost the colors.

Although there are many tools that you can use to increase mid-tone contrast, including Curves, we often find using CEP more efficient. We applied the Pro Contrast > Dynamic Contrast and Correct Color Cast sliders. We also applied a small amount of CEP's Tonal Contrast (set to Balanced Contrast) to further energize the mid-tone detail. We used the saturation slider within the Tonal Contrast filter to help boost the colors. The final image has greater visual intensity from the additional visible detail and the luminosity contrast.

Exercises

1. Pick five images that you like and rate the overall level of energy in each on a 1–to–10 scale, keeping in mind that 1 means the image is very dull and 10 means it's so busy that you don't know where to look.

2. Repeat with five images that you don't like. Is it possible that you'd like these images more if they had more or less visual intensity?

3. Look at the five images that you like, one at a time, and note where you first look and then where your eye lands. What element is initially drawing your eye and what ultimately holds it in one area?

4. Practice developing a game plan for three images, and then go ahead and optimize them. When you're done, check to see your gut-level reaction to the total visual intensity of the images, and where your eye goes.

Going Beyond with Creative Digital Techniques

- Extending Dynamic Range 296
- Single Image Processing 300
- Increasing or Decreasing Details 302
- Adding Texture 308
- Combining Elements 312
- Relighting an Image 315
- Blurs and Reducing Details 317
- Exercises 325

Today's digital darkroom enables us to go far beyond making basic exposure adjustments to our images. There are all sorts of techniques that we can use to make each image more expressive of our individual vision. Many of these tools maintain the realistic look of the image, whereas others are more creative and venture into an area that combines photography and digital art. Keeping the principles of visual intensity in mind when applying these techniques helps create "WOW!" images, rather than images that just look over-processed.

(A)

(B)

FIGURE 1 (A) Some scenes that are beautiful to our eyes have too much contrast to be captured in a single shot by a camera. (B) When you view the histogram, you'll see that it appears to be cut off at both ends. That means you're missing details in both highlights and shadows.

In the last chapter we covered applying the principles of visual intensity to guide your game plan for optimizing each image and making basic adjustments. Now we're going to look at techniques that go beyond the basics to add impact to your images. You should consider these techniques jumping-off points rather than rigid rules. In many cases, you can achieve similar results using other software programs. We strongly recommend that you download trial versions of the various programs that we mention and take them for a test run before you buy them. Then take our ideas and grow with them, individualize them, and make them work to express your vision!

EXTENDING DYNAMIC RANGE

One of the issues that we face when translating what we see into a photograph is that our eyes see far more luminance values than even the best camera can. Nearly every novice has had the experience of thinking that a brightly lit scene looks quite impressive, reaching for a camera and taking a shot, expecting it to reflect the drama of the lighting, only to discover that the camera rendered the shadows as deep dark blacks and the highlights as blown-out whites. All too often, a situation that looks dramatic and spectacular to our eyes can look either too contrasty or too flat as a photograph. As discussed in Chapters Two and Six, a scene can have a huge dynamic range, but your camera can only capture about ten stops. It's fairly well known that subtle details in shadows and highlights may be lost because of this, but what's less frequently considered is that subtle mid-tone differences may be less apparent as well. Restoring details to the highlights and shadows, and/or enhancing the visibility of details and texture in the middle of the tonal range can increase the energy of an image by converting an area that's just one shade, or black or white, into one with more tonal gradations. This gives your eye more to look at and emotionally react to, which adds to the visual intensity.

Consider a scene like the one in Figure 1. Your eyes see potential for a good image; in fact, you may be quite taken with the beauty of the moment, but your camera captures something quite different. The image has large areas that are too light and others that are too dark. Although the overall level of energy in the image is moderate, it's unpleasant. When you ask what components are contributing to that energy, you quickly see that most of it comes from luminosity contrast and not enough from detail, texture, and/or color. We need to decrease the luminosity contrast by extending the dynamic range in the image and then consider increasing the energy from other components such as color and/or detail to make sure the intensity doesn't become too low. Creating a high dynamic range (HDR) image will decrease the extreme luminosity contrast and increase the detail, texture, and color information.

To extend the dynamic range of an image, you can either combine data from several images captured at different exposures or you can work with a single image in a variety of ways.

Combining Multiple Images

If you check your histogram while shooting and see that there are spikes at one or both ends and that the graph appears to be cut off, in many circumstances you can take a series of images at different exposures that you will combine later on with your computer. (A few cameras, including the iPhone, are capable of combining the shots immediately in-camera.) Ideally, you'll take one shot that is exposed so that you capture all the highlight detail, even though the rest of the image may be far too dark (meaning that there's no spike on the right side of the histogram), one exposed so that you capture all the shadow detail, even though the rest of the image may be far too bright (there's no spike on the left side of the histogram), and one or more in between. Use your meter or histogram to determine the dynamic range of the scene, and then take images that are about a stop apart. It's best to vary the shutter speed rather than the aperture so that the depth of field remains the same and the images can be easily combined. It's also a good idea to keep the white balance the same by using a specific white balance setting rather than "auto," and switch to manual focus so that you maintain the same focus point.

There are numerous programs capable of creating HDR images. Adobe Photoshop even has a built-in tool, Merge to HDR Pro, that will quickly turn a group of images into an HDR image. Another option is to stack the images as layers in Photoshop or Elements and then combine them manually, using layer masks. This can be a painstaking process, but in some cases offers the most control. We sometimes use that approach when creating semi-transparent flower images photographed on a light box. Our current favorite programs are Nik Software's HDR Efex Pro and HDR Soft's Photomatix Pro. We find that Photomatix is sometimes faster and easier, but that we have far more control over the results when using HDR Efex Pro since it lets you drop control points, which automatically mask parts of the image and let you choose which algorithm to use to combine the images.

No matter which program you prefer, the overall process is quite similar. Information is taken from each of the exposures as shown in Figure 2 and combined into a single image with increased visibility of details in the highlights and shadows, as you can see in Figure 3. Thus, the foundation of visual intensity is based less on an over-abundance of luminosity contrast and more on increased detail, texture, and color information.

All HDR processes run the risk of adding too much information and altering the expected balance of luminosity contrast so that there is too much energy in the final result. Depending on the settings you pick, you can create very different looks when creating an HDR image. While some people prefer a natural looking result and others a more stylized grunge effect, you must be vigilant to not create chaos! When you increase the tonal gradations in an area of the image, you increase the energy associated with that area. So if you apply strong HDR settings to both your subject and the background, you may unintentionally cause the background to fight with the subject for attention or even to overshadow it.

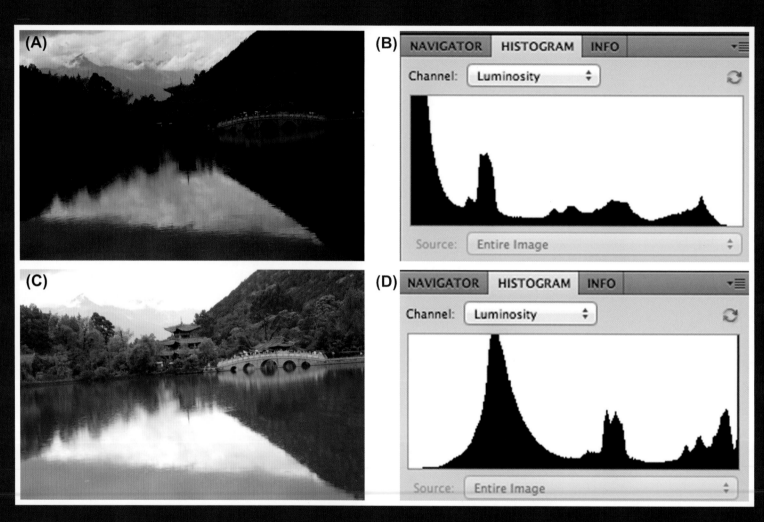

FIGURE 2 In addition to the shot in Figure 1, we also took two other exposures, (A) and (C), to capture highlight and shadow detail. Their respective histograms show that one (B) captures all the highlight information, and one (D) all the shadow information. We'll combine all three images to create a single image with more detail through the entire tonal range.

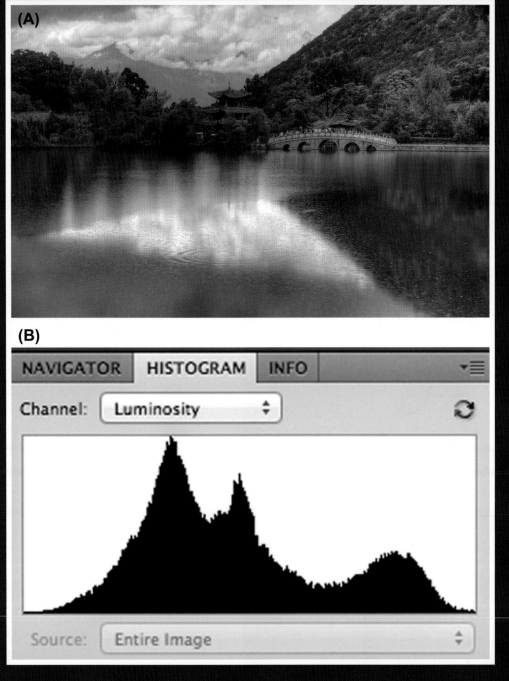

FIGURE 3 (A) This version of the image looks like what we saw with our eyes. (B) Note how the data have been redistributed throughout the histogram so that it tapers off toward both ends. Its visual intensity is higher than any of the components due to the increase in detail and color information even though the luminosity contrast has been reduced.

FIGURE 4 By over-processing the HDR image (A), we no longer use enough of the tonal range to provide good luminosity contrast (B). What should be background elements (the clouds) now have far too much energy, and they compete for attention. The image is chaotic.

The other major issue with many HDR processed images is that the shadows no longer look like shadows, and highlights may not look like highlights. As discussed in Chapter Two, we are accustomed to seeing certain amounts of luminosity contrast. Just as the initial single image from the camera in Figure 1 doesn't reflect what we saw with our eyes, many HDR images go too far and create images with far less contrast range or tonal variation than we expect to see, and so they look unnatural and over-processed.

We have deliberately gone way too far with the HDR processing in the version in Figure 4 to emphasize the potential risks. We have revealed more details (and halos and saturation) but decreased the luminosity contrast too much. Note that the image now uses too little of the tonal range—there are very few pixels in the darker third of the tonal range or in the lightest quarter. That means that we've lost a great deal of mid-tone contrast. Although the luminosity contrast is too low, the detail/texture contrast is too high. In addition the clouds are far too intense and draw your attention away from the subject. The overall energy of the image is too high and it also looks unnatural because the areas we expect to see as shadows are mid-tones, we can't see enough difference within the mid-tones, and the bulk of the image looks flat. Too much of a good thing is often not a good thing at all! Use HDR wisely so that it's not overdone.

SINGLE IMAGE PROCESSING

There are a variety of techniques available that help bring out the details and that may alter the luminosity contrast in a single image. One approach is to convert a single RAW file multiple times using different exposure settings and then combine those versions using software as described previously for multiple images. Alternatively, many HDR programs, including

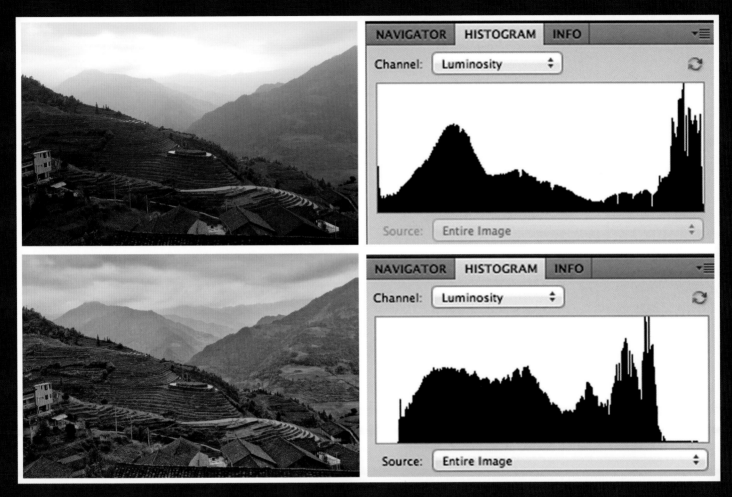

FIGURE 5 It's possible to use HDR programs with a single image to increase the visibility of details in the highlights and shadows. Doing so will often increase the visual intensity of the image.

Photoshop (Image > Adjustments > HDR Toning), as well as Nik's HDR Efex Pro and Photomatix Pro will process a single image. Just as for combining multiple images, the trick is to keep an eye on the overall energy level of the image as you use the software so that the final energy level doesn't accidentally creep up too far and/or you don't lose your shadows totally. You want to create impact, but not so much that your audience feels like they've been hit over the head with a baseball bat.

Look at the original image in Figure 5. It's fairly bland and lacks energy. Further, there's very little detail in the sky. The foreground details, the textures and the various shapes all contribute some energy to the image, but it needs more. In order to improve its visual intensity, we need to brighten some of the darker details so that they stand out and reveal more detail in the sky. We used HDR Efex Pro to increase the saturation and the perceivable details, particularly in the mid-tones, as well as slightly in the highlights and shadows, thus increasing the overall visual intensity of the image. Single image toning often works well when there is a fair amount of data near the ends of the histogram but most, if not all, of the information has been captured in the single shot.

INCREASING OR DECREASING DETAILS

Adobe Camera Raw (ACR), Nik Software, Topaz Labs, and various others offer filters that claim to increase (or decrease) the perceived details within an image. These differ in the extent to which they modify the original luminosity contrast of the image while enhancing the details. The results can be similar to single-image toning from an HDR program, but on the whole these tools tend to retain the sense of shadows and highlights more readily than single image toning. Most increase the localized contrast to give the impression of increased detail and are applied more selectively by the software than single-image toning, which is applied equally to the entire image. The more detail, the more energy the image will have. These filters can often yield impressive results, but regardless of which program you use you do have to be careful not to create artifacts.

Similarly, if the initial energy level of an image is too high, one way to decrease it is to use these tools to decrease the amount of detail so that other elements, such as color, lines, and shapes, become the prominent aspects of the image. We'll take a closer look at some of these tools because we find that these are often key adjustments in taking your images up a notch.

Nik Color Efex Pro Tonal Contrast

One of our favorite approaches to expanding the visible detail in an image is to adjust the tonal contrast separately for the highlights, mid-tones, and shadows. This could be done using a series of intricate curves, but we find it far easier and faster to use Nik Software's Color Efex Pro 4 (CEP) Tonal Contrast filter. By adjusting the sliders, you quickly determine how much tonal contrast to reveal in each segment of the tonal range. That way you can directly control how the highlights, mid-tones, and shadow areas are affected. In addition, you can choose among several different types of contrast (standard, high pass, fine, balanced, and strong) for slightly different results. We find this often makes a huge difference in the impact of the image, even when using subtle settings. It usually gives the impression of increasing the amount of detail, which thereby increases the visual intensity, while maintaining a believable, natural image. (Note that in our opinion the default settings are almost always too strong.) Of course you wouldn't want to use this filter on someone's skin in a portrait, but applied selectively to their hair or eyes it may be impressive. As always, the key is to be very aware of how much energy you're adding to the image.

Clarity Slider

The Clarity slider in Adobe Camera Raw and Lightroom, and the Definition slider in Apple Aperture increase mid-tone contrast, meaning that light tones get lighter and dark tones get darker but the effect is modulated so that pixels don't become pure white or pure black without detail. You can see this by watching the histogram change as you pull these sliders from one extreme to the other. The distribution of pixels will change so that pixels are slightly shifted away from the mid-tones toward the extremes, but not so that any clipping is created. Visually these tools often add a sense of slightly

FIGURE 6 Using the Tonal Contrast filter, we selectively increased the visibility of details within the highlights, mid-tones, and shadows. Doing so increased the visual intensity of the image by increasing the amount of detail and texture perceived.

FIGURE 7 (A) Initial image. (B) By using the Clarity adjustment in ACR, we revealed more mid-tone contrast energy and mid-tone details. It's often a subtle effect, which can make a huge difference.

increased sharpness and/or detail, as well as slightly increasing saturation. Used to an extreme, these sliders may create artifacts, but used gently they can seem almost magical as they gently increase mid-tone contrast. By creating the impression of more detail, they increase the energy in an image. When done carefully, these tools can add just enough energy to make an image pop.

Let's consider the image in Figure 7. It's a good image, and the overall energy level is moderate. But it feels just a little bit bland. Looking at it leaves you with the sense that there's nothing obviously wrong with the image, but it probably won't hold your attention for too long (unless you were looking at it trying to figure out what's wrong!). That's often the sense you'll have when the mid-tone contrast of an image needs to be increased. The image will seem "nice," but you want to quickly move on. In fact, it needs more mid-tone contrast to emphasize some of the mid-tone details.

At times you may want to emphasize details or mid-tone contrast just in your subject, to help draw attention to it. To apply Clarity locally in ACR or Lightroom, use an Adjustment Brush and set the strength as desired. Note that you can set a negative value for the slider and this will reduce the detail. If you brush in negative clarity in the background areas, by comparison, the areas you don't brush over (the subject) will appear even more detailed. If you're concerned about adding too much energy, subtly reducing the amount of detail in the background may work well to help draw attention to the subject without making the image too busy.

In Aperture you can achieve similar results by brushing in the Definition adjustment wherever you want to increase detail. To decrease detail in areas, click the Brushes icon, choose Blur, and brush over the areas you wish to blur.

TIP

As we mentioned in Chapter 10, one of our favorite tricks for making an image pop is to increase the mid-tone contrast, whether in Curves or by using the Clarity or Definition slider, single-image toning, or Tonal Contrast. Although the Clarity and Definition sliders are quick and easy ways to add mid-tone contrast, they offer fewer options for control than Tonal Contrast or single-image toning.

Nik Color Efex Pro Detail Extractor

Sometimes you'll want to make more dramatic changes, with more controls, than are possible with the Clarity and/or Definition sliders. CEP's Detail Extractor filter is one of our favorite ways to increase the visibility of details. As the name implies, it emphasizes details throughout the image, and it does this by striving to balance the tonality of each area. If you have an image with uniform tonality, applying the Detail Extractor won't change the overall luminosity contrast of the image significantly. However, if you have an image in which there are some areas with considerable tonal variation, applying the filter will rebalance all of the tonal levels within that area, which will then affect the overall luminosity contrast. As the luminosity contrast is changed, its contribution to the overall visual intensity may decrease while the energy coming from details may increase. It becomes important to be aware of which parts of your image now have more visual intensity and which parts have less.

As shown in Figure 8, when using the Detail Extractor, set the Effect Radius controls to Fine to bring out as many details as possible, Normal for a moderate amount of detail, and Large to emphasize just the larger details. The best setting depends on the particular image. The Detail Extractor (DE) slider is the main control, or the "throttle" determining how much detail is emphasized (and how much luminosity contrast is adjusted). By adjusting the Contrast slider, you can increase or decrease the overall luminosity contrast, which can mitigate some of the loss of luminosity contrast introduced with the DE slider. It's convenient that Nik includes a Saturation slider in the interface, since you can use it to boost (or lower) the amount of energy coming from color saturation within the image to maintain a pleasing overall level of visual intensity. We also find it quite helpful that you can use the Control Points to apply the Detail Extractor just to localized areas or to temper its effects elsewhere. In this way you can ensure that you're creating the desired level of intensity for your subject and background so that they readily separate from one another.

Topaz Detail 2

Topaz Labs' Detail 2 is a plug-in devoted to detail enhancement or suppression. As you can see in Figure 9, there are numerous presets for emphasizing or smoothing out details that serve as good starting places. On the right side of the interface there are six sliders to control the strength of the detail adjustments. The Small, Medium, and Large Detail sliders allow you to determine which areas are considered small, medium, or large details. A quick pull of the sliders to the extremes lets you see what this means for your particular image. The associated Boost slider then accentuates (or suppresses) these details. Often a very light hand is helpful with the Boost sliders. Be particularly careful with the Small Boost slider because it can aggravate any noise issues present when pulled to the right—of course moving it to the left can reduce some noise, but it may remove details as well. Topaz Detail 2 contains additional sliders to let you modify the overall brightness and white balance, as well as to protect highlights and/or shadows and modify saturation and de-blurring. Thus, you can control the overall luminosity contrast as well as color contrast while increasing or decreasing the apparent details in the image.

Although the adjustments in Topaz Detail 2 are applied to the entire image, as you can see in Figure 9 it's possible to increase details selectively—as with the raccoon's fur—by adjusting the detail size sliders. Alternatively, you can use this adjustment on a new layer and then use a layer mask to reveal the adjustment only in certain areas.

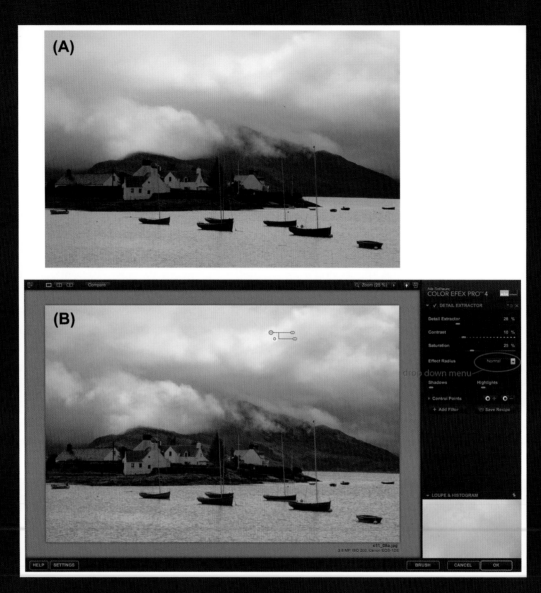

FIGURE 8 (A) Initially the image was of low visual intensity, lacking enough detail, color saturation, and/or luminosity contrast. (B) We used the Detail Extractor to bring out the details throughout the image as well as to add some contrast and color saturation. Now the image has more energy and is more interesting to view.

(A) Initial image. (B) By adjusting the Small Detail slider in Topaz Detail 2 we were able to emphasize the details in the raccoon's fur wi[th]... [ex]tracting details to the background. This adds visual intensity to the subject and helps it to stand out from the background.

We suggest that you experiment with the various ways to add detail and decide which you prefer. When increasing detail in your images, be careful not to let the overall visual intensity of the image creep up too high. In addition, be certain that you don't energize the background with so much detail that it competes with the subject for attention.

ADDING TEXTURE

Sometimes you're faced with an image that's nice but which has relatively large areas that lack significant texture or detail. Increasing the detail in the subject alone may not be enough. One option is to add a texture, particularly to the background. Although this will obviously increase the energy level coming from texture in the background, surprisingly it may decrease the contrast between the amount of texture in the subject and the amount in the background. Sometimes this helps make your subject feel more integrated into the background, rather than an isolated object, while maintaining a pleasing overall level of visual intensity. In addition, it tends to give the image a painterly feel.

Adding a texture is not a new technique. The Victorians also purchased glass plate textures that they used in their darkrooms. Masters of film photography such as Freeman Patterson often stacked two slides—one a photograph of the subject, the other of a specifically chosen texture—to create a final image that was often mystical and far beyond the ordinary. Since the two slides were sandwiched together, in essence doubling their density, each slide needed to be over-exposed. The trick was to determine how much to over-expose each image, which made for a lot of trial and error to prevent the texture from overpowering the subject, while still remaining visible. And of course you had to carefully consider the color of the "texture" slide, as it would greatly impact the visual intensity of the final result as well. These hurdles limited the popularity of the technique.

Creating a texture composite is much easier in the digital darkroom since you can modify the exposure of the individual images after the fact and precisely control the way in which they are blended together. You can balance the intensity of the texture effect with the energy of the subject and opt to apply it just to the background areas if you wish. Keep in mind that adding a texture changes not only the energy from texture contrast but the relationship between the subject and the background. It may also alter color characteristics, thereby changing the energy coming from color, and it can alter the luminosity contrast by filling in very light areas with texture, but darkening dark areas still further. Knowing this means that, as you apply a texture, you need to reassess these sources of energy and make modifications (such as applying a layer mask) to retain an overall level of visual intensity that you find pleasing.

With some images you may wish to experiment with additional textures and/or filter effects such as glows and lighting. At this point you are an artist painting with pixels and the final appearance of your image depends on your vision. The key is to reassess the image and be certain that you're heading in the right direction. Compare the original image and the processed version. Do you prefer the original? If so, try to figure out where you went wrong. For instance: have you added too much texture? Is it in the wrong place? Does the color cast fight with the image?

When experimenting with textures, it can be very easy to get so involved with the process that you lose sight of the image. We suggest that you take a break and physically walk away from the computer after you've been working for a while, but leave the image up on full screen. Then when you return, immediately rate the overall energy of the image. Is it good or does it need to be adjusted?

Done carefully, adding textures is a way to modify the energy within an image while maintaining the focus on your subject matter. You can create your own textures (as we describe in the sidebar on page 318) or search the Internet for both free textures and others that are for sale. Some sources that we currently like are www.shadowhousecreations.blogspot.com and www.flypapertextures.blogspot.com.

FIGURE 10 (A) Initial image. (B) Texture. Adding a texture to the background increased the overall energy of the image but simultaneously helped integrate the pansy with the background. (C) Adding a texture often creates more of a story and that adds visual interest to the image. We think the version with the added texture is a lot stronger.

ADDING A TEXTURE

The basic technique for adding a texture is simple. In Photoshop or Elements, you open your image and one or more texture images and combine them using various blending modes and opacities.

1. Open the primary image and perform any desired image clean-up (dust and spot removal, etc.).

2. Open the texture image and perform any desired image clean-up.

3. Choose the Move tool (press V) and drag the texture on top of the image file.

4. To quickly resize the texture layer to be at least as large as the image file, choose Edit > Transform > Scale. Drag the handles to resize the layer and press Enter/Return to apply the transformation. If the texture has a varied pattern to it, consider making it larger than the primary image. That way you can use the Move tool to move the layer and fine tune its position relative to the background image.

5. Change the Blending Mode in the Layers Panel to actually combine the images (see Figure 11). You'll soon develop favorites, such as Darken, Multiply, Screen, Overlay, and Soft Light. But you may want to experiment with seeing all the possibilities. We often choose Overlay or Soft Light.

6. Initially the effect may be too strong and the visual intensity of the image may be too high, in which case you'll need to reduce the opacity of the texture layer. Doing so helps return the overall energy of the image to a more pleasing level.

7. You may want to flip, rotate, or adjust the position of the texture layer. To do so, click on that layer, and choose Edit > Transform > Rotate or Flip.

8. If you want to reduce or remove the texture from part of the image, such as the subject, add a layer mask to the texture layer by clicking the Add Layer Mask icon at the bottom of the Layer Panel. Select the Brush tool, make it a soft brush, and adjust the size. Then click the black and white color swatches at the bottom of the Tool Panel (or press D) and then make sure black is in front. Be sure that the layer mask is selected (it will have a square around it in the Layer Panel). On the Tool Options bar at the top of the interface change the Opacity to 50% or less and begin painting over the subject. Press Control/Command + Z to undo if the effect too strong or not strong enough, and adjust the brush opacity setting accordingly.

9. Sometimes the texture layer will alter the color and/or luminosity contrast too much. To change the contrast or color of just the texture layer (so that it will blend more easily), select the texture layer, and then add the appropriate adjustment layer (Curves, Hue/Sat Vibrance and so forth). Press the clipping icon (located in the Properties Panel in Photoshop CS6 and in the individual Adjustment Panel in earlier versions of Photoshop, as shown in Figure 11) to clip the adjustment layer to the texture so that it affects the texture layer only and not the entire image. Adjust the settings as desired. By applying adjustment layers directly to the texture layer, you can make the color and/or luminosity effects more subtle.

CREATING YOUR OWN TEXTURES

You can photograph almost anything to use as a texture—from paper towels to wooden siding to concrete to sand to clouds. Let your imagination soar! The texture we used with the pansy was a photo of a textured glass window. If you're not sure that something will work as a texture, photograph it and give it a try. Fill the frame with just the texture. Try different angles and compositions, and getting closer as well as farther away. The more choices you give yourself to work with, the better. Be sure to keep your camera parallel to the plane of the texture so that the entire texture will be in focus—generally f/8 is adequate. If, however, you cannot hold the camera parallel to the texture, then you may need to shoot at a smaller aperture to get adequate depth of field.

FIGURE 11 Screenshots for Adding Textures in Photoshop.

FIGURE 12 (A) Without the bird, the image is boring and lacks a story. (B) With the bird, we have a story and a comfortable level of visual intensity.

COMBINING ELEMENTS

Before we even start this section we are going to acknowledge up front that some people are not comfortable with adding elements to images, and that's perfectly fine. You might still want to read through the section so that if you're in the field creating a similar image you know what circumstances you're hoping will occur naturally or can take steps to make it happen. Obviously with forensic, natural history, or photojournalism images you won't be adding elements in the digital darkroom. But in the field you could position yourself and time the image to take advantage of existing elements.

Sometimes you capture an "almost" image. You look at it and there are lots of aspects of it that you like, but something seems to be missing. It's a little boring. The overall visual intensity feels just a little bit too low, but when you look at the basics—the luminosity contrast, texture, detail, and color contrast—they all seem to be fine. What may be missing is a place for your eyes to land—that is, a clear subject to complete the visual story. We've noticed this particularly with landscape images where the background is lovely but there's not an obvious subject. In such cases, it's the energy from a clear visual story that's missing, or if it's not completely missing it needs to be increased.

For example, consider the image in Figure 12. The photographer, Jack Anon, was captivated by the beautiful soft early morning light reflecting in the stream and the lovely framing provided by the vegetation along the sides of the water. The trees and water form great leading lines and somewhat triangular shapes and lead us into a point in the image. But when we get there, there's nothing. Visually we're let down. Something's missing. The design of the picture led us to expect something there but didn't follow through.

When we added a bird to the image—small and silhouetted—in keeping with what you might have seen naturally if you were there—the image becomes far stronger. That small silhouette increases the visual intensity of the image by adding a subject to give us a visual story. Tons of birds everywhere might have been too much, but a single flying bird and its reflection maintain the calm, serene mood while preventing the image from being boring. It adds the story to the sunrise.

At times an image will have subject matter and background, but the background (or the subject) needs something to help with the story that the image is telling. It might be what seems like a minor detail, such as a moon or clouds in the sky, but it adds to the completeness of the story, and as such it increases the visual intensity just enough by giving us a little more information. Consider the image in Figure 13. Although we have enough energy (luminosity, detail, color, form, and story) in the foreground, the image with a detail-less sky is just a little low in visual intensity. We don't need to add a blue sky and cumulus clouds or a vivid sunset—that would be inconsistent with the lighting in the image. Rather we can just add a different gray sky that has some interest to it, with more luminosity contrast and shapes. The sky remains a background element but enhances the overall energy of the image.

Similarly, the moon adds to the impact of the image in Figure 14. However, this couldn't exist in reality, so it's important to make it clear that this is not a photojournalistic shot. We sometimes slightly exaggerate the size of the moon in such cases to add to the surrealistic feel. You can opt to add a moon as realistically as possible or you can exaggerate it for effect. But when you add a component, be honest about it!

FIGURE 13 Without the clouds the image is okay (A), but with the clouds (B) the story is more complete and the image is more dramatic. The clouds provide a small but vital increase in the visual intensity.

FIGURE 14 We added the moon because the leading lines of the bridge carried our eye across the image, but there was nothing there. It seemed to ask for a moon, so we added one, knowing that for some people this crosses the line. For us, it's an artistic rendition, not a documentary shot.

Clearly, every image doesn't need a bird, a moon, or puffy white clouds added. But when the initial visual intensity of an image is too low, such elements can increase subject energy and make all the difference. We suggest maintaining a file of elements that you might want to add to other images. Shoot full moons and crescent moons, all sorts of clouds, and anything you can think of that you might add to the type of images that you take.

ADDING AN ELEMENT

To add an element to an image, open both the image with the element and the main image. Use any of the selection tools to select the object. We suggest using the Refine Edge tool in Photoshop to carefully examine the edges to ensure that there are no telltale colors from the background of the other image and to soften the edges to make them appear more natural (See Figure 15). Then drag the element onto the main picture using the Move tool (V). Use Edit > Transform to scale and reposition the element so that it becomes an integral part of your image. (For more details on techniques for creating composites, see our book, *Photoshop CS5 for Nature Photographers: A Workshop in a Book*, Anon and Anon, Sybex, 2010.)

FIGURE 15 Screenshot showing adding an element to an image

When selecting an element to add, be careful to make sure that the lighting on it is from the same direction as the rest of the picture unless it's logical that it would be lit by an outside source. (You don't want to imply that you were photographing on a planet with two or more suns!) Similarly, be certain that the white balance and color casts are compatible; if they aren't, take the time to correct them in Photoshop.

RELIGHTING AN IMAGE

As we covered in Chapter Six, lighting is critical to the success of an image. It may make or break it as well as influence the story and the mood. Obviously, it's important to do your best to use and capture perfect lighting while taking the image in-camera. But sometimes you realize after the fact that the lighting is not quite what it needs to be. Perhaps the lighting on the subject is just subtly darker than elsewhere in the image or perhaps the lighting was flat and the subject just doesn't stand out enough from the background. When you look at the image, you see the subject, but your eye wanders elsewhere to background elements.

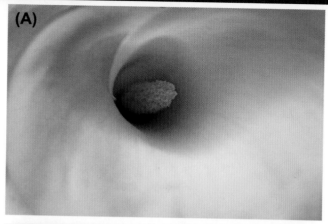

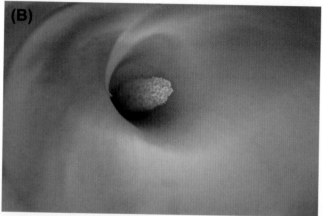

FIGURE 16 (A) Initial image. (B and C) A point light adds the necessary energy for the image to go from blah to pleasing and directs our attention to the center of the flower.

One way to adjust the energy associated with the subject is to make it slightly brighter than the background.

There are some basic tools that we covered in Chapter Ten, such as dodging and burning or making targeted exposure adjustments using a layer mask, that can help adjust the lighting. But one of the most impressive tools we've found is the Lighting Effects filter found in both Photoshop and Photoshop Elements 10. The difference between adding lighting effects and the other more basic tools is that the appearance of the light falloff is often far more natural than you can easily achieve with the other tools. In Photoshop, you access this filter from Filters > Render > Lighting Effects. Adobe extensively revised this tool in CS6, and for us, it's a major reason to consider upgrading.

You have the choice to add various types of lights to the image, much as you might use in a studio (with the exception of backlighting). For example, the flower image in Figure 16(A) lacks visual intensity because the part of it that holds the most promise to be interesting, where there's some color and texture, happens also to be in shadow. By adding a point light to the flower, we change the balance of the lighting, which helps keep the viewer's eye on the interesting part of the image and increases the associated energy by making it brighter.

When using the Lighting Effects filter, we find point lights to be easier and more intuitive to use initially, but you may find spotlights quite helpful for more dramatic effects, as shown in Figure 17. (The different styles of lights have different falloffs and spreads.) Every time you click on one of the three lighting icons near the top of the interface, you add a light. You can then reposition each light by clicking and dragging it. There are on-screen controls to

resize, reposition, rotate, and modify the intensity of each light. That way you control the angle and intensity of the light, where it originates, and the ending point. There are additional sliders on the right side of the interface that allow you to adjust other parameters, including the color of the light. That way you can tint the light to emulate sunlight, or any other type of light. We often choose a subtle yellow to add a warm tone, but you can use whatever color would be consistent with the existing lighting in the image.

The Lighting Effects filter is a powerful tool that can be used to add subtle or dramatic lighting modifications, adjusting the overall visual intensity of the image by altering the relative brightness of an area as well as the mood of the image. In addition, they can help focus the viewer's eye on the subject as in Figure 16 and Figure 17. Keep in mind that since you can't recreate depth with a flat photo, you have to be careful to make sure that things appear to be lit naturally with this filter. Use layer masks to help create additional natural falloff and give the illusion of depth.

BLURS AND REDUCING DETAILS

There are two general approaches to using blur tools; these will affect the overall visual intensity of the image in very different ways. A blur can be used to reduce the texture and detail throughout the image, to create the more painterly effect mentioned in Chapter Ten, or to reduce the energy associated with a specific element such as the background.

Adding a blur to the background is a powerful option for drawing attention to the subject. Doing so reduces the energy in the background due to the decreased texture, detail, and contrast. By comparison the

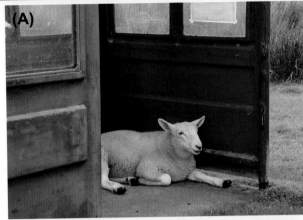
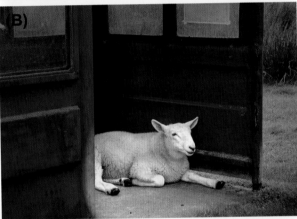

FIGURE 17 (A) Initial image. (B and C) We used Lighting Effects to slightly darken the background while creating the illusion of light striking the lamb and part of the doorway. This adds visual intensity to the lamb while decreasing intensity slightly in the background drawing your eyes to the subject.

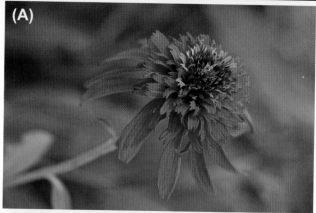

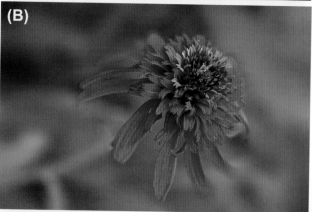

FIGURE 18 (A) Sometimes you need to stop down slightly to render an entire flower sharp, but doing so captures more definition in the background than you want. (B and C) An iris blur can blur the background as if you'd been shooting wide open and decrease the background distractions.

subject has more detail and/or texture, and therefore visual intensity, so our eyes naturally tend to land on the subject. This is the same principle that we use when we opt to use a large aperture in-camera to blur out the background.

Iris Blur Filter

Photoshop CS6's Iris Blur (Filter > Iris Blur) is part of the Blur Gallery. Iris blur is a powerful tool for adding blurs to specific parts of an image while retaining the original sharpness in others, without needing to manually create a layer mask. (Unfortunately, the new blurs can't operate on smart filter layers, so we suggest that you duplicate the background layer of your image before accessing this tool.) Once you open the tool, it's quite intuitive to use. You set the overlay circle over the part of the image that you want to remain sharp and adjust the intensity of the blur that's applied elsewhere, either on the on-screen circular overlay or via the intensity slider on the right, as shown in Figure 18C. You can position the sharp area anywhere it needs to be and you have the option to add pins that will maintain other sharp areas that are auto-masked. Click the square handle on the outer circle to make its shape more square or one of the small circular handles to resize or rotate it. Click one of the inner four dots to expand or contract it and place them over the area that needs to remain sharp. Add additional pins as needed to protect other areas. It's quick and easy. By applying this filter on a separate layer you can adjust the opacity of the layer later, to reduce the effect if you were a little heavy handed, and you can add a layer mask to further tweak the visibility of the effect.

Applying an Iris blur, whether it's subtle or more obvious, is another tool you can use to rebalance the energy toward the subject.

Paint-Simulating Software

While blur tools can be used over the entire image to create a painterly effect due to the decrease in detail, there are other tools that add a texture to simulate paint while also blurring details. Although the reduction in energy due to the blur might reduce the overall energy of the image, the visual intensity of the image may stay virtually the same or even increase due to the bristle/paint texture, depending on the settings you choose. In order to maintain some separation of subject and background, you may need to apply different settings to the blur for the subject and background.

There are far too many programs available for us to cover all the options for creating painterly effects. Instead we'll show examples of Photoshop CS6's Oil Paint filter and Topaz Simplify. No matter which program you use, keep thinking about both the overall intensity of the image and which components are contributing to the energy. Since you're altering the detail energy, you may need to adjust color and/or luminosity energy accordingly to compensate.

Let's first look at the image of farmhouse steps in Figure 19A. It's a pleasant image that seems as if it could have been a painting, so we used the Oil Paint filter in Photoshop CS6 to create the final version. Note that, although we've reduced the details, we've also added texture and shape contrast; thus the overall visual intensity remains similar. Adjust the sliders to determine the amount of brush texture and how much detail is removed, as shown in the screen-shot in Figure 19D.

We used Topaz Simplify on a false-color infrared original of an old schoolhouse in Figure 20. Initially the image lacked impact and didn't convey the feeling we had when we saw the old schoolhouse. Converting it to monochrome didn't help. We swapped the blue and red channels in Photoshop by opening the channel mixer and changing the red output channel to have values of red = 0, green = 0, and blue =100, and modified the blue output channel to have values of red =100, green = 0, and blue = 0. That way the bluer color appears in the sky. We then experimented with Topaz Simplify and created a version that captures the feeling of the old school-house and has more visual intensity than the original. As you can see, the details and colors are far different than the original photograph and the image is now closer to what we'd call photo-art. But we rather like it!

Adding Glows

The last option for reducing details that we will mention is to create a glow. Glows often add a dreamy mood to an image that affects the story it conveys. In the days of slide film, this was called the Orton technique, created by taking one shot that was tack sharp and over-exposed by one stop and another shot of the same thing defocused to be a blur, and also over-exposed. The two slides were then combined in a single mount and had a dreamy feel to them when projected. It was challenging to get both the exposures and the amount of blur correct.

Some digital cameras are able to create in-camera multiple exposures. This allows you to create results similar to the Orton technique in-camera with the advantage that you can preview the results and tweak your technique accordingly. You can also create similar effects from a single shot in the digital darkroom, and this has the advantage of being far more forgiving and controllable in terms of amount of blur and exposure. We often use Nik CEP's Glamour Glow for this (See Figure 21), although you can create a similar effect manually in Photoshop. The effect that a glow has on the overall visual intensity of the image will vary depending on the settings and technique that you use. In general, a glow will increase luminosity contrast while decreasing the energy from texture and details. If initially the visual intensity is too high due to detail or texture contrast, the overall visual intensity may decrease slightly. In other cases the visual intensity may remain similar, although luminosity contrast will play a more dominant role as the texture and details become less important.

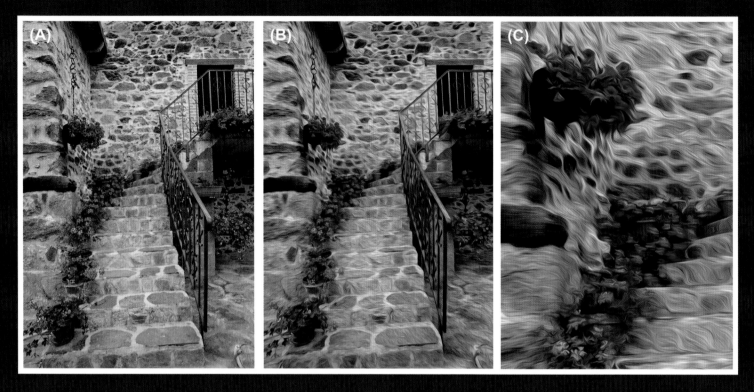

FIGURE 19 (A) Initial image. (B) The Oil Paint filter gives this image the illusion of having been painted. (C) A magnified section shows the brush texture and softer swirl shapes.

FIGURE 19 (D) We used strong settings to be able to show the brush strokes and oil painting effect clearly in this example. You may prefer more subtle settings.

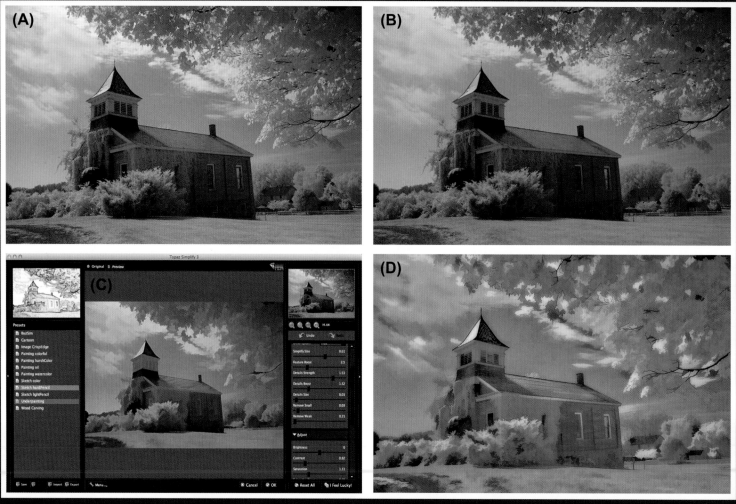

FIGURE 20 (A) Initial image. (B and C) We used Topaz Simplify to convert this infrared image of an old schoolhouse into (D) a painterly version with less detail but more shape contrast, luminosity contrast, and color contrast.

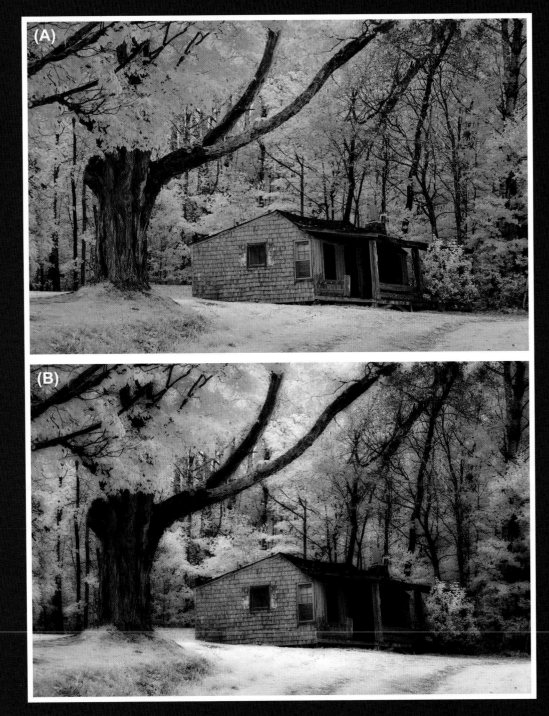

FIGURE 21 (A) Even though the luminosity contrast was too low in the original image, the overall visual intensity was too high because there were too many lines and details. (B) We used the Glamour Glow filter to reduce the texture and detail contrast, while simultaneously increasing the luminosity contrast. This adds a dreamy feel and the overall visual intensity becomes more pleasing.

To simulate the Orton effect in Photoshop, take the following steps:

1. Duplicate the background layer.
2. Change the blending mode for the new layer to Overlay. The image is likely to become too contrasty. In some cases you may prefer the result of a different blending mode such as Screen, Multiply, or Soft Light.
3. Choose Filter > Blur > Gaussian and blur the layer as needed. The preview window will show the results of the two layers combined.
4. If the image is too light or too dark, add a Curves adjustment layer (or Levels or Brightness/Contrast). We recommend clipping the adjustment to the layer beneath it so that each layer can be adjusted separately, although you could opt to use a single adjustment to modify the entire image.

FIGURE 22 Screenshot showing how to create a glow using Photoshop.

No matter which approach you use, adding a blur reduces the detail but may increase saturation and contrast. You need to be vigilant that the overall amount of energy associated with the image remains pleasing.

In this chapter we've just touched the tip of the proverbial iceberg of digital darkroom tools altering the visual intensity of your image. New techniques and tools appear frequently letting you modify images in ways that were previously unfathomable. Experiment and see how you might incorporate them into your images. Don't limit yourself to just the techniques we've discussed. Use anything and everything out there to create images that show just how you *See It!*

We hope that you will continue to use our approach of considering the amount of energy your image has and noting where your eye goes as the foundation for making adjustments to guide your viewers' eyes to your subject and to create images with the WOW! factor. We think you'll find that once you get accustomed to evaluating the location and amount of energy in the various parts of an image, and which components are creating that energy, efficiently optimizing your images will become far easier.

Exercises

1. Select two images in which the subject is not sufficiently separate from the background. Try blurring the background and/or adding detail to the subject to help add energy to the subject and decrease the energy in the background.

2. Select two images where the lighting is such that your eye does not readily go to the subject. Relight the image to add luminosity contrast to the subject. Decide whether you also need to slightly darken the background.

3. Select two images and experiment with creating painterly effects, even if you normally prefer more documentary-style images. Note what happens to the visual intensity of the image and further adjust the luminosity contrast and color contrast as needed. Doing so will help you gain a better feel for the energy that details and textures provide. Note what works for you and what doesn't.

4. Keep making game plans based on visual intensity, and continue experimenting, practicing, and creating!

Block, Bruce. *The Visual Story*. Boston: Focal Press; 2007.

Changizi, Mark. *The Vision Revolution*. Dallas: BenBella Books, Inc.; 2009.

Freeman, Michael. *The Photographer's Eye*. Boston: Focal Press; 2007.

Livingstone, Margaret. *Vision and Art The Biology of Seeing*. New York: Harry N. Abrams, Inc.; 2002.

Lynch, David, and William Livingston. *Color and Light in Nature*. New York: Cambridge University Press; 2001.

Mante, Harald. *Color Design in Photography*. Boston: Focal Press; 1972.

Solso, Robert. *Cognition and the Visual Arts*. Cambridge: MIT Press; 1996.

Zakia, Richard. *Perception and Imaging*. Boston: Focal Press; 1997.

Selected Bibliography

Index

Note: Page numbers with "f" denote figures; "t" tables.

A

Abstract images, 192f–193f, 193
Actions of, 42–44, 44f–45f
Active colors. *See* Warm colors
Adler, Lindsay, 202f–203f, 203–205
Adobe Camera Raw (ACR), 272–273, 277, 302
 Clarity slider, 302–305, 304f
Afterimages, 30f, 31
Afternoon, light in, 154
Aging, and vision, 44–48, 47f
Airlight, 154
Alpenglow, 154
Amodal perception, 68
Aperture, 120
Apple Aperture, 272–273, 272f, 277, 284–285, 304
 Definition slider, 302–304
Archetypes, 164

Artificial light, 156–157, 158f
Aspect ratio, 135
Assembling, of frame, 122–135, 125f
 cropping, 133–135, 134f, 136f–137f
 intensity, 122–124, 125f
 objects, relationship between, 129–133,
 129f–132f
 positioning, 104–159, 266
 visual weight, 128–129

B

Back lighting, 149, 150f
Background, in images, 227, 231–233, 232f, 240
 adding blur to, 317–318, 317f–318f
 digital manipulation of, 287, 289f
Beauty dishes, 145–147, 146f
Becker, Art, 216f–217f, 217

Binocular depth cues, 105–107
Black points, in digital manipulation, 271–273,
 272f, 274f–275f
Black-and-white photography, 98
 vs. color photography, 98–100
Blackmore, Clay, 214f–215f, 215–217
Blindness, color, 26
"Blue hour", 93–95
Blurs/blurriness, 28–29, 29f, 317–325
Bokeh, 121, 121f
Brain
 groupings and, 68b
 interpretation of, 157
 processing
 of faces, 41–42, 42f–43f
 of light, 35–44
 recording of light, 29–35
 understanding of action, 42–44, 44f–45f

Brightness, 85–86, 86f, 143, 143f. *See also*
 Contrast. *See also* Luminance
Burian, Peter, 212f–213f, 213–215
Burning, in digital manipulation, 277, 277b, 278f

C

Camera Raw. *See* Adobe Camera Raw (ACR)
Cameras, 2–3, 2f
 infrared (IR) cameras, 258–261, 260f
 lightfield camera, 178
 tilted cameras, 166
Caponigro, John Paul, 192f–193f, 193–195
Cataracts, 45
Category learning, 163
Circles, 59–60, 61f
Collective unconscious, 164
Color blending, 97, 97f
Color blindness, 26
Color calibration, 95b
Color checker, 45, 46f
Color constancy, 38, 41
Color Efex Pro 4.0 (CEP), 270b–271b, 273, 276f,
 277, 279–281, 287, 292
 Detail Enhancer, 305, 306f
 Glamour Glow, 319, 323f
 Tonal Contrast filter, 302, 303f
Color opponent pairs, 30–31
Color therapy, 84
Color triangle, 91, 91f–92f
Color wheel, 86–87, 86f–87f
Colors, 82–101
 adjustments, in digital manipulation, 279–281,
 280f, 282f–284f
 black-and-white vs. color photography,
 98–100
 impact of, 87–89
 matching, 89–93
 palette, visual effects of, 93–97
 pastel variants of, 88f
 properties of, 84–86
 rainbow model of, 85f
 representation of, 30–32, 30f–32f
 for storytelling, 181
 sources of, 84–87, 85f
 with equal luminance, 39b

Communication. *See* Semiotics
Complementary colors, 89, 89f
Components, image
 awareness of, 19–21, 20f–21f
 focusing on, 14–15, 14f–16f
Composition, 227–230
 progression in, 3–7, 4f–6f
Concept learning, 163
Contrast, 143, 143f
 role in digital manipulation, 268. *See also*
 Brightness. *See also* Luminance
Convergence, 105
Cool colors, 91–93, 93f
Cornea, 25
Cornsweet illusion, 33, 34f
Cropping, 115b–116b, 133–135, 134f, 136f–137f,
 283–284, 285f
Crowd, shooting across, 131, 133f
Cultural differences
 in colors, 88
 in viewing image, 13b

D

Daylight, emission spectrums of, 147f
Deep space, 105
Depth cues, 246–248, 247f–248f
 binocular, 105–107
 monocular, 107–111, 108f–110f
Depth of field, 105–111
 choosing, 231–234, 231f–233f
 lens choice and, 116–122, 119f–120f, 123f
 in macro lenses, 252
 shallow, 121–122
Details, increasing or decreasing, 302–308,
 317–325
Diffusers, 145
Digital infrared cameras, 258–260
Digital manipulation, for improving visual intensity,
 266
 color adjustments, 279–281, 280f, 282f–284f
 cropping, 283–284, 285f
 distracting elements, 287, 288f–289f
 game plan, development of, 266–271,
 291f–292f
 images, selection of, 266

 lighting, 277–279, 279f
 mid-tone contrast, 273, 276f
 rotating, 284–285, 286f
 tonal adjustments, 271
 white and black points, setting, 271–273,
 272f, 274f–275f
Digital techniques, creative, 295
 blurs, 317–325
 details, increasing or decreasing, 302–308,
 317–325
 dynamic range, extending, 296–300,
 298f–300f
 elements, combining, 312–314, 312f–313f,
 315f
 relighting, of images, 315–317, 316f–317f
 single image processing, 297–300, 301f
 textures
 adding, 309f, 311f
 creating, 310b
Direct light, 149–150
Direction of light, 147–157
Distracting elements, digital manipulation of, 287,
 288f–289f
Dodging, in digital manipulation, 277, 277b, 278f
Double-opponent cell, 31
Dutched cameras. *See* Tilted cameras
Dynamic range, 155b–156b
 extending, 296–300, 298f–300f

E

Edges, of frame, 133–135, 134f, 241
Editing, using visual intensity for, 17–19
Electromagnetic (EM) spectrum, 24, 25f
Elevation, as depth cue, 111
Emotions
 of colors, 87, 87t, 88f
 facial, 12–13
 joy, anger and stable shapes, 61–63,
 62f–63f
 of shapes, 60–61
Equilateral triangle, to pick color combinations, 84,
 90
Eye line, 56–57, 57f
Eyes
 detection of light, 25–29, 26f–27f

and interpretation of brain, 7–13, 7f–9f, 12f
movement of, 11b, 13f
recording of light, 29–35
set up of, 26–28

F

F-number, 120
Faces, brain processing of, 41–42, 42f–43f
Facial emotions, 12–13
Familiar size, 109
Fibonacci grid, 127f–128f
Field, creating images in, 221–262
 choices, 227–247
 first steps, 222–225, 223f–226f
 initial approaches and choices, 222
 multiple shots, taking, 248–250, 251f
 tools and techniques, 250–261
Field of view, 111–116, 112f
Figure/ground, 105–111
Filters, 241–246, 244f–246f
 for increasing and decreasing details, 302
Finding, images, 175–177, 176f–177f
First impressions, counting of, 266–271, 268f–269f
Fisheye lens, 59, 61f, 254–257, 258f. *See also*
 Wide-angle lenses
Flashes, 156
Flat space, 105
Fluorescent light, 147
Focal length, 115
 for field images, choosing, 227
Focus, for storytelling, 178, 180f
Foggy images, 273, 275f
Fovea, 28
"Frame within a frame" technique, 131
Framing, 103–139
 assembling, 122–135
 checking, 166, 239f–240f, 242f
 depth, 105–111
 figure/ground, 104–105
Front lighting, 148, 148f

G

Genes, and subjects perception, 166
Gestalt, 63–69, 64f

and brains, 68b
closure, 67–68, 70f
common fate, 65–67, 67f
continuation, 67, 68f–69f
and music, 72b
proximity, 63–64, 64f–65f
psychology, 63
similarity, 65, 66f
Glaucoma, 46
Glow, creation of, 319
Goethe's triangle. *See* Color triangle
"Golden hour", 152, 153f
Golden ratio, 126
Golden rectangle, 126, 126f
Golden triangle, 126, 127f
Groups. *See* Gestalt

H

Hard light, 143–147
Haze, 154
HDR Efex Pro, 297, 300–302
Helmholtz-Kohlrausch effect, 95
High dynamic range (HDR) images, 296–300,
 34–35, 37f, 246–292, 298f–300f
Horizon, 129f, 130
 placement of, 229–230, 230f
Horizontal lines, 52–53, 52f
Horizontal shot. *See* Landscape orientation
Hue, 85, 86f
Hunt effect, 143
Hyperfocal point, 120–121

I

Illuminance, 142. *See also* Brightness. *See also*
 Luminance
Illusions, optical, 7, 8f
Implied lines, 55–57, 56f
Implied motion, directions of, 57, 58f–59f
Inattentional blindness, 19
Incident light, 142
Indirect light, 150
Infrared (IR) cameras, 258–261, 260f
Intensity. *See* Visual intensity
ISO, for field images, 238

K

Kanizsa triangle illusion, 68, 71f
Kinetic cues, 107
Kühne, Willy, 7, 7f

L

Lab color space, 32b
Landscape orientation, 122
Learning, 163
Lensbaby lenses, 254, 257f
Lenses
 choice of, 111–122, 115f, 117f
 depth of field and, 116–122, 119f–120f,
 123f
 for field images, 227
 fisheye, 61f
 macro, 250–253, 252f–253f
 tilt-shift, 253–254, 255f–257f
Light, 24, 140–159
 detection by eyes, 25–29, 26f–27f
 direction of, 147–157
 human visibility of, 24b
 mood and subject, 157–159
 processing by brain, 35–44
 quality of, 142–147
 recording by eyes and brain,
 29–35
Light meters, 142–143
Light modifiers, 145–147, 146f
Lightfield camera, 178
Lighting
 checking, 241, 243f
 in digital manipulation, 277–279, 279f
 for storytelling, 181
Lightroom, 272–273, 277, 284–285, 304
 Clarity slider, 302–305
Lines, 52–57, 52f
 implied lines, 55–57
Lowrie, Charlotte, 210f–212f, 211–213
Luminance, 142–143
 with center/surround, handling, 32–35,
 34f–35f
 equal, colors with, 39b. *See also* Brightness.
 See also Contrast

M

Macro lenses, 250–253, 252f–253f
Macular degeneration, 45
Meditating Philosopher (painting), 34, 35f
Memories, 163, 163f
 visual, 163
Mental photograph, 8, 9f
Midday, light in, 152, 154f
Mid-tone contrast, 302–304, 305b
 in digital manipulation, 273, 276f. *See also*
 Contrast
Mind, shooting visual intensity in, 15–17
Mirror neurons, 42–43
 and subjects perception, 166
Monocular depth cues, 107–111, 108f–110f
Mood, 157–159
Morning, light in, 152, 153f
Morris, Art, 198f–199f, 199–201
Morrison, Mallory, 196f–197f, 197–199
Mrs. Charles Badham (painting), 41–42, 42f
Multi-light setups, 156
Multi-picture stories, 183–185, 184f–186f
Multiple exposures, 257–258, 259b, 259f
Multiple images, combining, 297–300
Multiplication factor, 115b–116b
Music, and gestalt, 72b

N

Narrow lenses, 111–112, 113f–114f, 116, 117f
Natural light, 150–156, 151f
Negative space, 105, 106f, 135
Nik Software, 302
Non-destructive cropping, 285b

O

Objects, 172
 relationship between, 129–133, 129f–132f
Oblique lines, 52–53, 52f
Occlusion, 107, 109
Orientation, 111, 111f
Orton technique, 319

P

Paint-simulating software, 319, 320f–323f
Passive colors. *See* Cool colors
Patterson, Freeman, 205–207
Paulsen, Kirk, 208f–209f, 209–211
Peripheral vision, 28–29, 29f
Perspective, 107–109, 108f
Photomatix Pro, 297, 300–302
Photomosaic, 97, 98f
Photoshop, 270b–271b, 270f, 273, 277b, 278f,
 280–281, 284–285, 297, 310b
 Iris Blur filter, 318, 318f
 Lighting Effects filter, 316–317
 Oil Painting filter, 320f–321f
 Orton effect in, 324b, 324f
Portrait orientation, 122
Positioning, in frames, 125f–126f, 126, 159
Positive space, 105, 106f
Prägnanz, 68–69, 71f–72f
Pre-visualization of images, 175–177, 176f–177f
Prototypes, 164, 164f–165f
Purple color, 87

Q

Quality of light, 142–147
 soft vs. hard, 143–147
 warm vs. cold, 147

R

Rainbow, 86
Rectangles, 57–59, 60f
Relative size, 109
Relighting, of images, 315–317, 316f–317f
Retina, 25
Rhythm, visual, 69–71, 73f–76f
Ricard, John, 200f–201f, 201–203
Rods, 26
Rotating, 284–285, 286f
Royal purple. *See* Tyrian purple
Rubin vase, 104–105, 104f
Rule of thirds, 15–16, 122, 124f

S

S-shaped curves, 55b, 55f
Saliency map, 16–17
Saturation, 85, 86f, 281, 283f
Scintillating grid, 8f, 33f
Semiotics, 172, 174f
Sensors, in eyes, 26
Shades, 85–86
Shallow depth of field, 121–122
Shapes, 57–63
 joy, anger and stable shapes, 61–63,
 62f–63f
Sharpener Pro, 270b–271b
The Shrimp Girl (painting), 55f
Shutter speed
 choosing, 241
 for storytelling, 178–181, 181f–182f
Side lighting, 148–149, 149f
Signs. *See* Semiotics
Silver Efex Pro 2, 281
Simon, Steve, 194f–195f, 195–197
Simultaneous contrast, 34, 35f, 95, 96f–97f. *See*
 also Contrast
Single image processing, 297–300, 301f
Social networking theory, 43
Soft light, 143–147, 145f
Split-complementary colors, 90, 90f. *See also*
 Complementary colors
Stevens effect, 143, 143f
Stories, creating, 169–178, 169f–171f
 decisive moment, 177–178, 179f
 images, pre-visualizing and finding, 175–177,
 176f–177f
Storytelling. *See* Visual storytelling
Straight lines, 53, 54f
Subjects, 157–159
 perceiving, 162–169, 165f–167f
 placement of, 230
Sunrise, light during, 150–152, 152f
Sunset, light during, 154, 155f
Super-telephoto lens, 111